BRIARCLIFFE COLLEGE LIBRARY

THE ART OF SPORT

the best of Reuters sports photography

BRIARCLIFFE COLLEGE LIBRARY

REUTERS :B

Published by **Pearson Education**
London • New York • San Francisco • Toronto • Sydney • Tokyo • Singapore
Hong Kong • Cape Town • Madrid • Amsterdam • Munich • Paris • Milan

PEARSON EDUCATION LIMITED

Head Office:
Edinburgh Gate
Harlow CM20 2JE
Tel: +44 (0)1279 623623
Fax: +44 (0)1279 431059

London Office:
128 Long Acre
London WC2E 9AN
Tel: +44 (0)20 7447 2000
Fax: +44 (0)20 7447 2170
Website: www.business-minds.com

First published in Great Britain in 2003

© Reuters 2003

The right of Reuters to be identified as author of this work has been asserted by
them in accordance with the Copyright, Designs and Patents Act 1988.

ISBN 1 903 68412 9

British Library Cataloguing in Publication Data
A CIP catalogue record for this book can be obtained from the British Library.

All rights reserved; no part of this publication may be reproduced, stored
in a retrieval system, or transmitted in any form or by any means, electronic,
mechanical, photocopying, recording, or otherwise without either the prior
written permission of the publishers or a licence permitting restricted copying
in the United Kingdom issued by the Copyright Licensing Agency Ltd,
90 Tottenham Court Road, London W1P 0LP. This book may not be lent,
resold, hired out or otherwise disposed of by way of trade in any form
of binding or cover other than that in which it is published, without the
prior consent of the publishers.

10 9 8 7 6 5 4 3 2

Designed by Ian Roberts
Typeset by Pantek Arts Ltd, Maidstone, Kent.
Printed and bound in Great Britain by Bath Press

The publishers' policy is to use paper manufactured from sustainable forests.

FOREWORD

The Art of Sport is a book about sport, but not only this: it is also a book about the beauty, the unexpected, the grace, the anguish, the triumph and the pain of sport.

In this collection, Reuters photographers have captured the significance of moments in time. More often than not the photograph needs no caption: it tells its own story more vividly than words can.

Sometimes the picture is so perfect in its detail and perspective that it looks as if it has been posed, but it has not. Reuters photographers cover the world's events as they happen and capture images of breaking news and sport for the daily news file. They work in the most competitive circumstances but many of their pictures, such as the ones assembled in this book, are remarkable in ways that mean the shots outlive their immediate news value.

Curiosity, persistence, patience, precision, the best angle and a sense of perspective are the ingredients of a great photograph. The photographer has to exhibit real vision and talent to get more than just a record of the event.

The military precision of pursuit cycling is frozen by Dan Chung in the cover picture. The blurred background is the only indication of the riders' speed.

All the poise balance and agility of a gymnast is captured in the back cover frame by Mike Blake, in his shot of a young Spaniard with a hole in her shoe, balancing on the beam at the 2000 Sydney Olympics.

The Art of Sport is a collection of pictures in the broadest sense. There are few 'decisive moments', no winning goals nor holes in one. The pictures represent sports photography beyond the cut and thrust of daily competition and many immortalize key moments in history. The Afghan boxer exercising under a poster of Muhammad Ali in a small Kabul boxing club after the fall of the Taliban is one of these moments. Under the strict Taliban rule boxing was condemned and Damir Sagolj's picture encompasses a return to freedom – as well as the immortality of Ali.

This book is dedicated to all Reuters staff and freelance photo-journalists. Without their vision and enterprise it would not have been possible to produce such a compelling collection. In the last year, twelve Reuters photographers have received international awards for their outstanding work.

Monique Villa and Steve Crisp

With special thanks to David Viggers, Alexia Singh, John Mehaffey, Dave Cutler, Mair Salts, Alisa Bowen and Amanda Thompson.

Serena Williams returns at Wimbledon
28 June 2002

Jeff J. Mitchell

The year 2002 saw the emergence of Serena Williams from the shadow of her elder sister Venus to win the French Open in Paris on clay and the Wimbledon title in London on grass.

The sisters' father Richard, who coached the pair on public courts in Los Angeles while rival gangs took pot shots at each other, had gone on record as saying he believed 20-year-old Serena had more talent than Venus, two years her senior. What she did not have before 2002 was self-belief. 'I saw her becoming a more distinct personality about two years ago,' said her mother Oracene. 'At first, she was just emulating Venus. Now she's totally different.'

Serena's new positive attitude was evident during an athletic and sometimes spectacular Wimbledon final, in which she beat her sister 7–6 6–3 in a fiercely competitive match. Chris Evert, who vied for supremacy in the women's game with the more physical Martina Navratilova during the 1980s, said she was only glad she was not still playing. 'It was the hardest-hitting women's match I have ever seen,' Evert said.

By the end of Wimbledon, the sisters had played each other in three grand slam finals in the space of 10 months. Inevitably, the critics have muttered that the pair are so far beyond the rest of the field that they are ruining the game. 'Nonsense,' said Evert. 'They've thrown down the gauntlet to the other players to try to catch up. It's up to them to figure out the best way to do that.'

THE ART OF SPORT

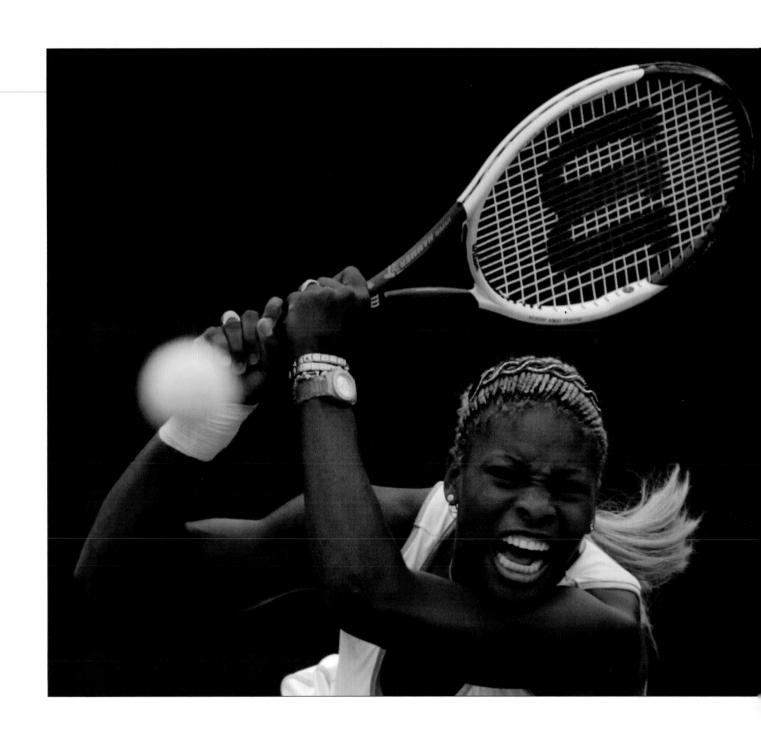

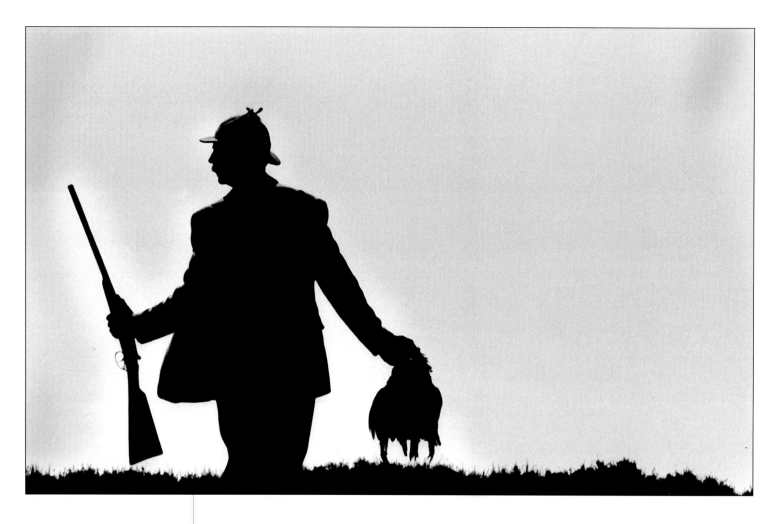

The Glorious 12th
12 August 1996

Jeff J. Mitchell

Silhouetted against the sky on a hot and hazy day in the South West of Scotland, local gamekeeper Derek Goodwin collects grouse at a Glorious 12th shooting party on an estate near Dumfries. August 12 is the annual start to the grouse shooting season and Derek is the local gamekeeper at Wanlockhead, Scotland's highest village.

The tradition of the Glorious 12th dates back to the middle of the 19th century when the nobility and industrialists of Victorian Britain packed their bags and retreated to Scotland. Queen Victoria's husband Prince Albert was a particularly keen shot and timed his summer break to coincide with the start of the grouse season.

Queen Elizabeth still holidays at Balmoral, bought by Queen Victoria in 1852, but royalty is rarely glimpsed trudging through the heather with gun in hand. Instead, wealthy American and European tourists pay appropriately steep prices for the privilege of shooting small game birds.

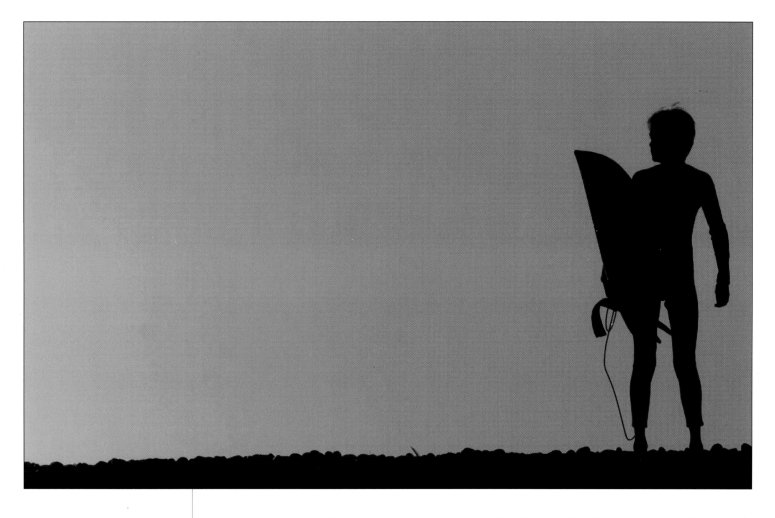

A lone surfer at sunset
19 March 2001

Mike Blake

A young surfer gazes at the setting sun, just about the only light left in California, after a day of rolling power blackouts which struck the state on March 19 2001. Officials had ordered blackouts, which doused lights from San Francisco in northern California to the boutiques of Beverly Hills and the beach communities of San Diego.

Asked to find an image conveying the impact of the blackouts, Mike decided electricity was difficult to capture on film. Even more so, a lack of electricity. Instead he opted for a shot of a boy prepared for the quintessential Californian sport, which requires only four basic elements: sun, sea, surf and sand.

Jones slams into the wall
6 April 2002

Tami Chappell

Atlanta Braves centerfielder Andruw Jones, noted for his spectacular catches, hits the wall as the ball bounces high above his head on a double by the New York Mets' Edgardo Alfonso in the third innings at Turner Field in Atlanta, Georgia.

'I always keep an eye on him whenever the ball goes near him,' said Tami. 'In this case I thought he looked like a cartoon character when he slammed into the wall. He bounced right off and kept playing. It was an unusual moment and the fans' reactions in the picture were nice. This picture played in various publications around the world.'

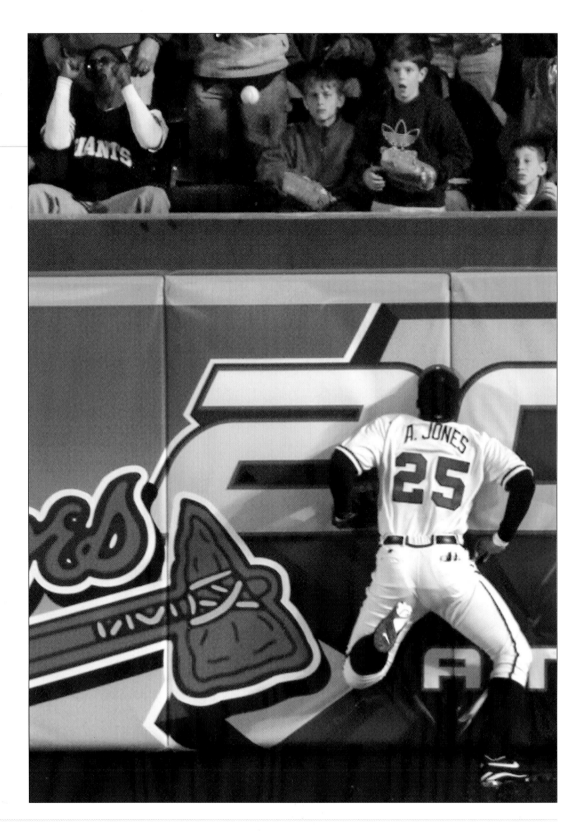

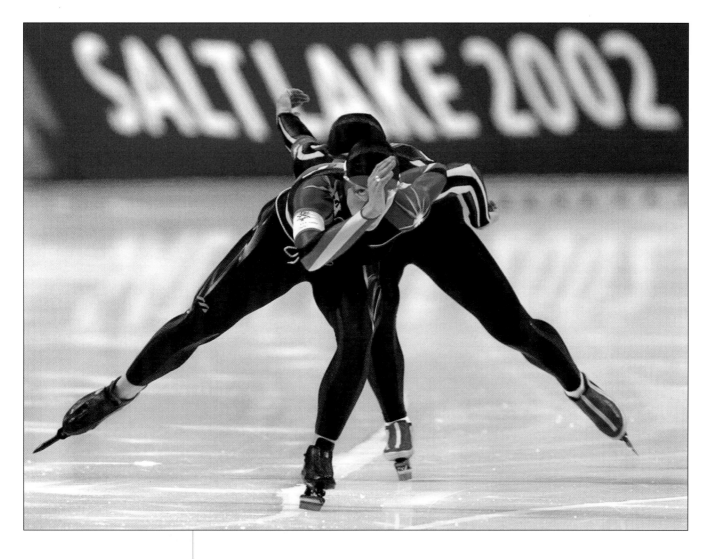

Friesinger sets a world record
20 February 2002

David Gray

Speedskaters Anni Friesinger of Germany and Aki Tonoike from Japan merge into one in the 2002 Salt Lake City Olympics women's 1,500 metres.

Friesinger went on to set a world record of 1.54.02 minutes during a competition at which records tumbled daily as a result of the super-fast ice and the thin mountain air, which provided less resistance for the skaters.

'At this particular spot on the track the skaters cross over lanes, giving the opportunity for a picture with both skaters in one frame. All the photographer has to do is follow them as they come up the straight and react at the right time,' explained David.

The presence of the Salt Lake 2002 sign in the background places Friesinger in the ultimate competition arena of the Olympic Games and allows the viewer to distinguish where the German skater is competing without having to read the caption.

Vieri photographed through his shirt
8 June 2002

Dylan Martinez

Italy striker Christian Vieri tugs off his shirt after scoring one goal and having another disallowed in a controversial World Cup 2002 group match against Croatia during which two Italian goals were disallowed.

The first disallowed goal came when Danish linesman Jens Larsen waved Vieri offside after a header that would have put the Italians ahead 1–0. Later, striker Filippo Inzaghi was penalized for pulling a defender's shirt before putting the ball in the back of the net, sparking outrage in the Italian camp.

Larsen later told Danish radio he made a mistake in the Vieri decision but had been right about Inzaghi. The Italians were not mollified and questionable refereeing decisions continued to haunt them until their premature exit from the Cup.

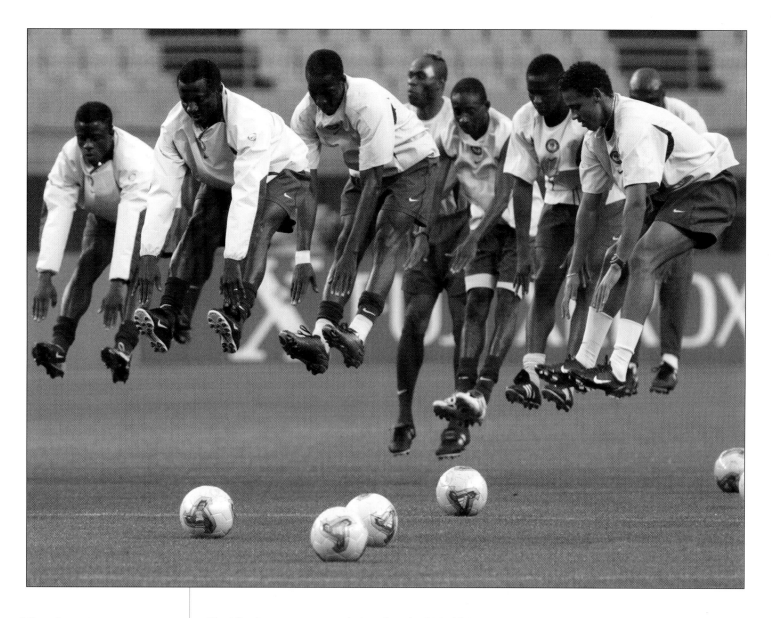

Nigerian players warm up
11 June 2002

Jim Bourg

The Nigerian team warm up before their final World Cup group match against England. The match was drawn 0–0 on a stifling afternoon in Osaka. England showed a lack of adventure in a mediocre match when just one goal would have been enough to enable England to head their group and avoid meeting their eventual quarter-final conquerors Brazil before the semi-finals.

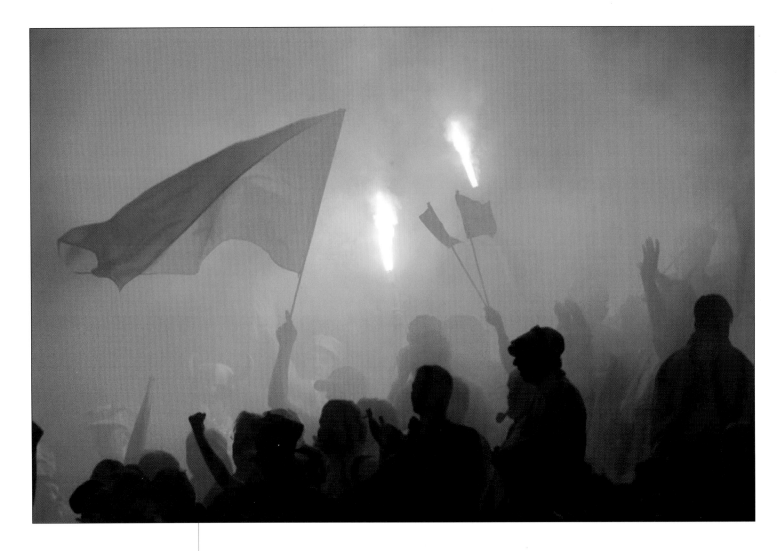

Danish fans burn flares
12 June 1998

Desmond Boylan

It could be a crowd scene from *Les Miserables*. It is actually a picture of Danish soccer fans burning flares as they celebrate their team's 1–0 win over Saudia Arabia in a group match at the 1998 World Cup in France.

Denmark advanced as far as the quarter-finals, where they gave eventual runners-up Brazil a testing examination before losing 3–2. The Brazil match was the last international for Michael Laudrup who threw his boots into the crowd. Within days his brother Brian had also retired.

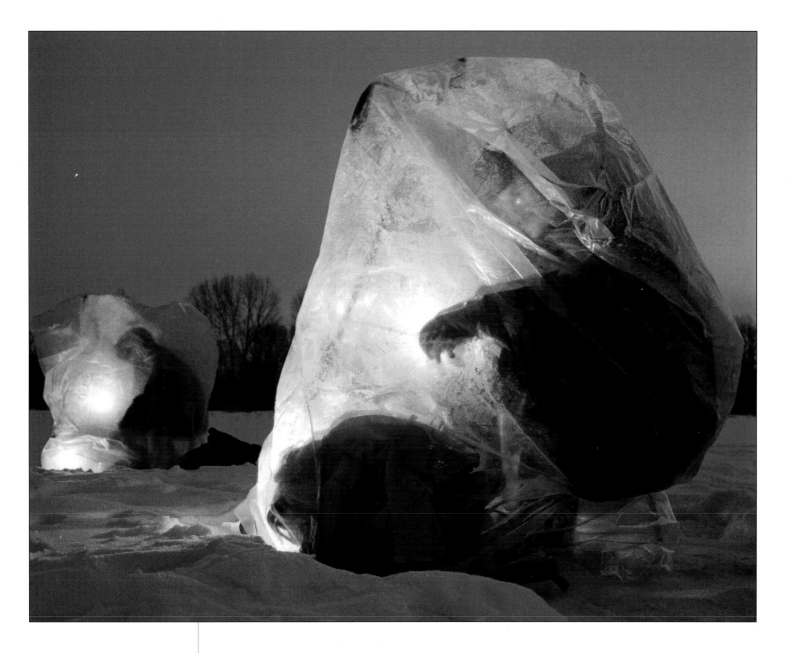

**Russian fishermen
practise patience**
18 November 2000

Andrei Rudakov

Fishing, Izaak Walton wrote in *The Compleat Angler*, first published in 1653 and often reprinted since, can offer a life of both action and contemplation.

Here, Russian fishermen, covered against the freezing temperatures, have time and opportunity to contemplate the infinite. Set against a brilliant, frozen blue sky the fishermen are perched on the ice of the River Tom near the village of Beryozovo outside the Siberian city of Kemerovo. The first autumn frosts herald the start of the ice-fishing season.

Reflection in cyclist's helmet
29 September 2001

Francois Lenoir

The cycling track is reflected in the helmet of Mexico's Nancy Contreras Reyes at the start of the women's 500 metres time trial at the 2001 world track cycling championships in Antwerp, Belgium.

'I took this photo when I was sent to cover the world track cycling championships for the first time,' said Francois. 'I was immediately struck by the shape and the reflection given off by this Mexican rider's helmet. I used a 400-mm lens, the longest I had with me, to shoot the brilliance of her helmet and the image it mirrored of the track.

'I wanted to get the best angle to capture all the scope of the reflection. You see by the unusual shape of the helmet that it belongs to a cyclist and the reflection from the helmet tells the whole story.'

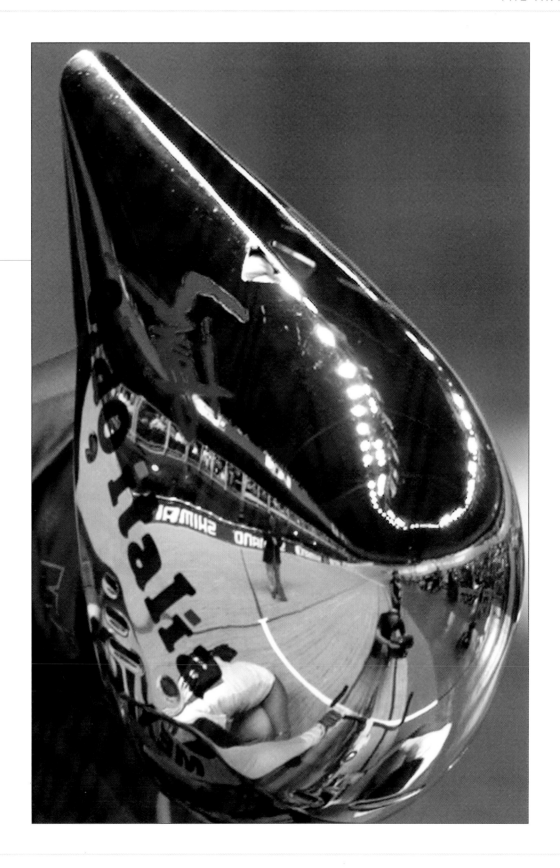

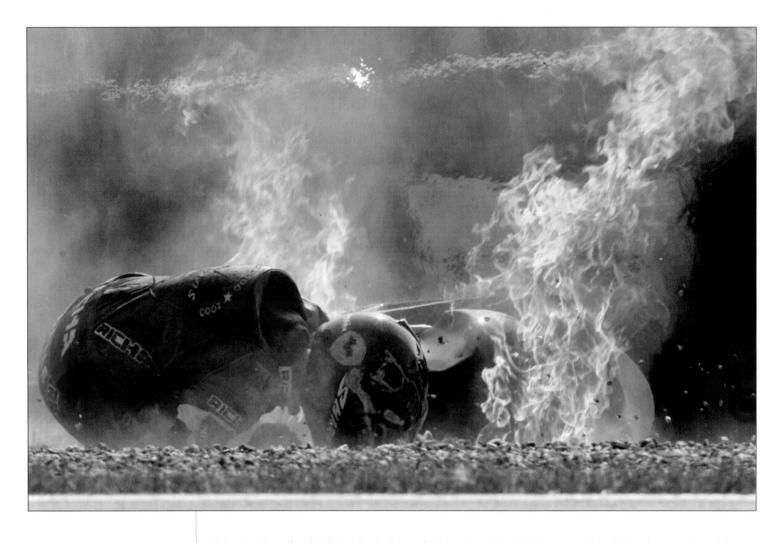

A dramatic bike crash in Brno
18 August 2000

Petr Josek

Sebastien Legrelle of Belgium lies in front of his burning Honda 500-cc motorbike during free practice of the Czech grand prix in Brno. Amazingly, he was uninjured.

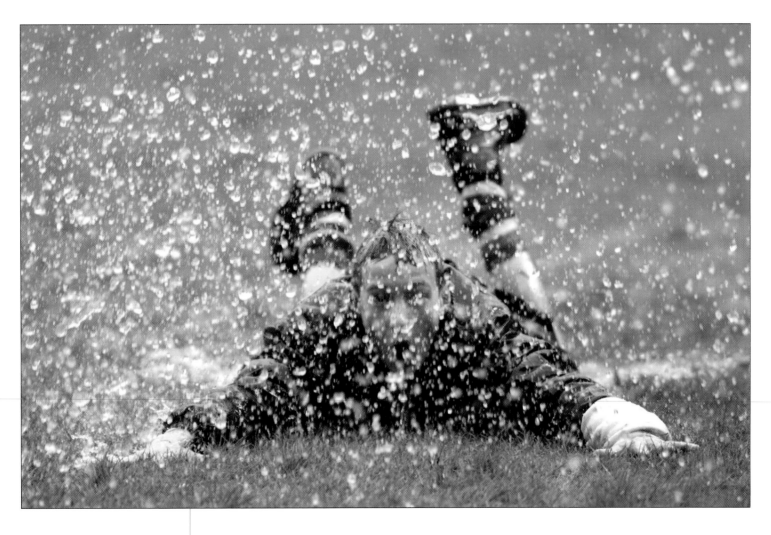

A rugby fan celebrates an unexpected victory
2 April 2000

Ian Hodgson

A Scotland rugby union fan body-surfs exuberantly on the sodden Murrayfield pitch after a rare win over the auld enemy. England had already won the 2000 Six Nations championship but needed a victory over the Scots to complete the grand slam. Instead they were repelled 19–13 by a fired-up Scots side.

England and Scotland played the first rugby international back in 1871 and in the days when the game was played predominantly by the professional and leisured classes, honours were shared, although the English had by far the stronger power base.

The English Scottish rivalry was at its most intense in 1990 when Will Carling, unfairly viewed north of the border as an arrogant representative of all that was wrong with England, took his side to Murrayfield with both sides seeking victory. Although England had played rugby of surpassing quality during the championship, it was the Scots who prevailed after they walked, rather than ran, on to the field to the blood-curdling wail of the bagpipes while the crowd worked themselves into a frenzy. It remains Scotland's most famous win over England.

Camera trickery as Helveg jumps over Bebeto
3 July 1998

Russell Boyce

Denmark's Thomas Helveg jumps over Brazilian Bebeto during their 1998 World Cup quarter-final.

'Positioned at the top of the stadium, a large depth of field created a strange foreshortened image which makes it appear that a giant soccer player has run on to the pitch,' said Russell.

'It is actually a clearance header by the player in the foreground. The picture caused a caption nightmare which had to go into details of foreshortening and perspective.'

Brazil advanced to the final but were defeated 3–0 by France.

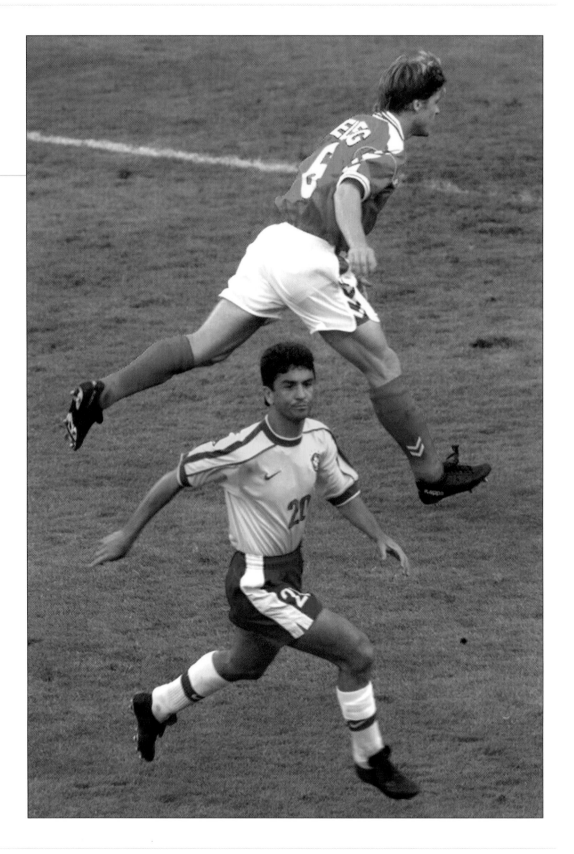

The long and the short
20 January 1996

Andy Clark

George Merzygian of the then Washington Bullets towers over Damon Stoudamire of the Toronto Raptors.

'I couldn't help but notice the difference in height between the two players and I soon discovered they very rarely met,' said Andy.

'After several close encounters that almost worked, I had just about given up when Stoudamire suddenly rushed down court and tried to go around Merzygian resulting in this photo.'

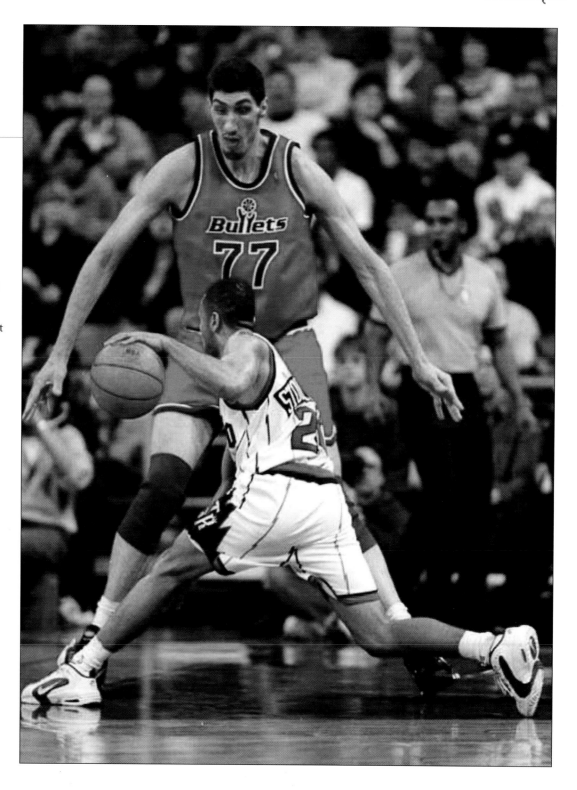

Rusedski at the US Open
1 September 1999

Kevin Lamarque

Greg Rusedski casts a long shadow as he plays a forehand return to Juan Carlos Ferrera of Spain in a first-round match at the 1999 US Open in Flushing Meadows. Rusedski survived until the fourth round, where he was knocked out by American Todd Martin.

The Canadian-born Briton has a devastating serve, clocking a world-record 146 miles an hour (234 kph), which combined with his left-handed angle can be unplayable on grass. His groundstrokes can be fallible, particularly on the backhand, and although he is a fine athlete Rusedski is also prone to injury.

His arrival on the international scene coincided with the advent of Tim Henman, whose boyish charm and obvious if sometimes infuriatingly brittle talent, has made him the darling of the Wimbledon crowds. Outside this pair, England have nobody with a hope of becoming the first home player to win Wimbledon since Fred Perry captured the last of his three titles in 1936.

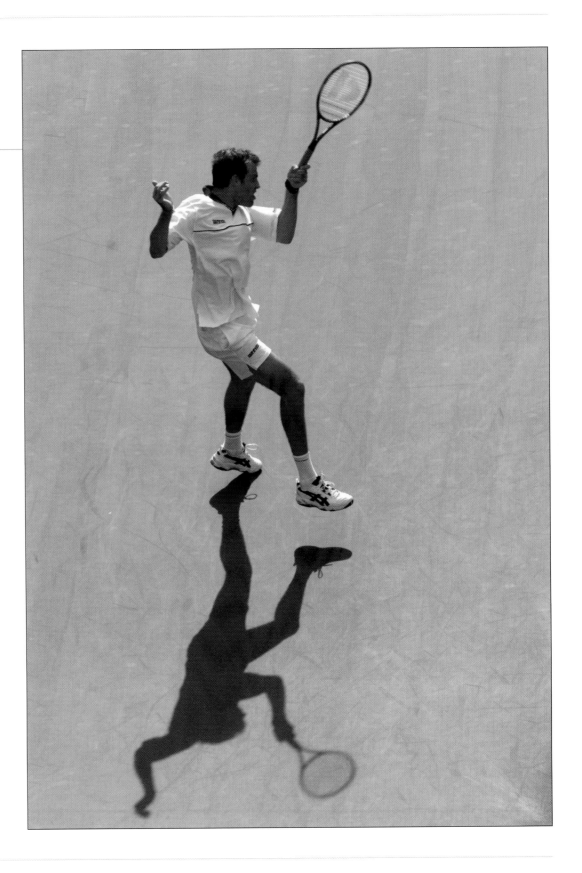

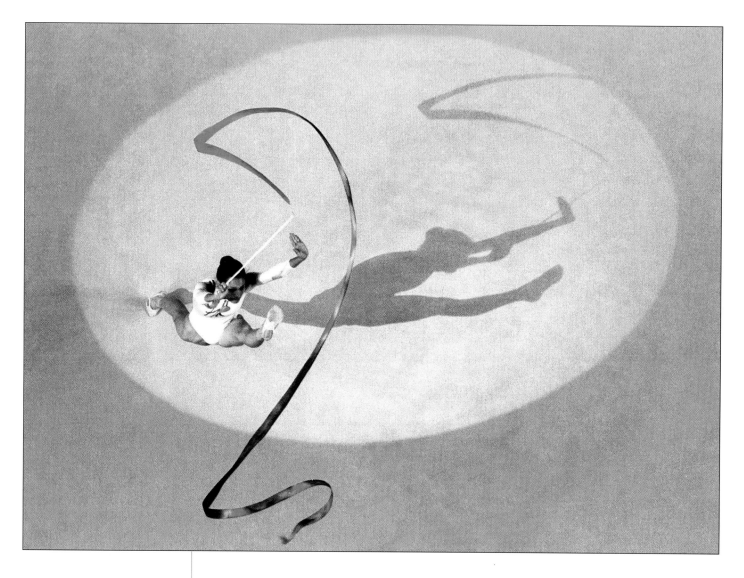

A practising rhythmic gymnast
2 June 1997

David Gray

Two dramatic elements distinguish this photograph of Australian Shaneez Johnston practising with the ribbon before the start of the Four Continents championships in Sydney – the high angle and the long shadow.

'I arrived at the practice session wanting to get a different picture,' said David. 'I thought that the ground-level backgrounds were far too messy so, I asked the venue manager if it would be possible to get into the roof.

'After much discussion, I climbed numerous ladders and into the lighting scaffolding. Leaning over quite precariously from nothing more than a narrow plank, I managed to get directly above the floor. After trying for around 20 minutes to get an interesting moment, a spotlight began tracking the girls.

'Using a lens which enabled me to go tight and wide very quickly and easily, I waited for Shaneez to jump. When she did her shadow was cast over the entire floor and the ribbon curled out far enough in the right direction. The picture was very satisfying because every element that I was after came into place at the same time.'

Diver captured under water
28 June 2000

Ferran Paredes

Ferran brings both technical skills and aesthetic appreciation to the difficult task of photographing aquatic sports, on this occasion the diving competition at the 2000 European swimming championships, filmed from an underwater window in Helsinki's Makelanrinne Swimming Centre.

'I had been a semi-professional waterpolo player for over 10 years in Barcelona and, as such, I had spent thousands of hours both above and below the water level,' he said. 'I have always been amazed by what happens in this magic, hidden and mysterious universe. As soon as I saw the competitors diving in from one of these windows I felt attracted to the elegance of their movement and the angelic appearance of the white bubbles against the blue background.'

The technical difficulties were immense. Ferran had no way of knowing when or where the divers would appear. Only a small part of the window yielded a clear view, it was very dark, and the divers crossed the frames at high speed. Patience and skill paid off when he took this picture of Finland's Satu Pirhonem.

'In the end, only one of the hundreds of frames I took, captured the moment I wanted and the feeling of being in a world of your own with just your thoughts for company.'

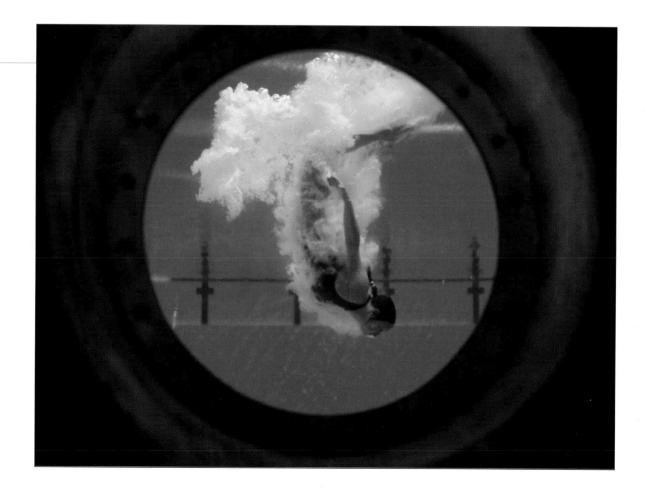

The header
10 June 2002

Desmond Boylan

Poland's Maciej Zurwaski goes up for a header against Portugal's Joao Pinto during a World Cup group fixture in Chonju, South Korea.

Portugal bounced back after their shock 3–2 loss to the US in the opening match to win 4–0 against Poland, thanks to a hat-trick from Pauletta and a late goal from Rui Costa.

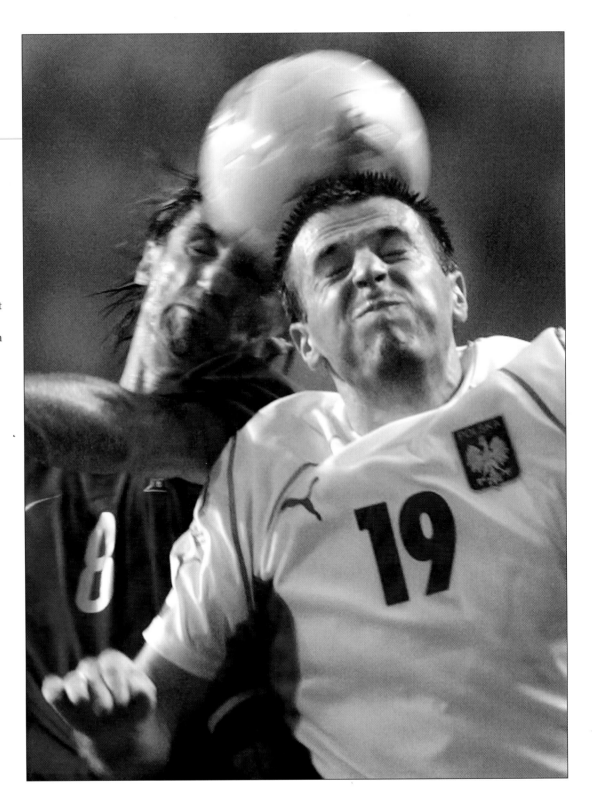

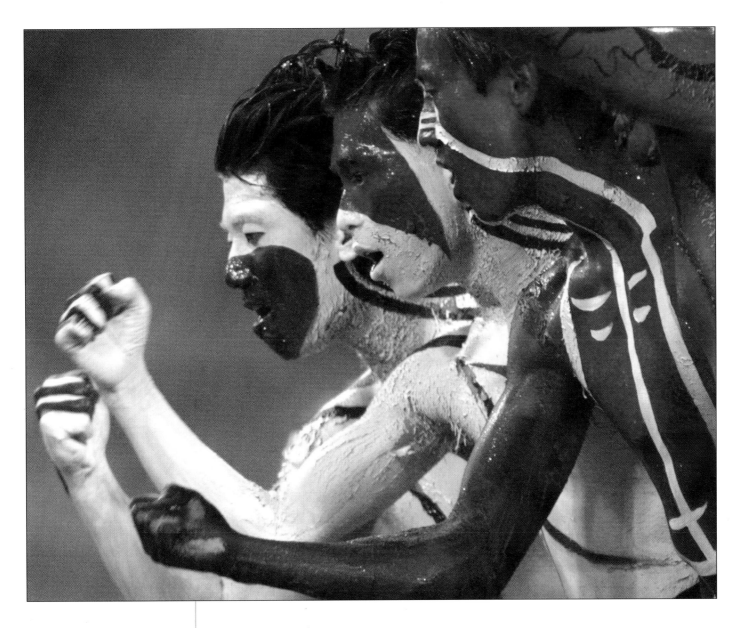

**Supporters urge on
South Korea**

18 June 2002

Paolo Cocco

South Korean supporters, painted in national colours, cheer on their team before the second-round match between South Korea and Italy in Taejon in one of the World Cup epics.

South Korean fans struck early in the pre-match propaganda war by placing placards on seats behind each goal spelling out 'Again – 1966', a reference to North Korea's shock win at the 1966 World Cup, where Italy were eliminated in the first round of the finals through a goal from Park Doo-Ik, who later went on to become a dentist.

The Italians were not amused when yet another disallowed Italy goal gave South Korea the chance to score a golden goal, winning the match 2–1 and putting Italy out of the competition.

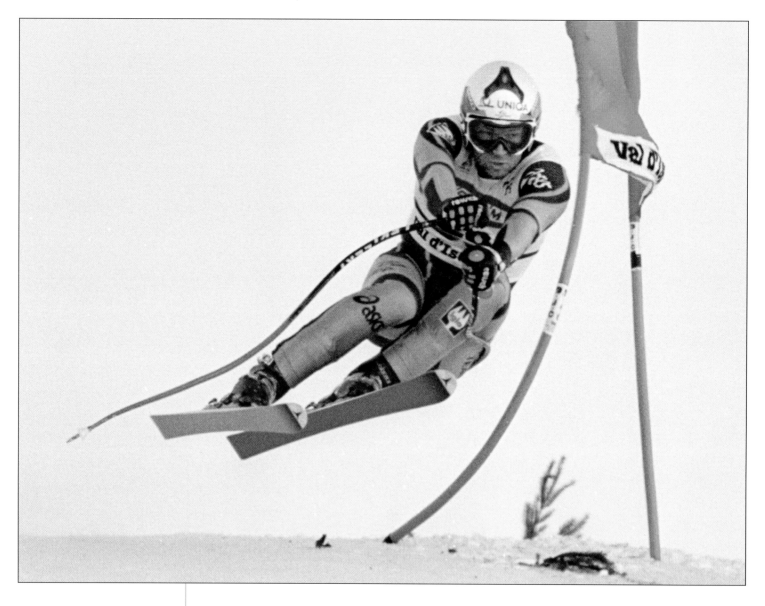

Eberharter wins at Val d'Isere

8 December 2001

Robert Pratta

Austrian Stephan Eberharter swept all before him in the run-up to the 2002 Salt Lake City Winter Olympics but then faced an agonizing battle to get to the top of the medals podium at the Games.

Eberharter started with a bronze in the downhill on the perilous Grizzly piste. He went one better with silver in the super-G, losing to the seasoned Norwegian Kjetil Andre Aamodt by a tenth of a second after claiming the Austrian team coaches failed to advise him adequately during the final stages of the race.

Finally, after leaving Snowbasin for Deer Valley, Eberharter won the cherished gold in the giant slalom. Here he is pictured winning the Val d'Isere World Cup downhill in December of the previous year.

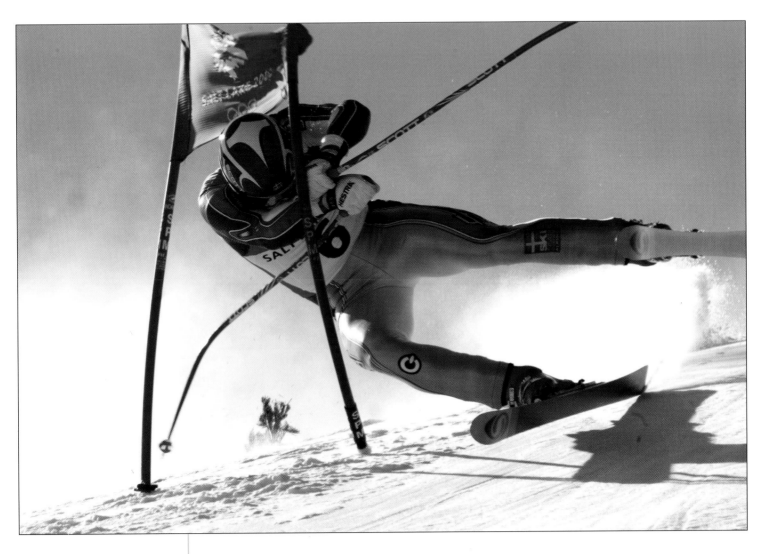

Nyberg crashes at the Salt Lake City Winter Olympics

16 February 2002

Stefano Rellandini

Olympic skiing is a high-risk sport, whatever the event. Television pictures can convey the emotions, but they flatten the perspective and show neither the sheer speed nor the steep inclines the skiers traverse.

Here Sweden's Fredrik Nyberg crashes into a gate during the men's Alpine super-G at the Salt Lake City Winter Olympics at Snowbasin on 16 February 2002. Unsurprisingly, Nyberg failed to finish the race.

'It was a strange place,' said Stefano. 'Usually the photographers have to be in position on the downhill course one hour before the start and you can't move from your place. I skied down the course to find a good spot but unfortunately, after three-quarters of the course, I still hadn't found what I wanted. I finally picked this position and was rewarded with this picture.'

Korean fans watch their team on a giant screen
14 June 2002

Kieran Doherty

From early dawn, fans dressed in the red of the national team gathered in cities throughout South Korea seeking a spot to watch the World Cup 2002 matches on specially erected giant television screens. The Kwanghwamoon intersection in Seoul was a favoured location, with fans singing and chanting and cars blowing their horns throughout the day.

Almost two million fans watched their heroes go out in the semi-final against Germany from the streets of Seoul. 'South Koreans ... have never been united before,' said a headline in the daily *Donga Ilbo*. 'We have experienced what it is to become one through the World Cup.'

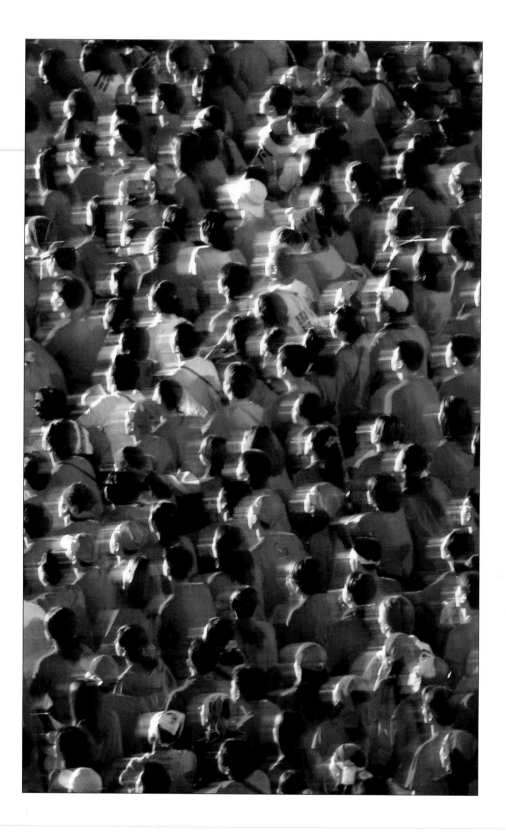

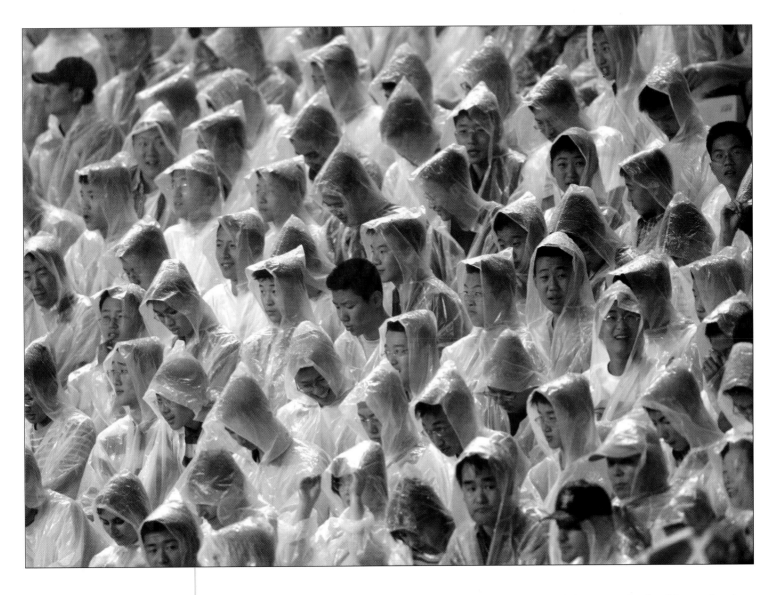

Waiting fans in the rain
10 June 2002

Desmond Boylan

Patient, poncho-wearing football fans sit in the rain before a group match between Poland and Portugal at the 2002 World Cup.

The first Asian World Cup, co-hosted by South Korea and Japan, was widely acclaimed as a success. One of the reasons was the extra dimension brought to the matches by the home fans.

Games featuring the co-hosts took place against the background of a deafening wall of sound. But whereas in Japan the fanatical local support was confined largely to the matches themselves, South Korea was gripped throughout by World Cup fever.

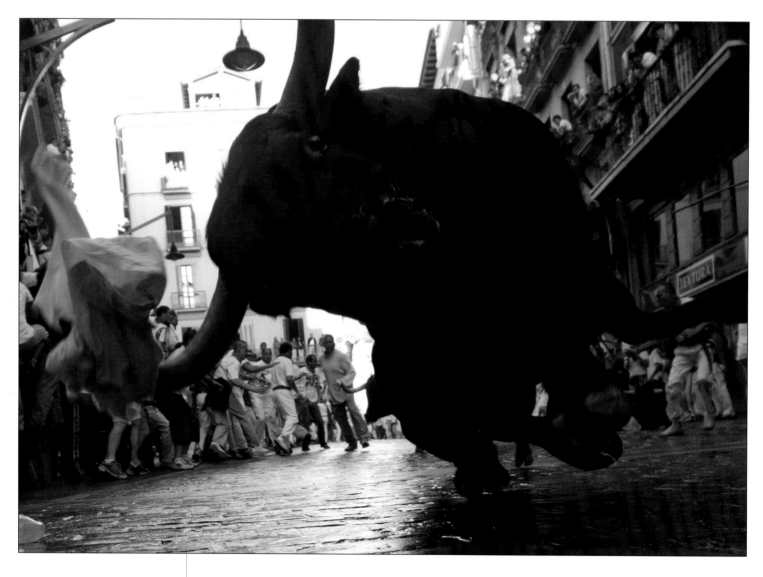

The running of the bulls
10 July 2002

Desmond Boylan

Desmond Boylan's close-up of an enraged bull, already bearing a T-shirt trophy on one of its horns, was carried around the world and prompted numerous inquiries about the fate of the photographer. One German paper ran the photo with a headline asking: 'How well is the photographer?'

But although thousands regularly join the beasts for the annual running of the bulls during the week long San Fermin Festival and each year several people are gored or trampled, Boylan remained safely behind the barriers set up along the route. Armed with a remote control, Boylan said he wrapped his camera in wads of bubble wrap leaving just the lens poking out and slid it out under the barrier on to the road.

'It was pandemonium. I saw the bulls coming – it was the biggest rush of adrenaline,' said Boylan, who snapped off two frames just as one beast came crashing towards the barrier.

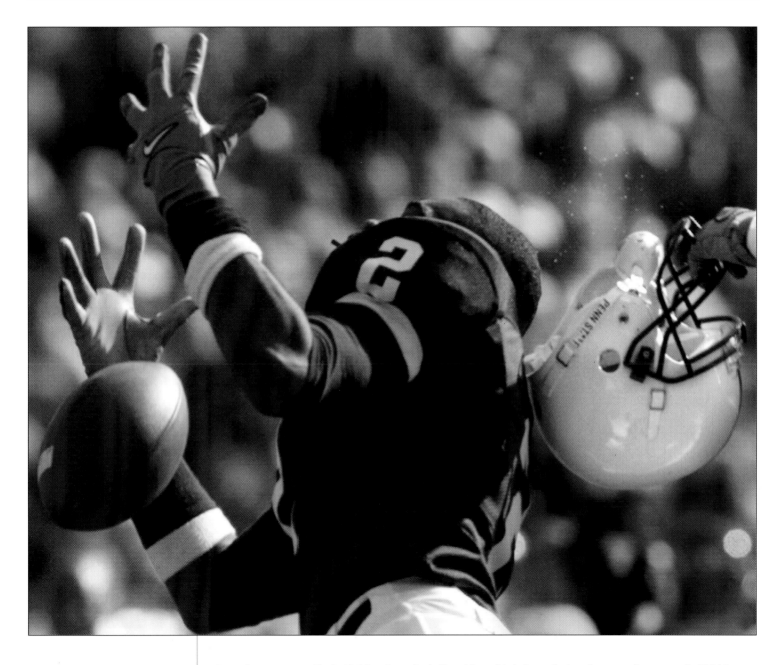

Player loses his helmet
6 November 1999

Jason Cohn

Penn State receiver Chafie Fields misses the ball and loses his helmet during the second quarter of a NCAA match against the University of Minnesota.

Cohn said: 'Anyone who has covered college football knows that it has the potential to be wilder and less predictable than NFL football. That makes it more fun, and sometimes more difficult to cover.'

'When Chafie Fields leapt into the air to catch a pass from his quarterback, I saw that coverage by Willie Middlebrooks was tight and there was potential for a nice picture. When I saw the image I was very pleased as it was emblematic of the Lions' luck that afternoon. There was no penalty called on the play when there clearly should have been. Had Fields caught the pass, the Lions might have been able to score again and would have won the game.'

A spectacular pile-up at Daytona 500
17 February 2002

Pierre DuCharme

A mess of metal around the car of Kenny Wallace (18) during the 44th annual Daytona 500 in 2002. To the right of Wallace is Kevin Harvick (29).

Pierre said that while drivers at the premier NASCAR event discuss strategy to avoid 'The Wreck' – a normal part of the race, photographers discuss the best place to shoot it.

'Placing photographers in the most likely spots becomes almost impossible without dozens of photographers,' he said. 'One strategy is to place a photographer as high above the track as possible, which at Daytona is the top of the main grandstand where race teams have their spotters.

'In the 2002 race, "The Wreck" involved 17 cars entering turn one and continued on the short chute into turn two. This picture was shot from the roof of the main grandstand.'

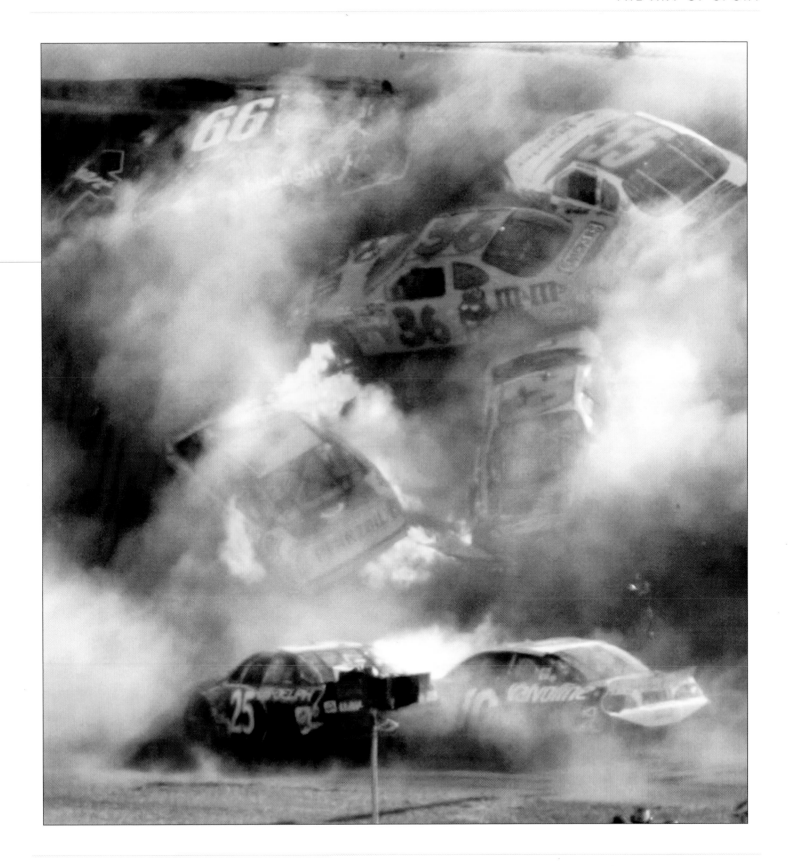

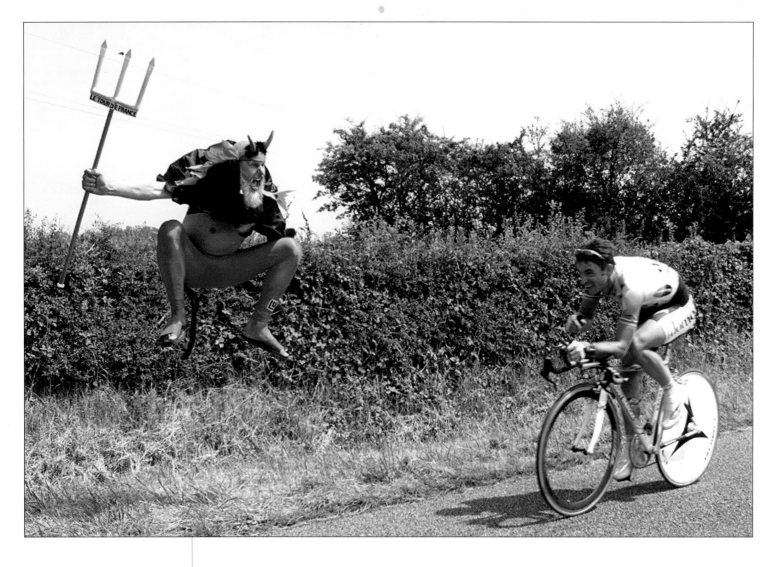

The devil at the Tour de France
27 July 2001

Jacky Naegelen

Support for the Tour de France, the world's greatest cycle race, comes in unusual forms. Here the devil in the shape of German Didi Semft jumps around in front of Dutchman Servais Knaven during the 61km individual time trial 18th stage of the 2001 event from Montlucon to Saint-Amand-Montrond. Knaven appears amused.

'The biggest challenge is to find different pictures every time,' said Jacky. 'The German cycling fan Didier Semft, known as the devil, used to be a fan of former Italian rider Claudio Chiappucci. He has been following each stage of the race for several years.'

Not so amusing was the tarnished image of the Tour in particular, and cycling in general, after the drugs busts of 1998, when the Festina team director confessed to providing banned substances to his riders. Six other teams withdrew, riders and managers were taken in for police questioning and hotel rooms were raided.

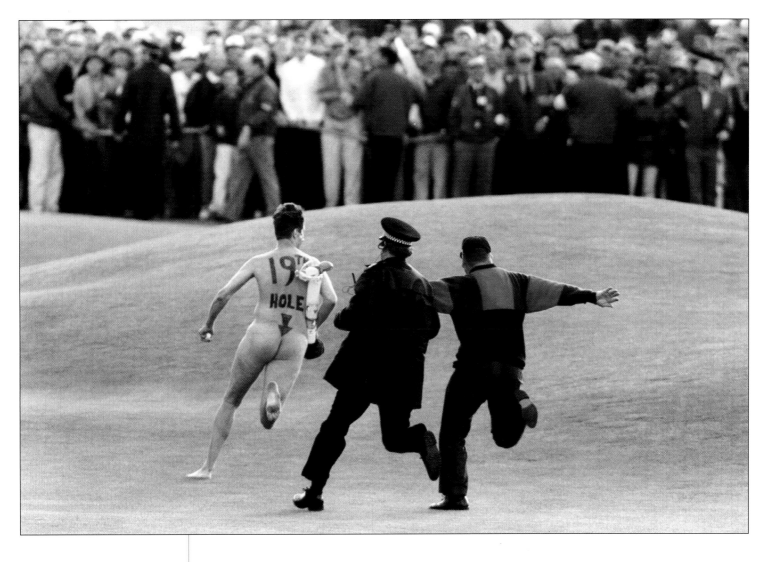

**A streaker interrupts
the British Open**
23 July 1995

Dylan Martinez

A streaker bearing an unambiguous message interrupted the play-off between John Daly and Constantino Rocca at the 1995 British Open. Security officials chase him off the 18th fairway without looking as if they want to get any closer.

The arc of the diver
31 July 1999

Fatih Saribas

Three judges watch as Frenchwoman Julie Danaux dives gracefully into the pool at the European swimming championships in Istanbul.

Diving was originally used competitively as a way to start a race, but during the 19th century, professional divers plunged from temporary towers up to 18 metres high into temporary pools. Diving as a competitive sport began in Britain in 1893 with a championship consisting of a standing head-first dive.

Today divers perform a set number of dives, which are marked by judges.

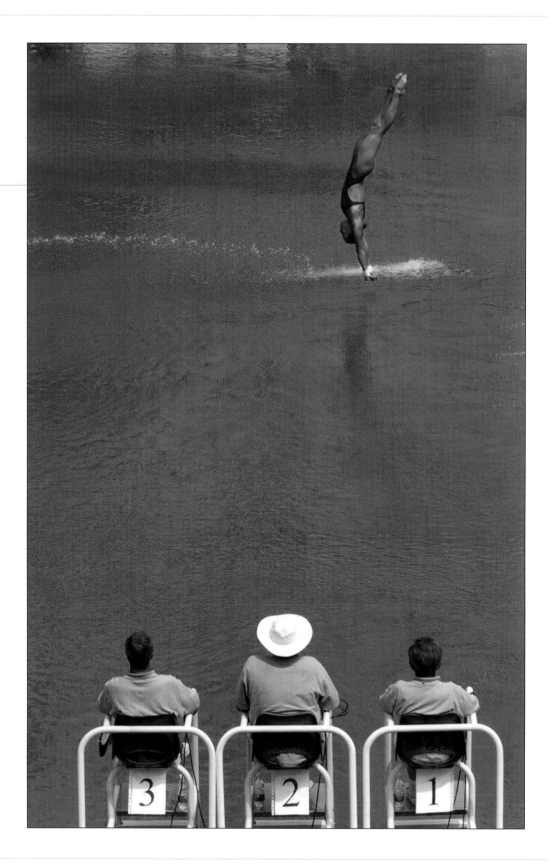

A competitor dives from a bridge
13 August 2000

Danilo Krstanovic

A competitor jumps from the platform of the Mostar Bridge which was destroyed in 1993 during the Bosnian war.

The bridge was built in 1566 during the Ottoman Empire by Mihar Hajrudin. Since World War Two foolhardy youths have regularly dived more than 100 metres into the Neretva river below.

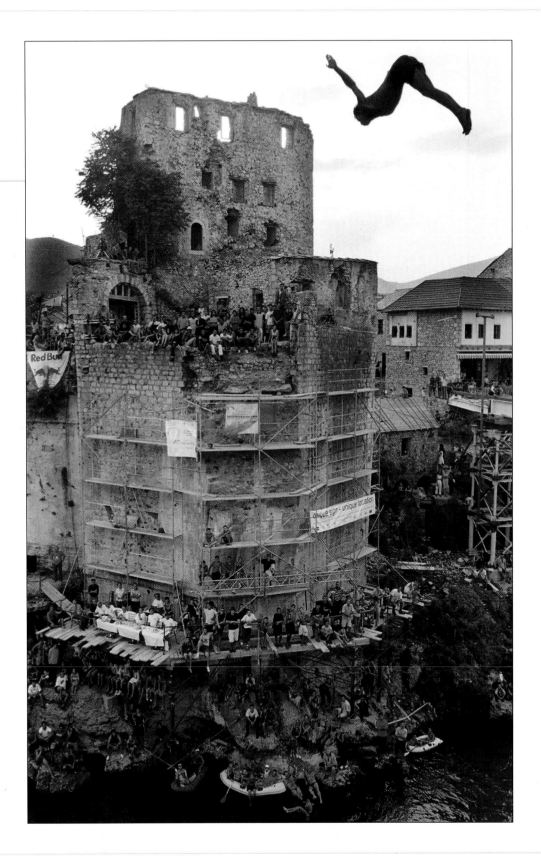

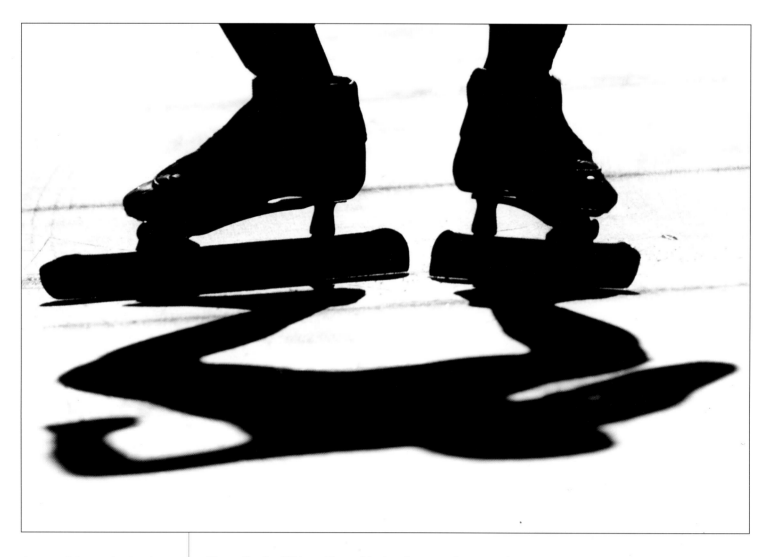

A speedskater's shadow
11 February 2001

Jerry Lampen

Unusually, the 2001 world speedskating championships in Budapest were staged on a 100-year-old outdoor rink. This led to problems when rising temperatures softened the ice and events had to be postponed until later in the day when the ice would be harder.

Jerry came up with this surreal image which was used widely by newspapers and magazines. 'I was trying to put scenery in the picture but didn't succeed,' he said. 'Some other photographers thought I was losing it because I was standing up and tossing and turning to find the right angle.'

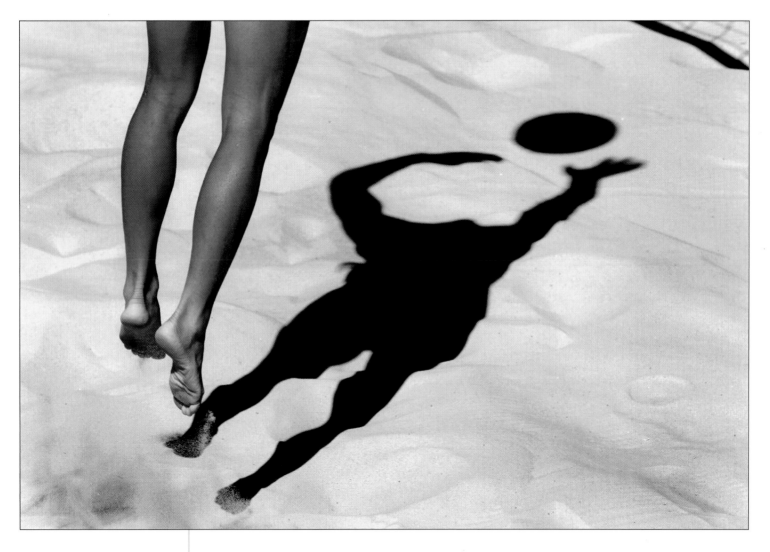

Beach volleyball at Bondi
13 September 2000

Kieran Doherty

Bondi Beach, the centre of Sydney's sea and surf culture, seemed the perfect spot to stage beach volleyball at the 2000 Olympics. Environmental protesters thought otherwise, but a compromise was reached and the event went ahead.

Kieran was sent along during the first practice session to search for an appropriate image. 'I was given access to any point of the stadium looking for a feature picture,' he said. 'I had a rough idea of the sort of picture I wanted and it took me about three hours to get a single, clean shadow. The net in the corner was pure luck.'

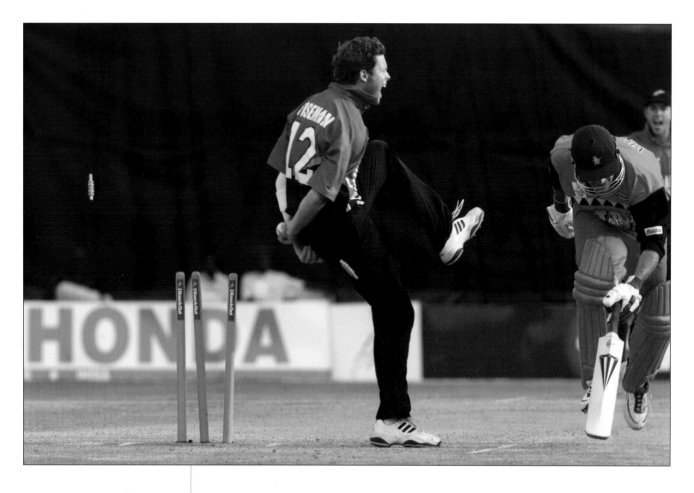

New Zealand bowler celebrates
9 October 2000

Mike Hutchings

New Zealand off-spin bowler Paul Wiseman celebrates after running out Zimbabwe's Dick Viljoen during their International Cricket Council knockout tournament in Nairobi on October 9 2000.

'I have always found one-day international cricket more interesting to shoot than the five-day game and less predictable in terms of the final outcome,' said Mike. 'With the pressure to score, and score quickly, there is always drama. Viljoen's dismissal for nine runs effectively put an end to Zimbabwe's batting challenge.'

Each of the major cricketing nations took part in a tournament ranked second only in importance to the World Cup. For the first time, New Zealand, anchored by a majestic 102 not out from Chris Cairns who was suffering from one of his many knee injuries, won a one-day tournament with a four-wicket victory over India in the final.

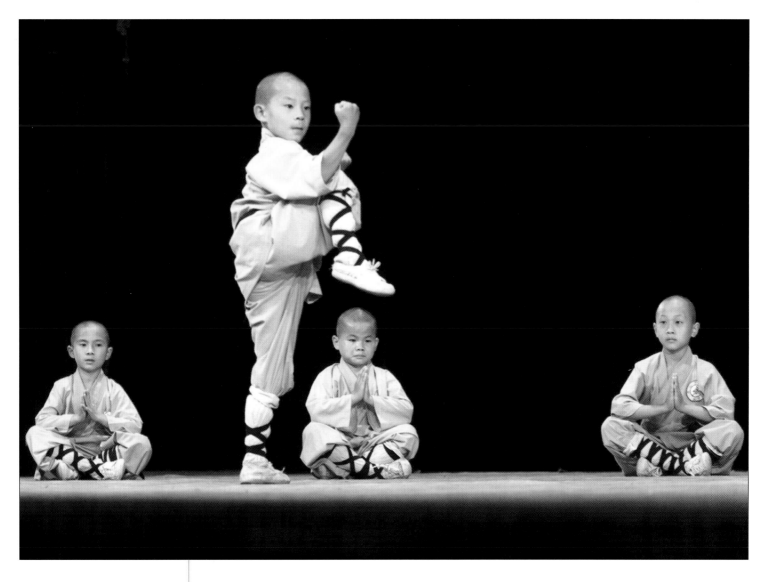

Young monks rehearse Shaolin Kung Fu

20 July 2001

Kin Cheung

Young monks from the Shaolin Martial Monks Troupe of Songshan perform Shaolin Kung Fu during a rehearsal of their performance of *Shaolin Heroes* in Hong Kong. The monks are all about eight years old.

'The performance depicts a beautiful drama of life in a Shaolin temple of four seasons, featuring the glory of Shaolin martial skills in their authentic form in four scenes, culminating in a finale that displays the essence of Chinese martial arts,' said Kin.

'The drama has been touring all over the world, taking upon itself the mission of spreading the spirit and culture of Shaolin.'

Tibetan herders play outdoor billiards
7 August 1999

Natalie Behring

Billiards, usually associated with the hushed confines of an English gentlemen's sanctuary in London's clubland, has won a mention in Shakespeare. In *Antony and Cleopatra*, the Egyptian queen calls to her attendant to join in. 'Let us to billiards: come,' she urges.

Natalie Behring has captured an even more unlikely setting. A group of Tibetan herders play billiards as a flock of goats and horses graze on the pasture above them near Xiangpi province in China's western Qinghai province.

'I took this photo while on a trip sponsored by the World Bank,' said Natalie. 'About 20 journalists were invited to see a site where China plans to relocate ethnic Tibetans and Muslims in a Han (Chinese) area.

'While we were driving through the countryside, I saw several situations similar to the one shown in this picture but since we were in a caravan of trucks, the driver refused to stop and let me take pictures. Luckily, on the way back to the provincial capital, I saw the billiard table from the car and the driver agreed to take a quick break. I just ran out of the car and snapped a few pictures.'

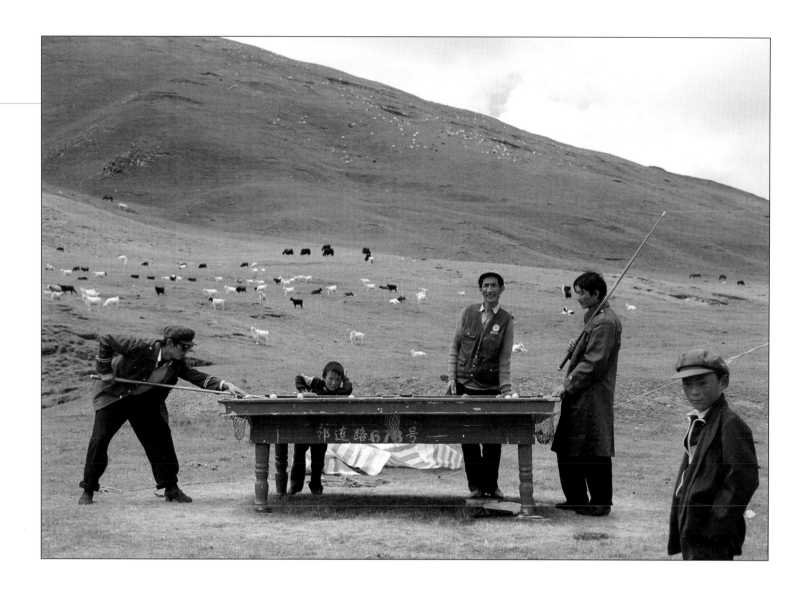

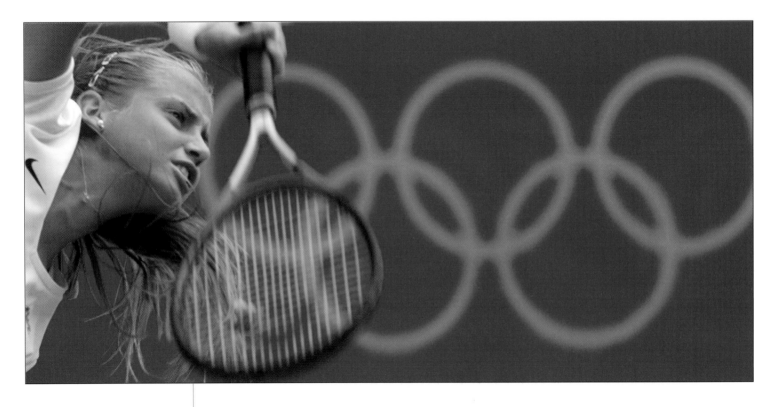

Dokic serves past the Olympic rings
23 September 2000

Kevin Lamarque

Dokic represented Australia in the 2000 Sydney Olympics and the Fed Cup before announcing on the eve of the 2001 Australian Open that she would revert to her original Yugoslav nationality and emigrate to Florida.

'I was pushed out of Australia by the media and Tennis Australia,' Dokic said. 'I felt they really wanted me out. It got to the point where it was unbearable.'

Dokic's father Damir, a former boxer and truck driver, had several run-ins with tennis authorities and was suspended from the women's tour in August, 2000, after being forcibly removed from the US Open for verbally abusing staff in the players' lounge. In the previous year, he was ejected from the pre-Wimbledon Birmingham tournament after accusing officials of being Nazis who supported the bombing of Yugoslavia.

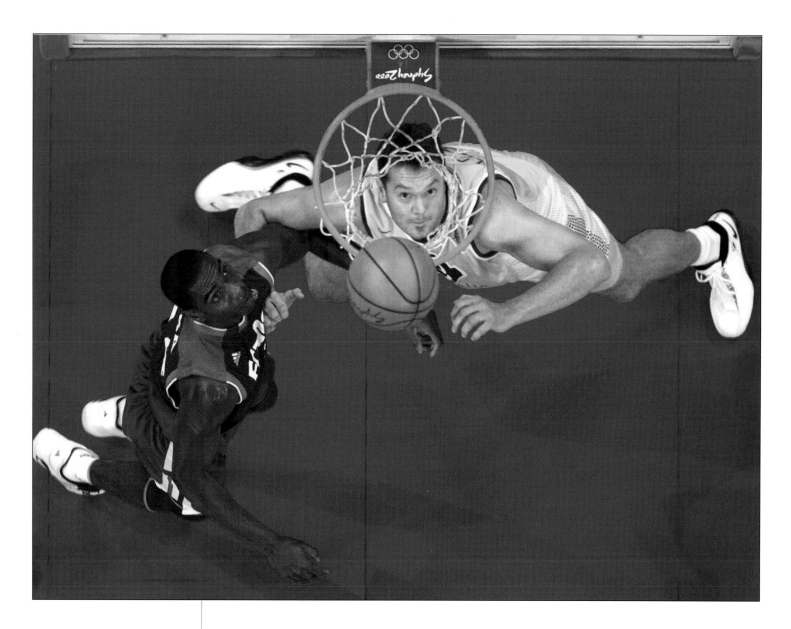

**Basketballer framed
by the hoop**
29 September 2000

Paul Hanna

To capture this unusual shot of Australian Olympic basketball captain Luc Longley framed by the hoop and the net at the 2000 Sydney Games, Paul Hanna went to unusual lengths.

Assigned an overhead spot for the semi-final against France, Paul was escorted on to the catwalk on the top floor of the dome to a small centre platform set above a giant screen, which hung from the ceiling in the middle of the court. From either end of the platform, suspended about 100 metres above the court, he was able to shoot straight down into either basket.

To gain perspective, Paul had to lean out over the waist-high railing with a camera and long lens strapped around his neck to prevent it falling if he were to lose his grip. Paul captured this striking image while hanging over the railing of the platform, waiting for the players to come into view.

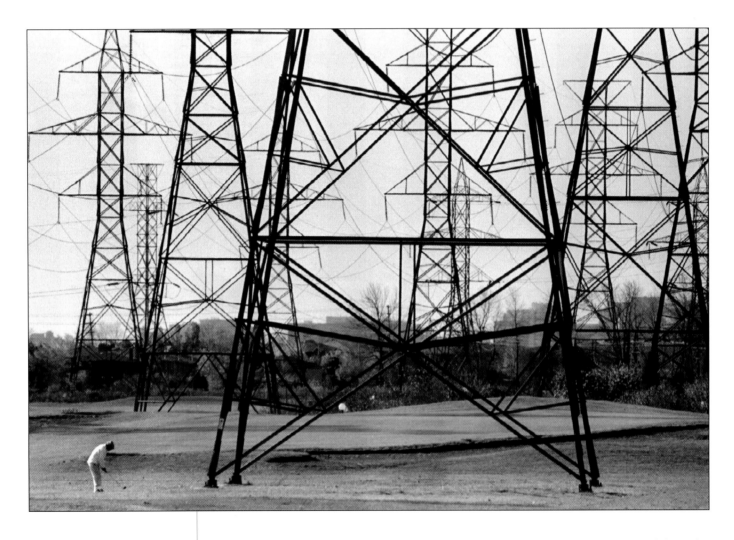

**Unnatural hazards
face golfer**
27 October 1994

Andy Clark

This is one of the more unusual challenges facing a golfer in a game with more than enough hazards for the ordinary club hacker. The lone figure is preparing to chip on to a green surrounded by dozens of electricity towers on a course in Centennial Park near Toronto airport. The course winds in and around the pylons.

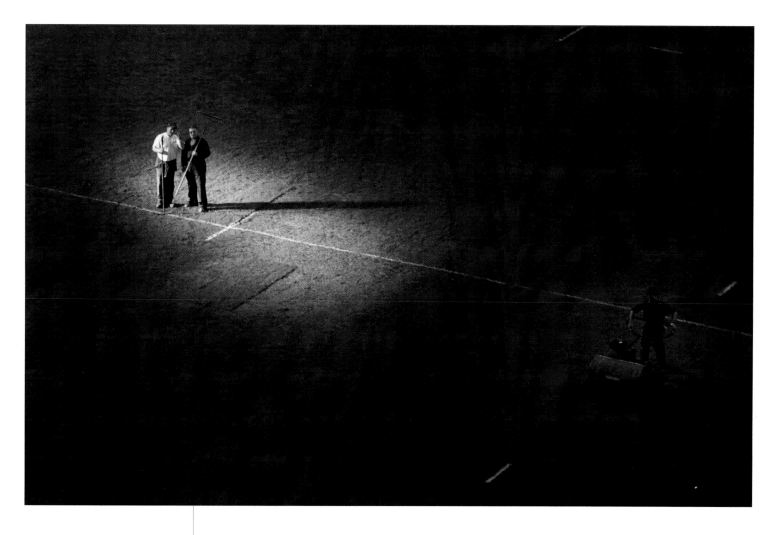

**Groundsmen examine
the turf**
5 November 1999

Ian Waldie

Groundsmen examine the patchy turf at the Millennium Stadium in Cardiff before the 1999 rugby union World Cup final between Australia and France. The stadium, constructed for the 21st century, has a retractable roof that can be closed in case of bad weather, sharply dividing opinion in the rugby world.

Traditionalists argue that the elements are an essential part of rugby, with rain, wind and biting cold adding to rather than detracting from the sport. One of rugby's attractions has been the contrast between the frost-bitten and rain-drenched grounds of the British Isles and New Zealand, which swing the emphasis to the forwards, and the hard pitches of South Africa and Australia, where the backs come into their own.

One of the more memorable games ever played, the 1961 test at Wellington's Athletic Park between New Zealand and France, was played in a gale so fierce that the team playing into the wind were forced to abandon kicking because the ball shot straight behind their heads. While playing into the wind, New Zealand played a flanker as an extra fullback, and the All Blacks narrowly won the extraordinary match.

The World Air Games
29 June 2001

Marcelo Del Pozo

Hot air balloons fly over the Spanish landmark 'Osborne's Bull' during the second World Air Games in Seville. 'When I heard about the games I wasn't expecting such a colourful and explosive visual display,' said Marcelo.

'For days I waited until the hot air balloons were positioned behind a recognizable Spanish landmark "Osborne's Bull" to compose an image in which the bull appears to be watching the race like a spectator.'

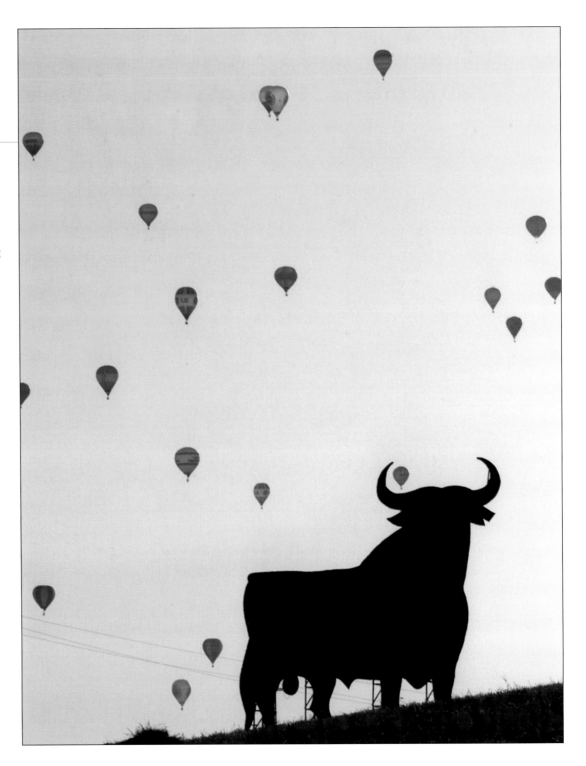

The loneliness of the losing goalie
10 March 2002

Larry Downing

The loneliest man in the arena. Edmonton Oilers' goalie Tommy Salo stands in ignominious isolation amid hats thrown into the rink after conceding a hat-trick to the Washington Capitals' Peter Bondra during an NHL match in Washington in 2002. Unusually, Larry took this picture after attending a match as a fan carrying his camera 'just in case'.

'I played organized hockey as a teenager in Massachusetts and then again at college in California and the sight of hats raining down on to the ice translates into one of the loneliest moments in sport. Hat-trick goals are very rare in hockey. I thought the photograph of the dejected goalie provided more impact than a picture of the jubiliation of the goal scorer.'

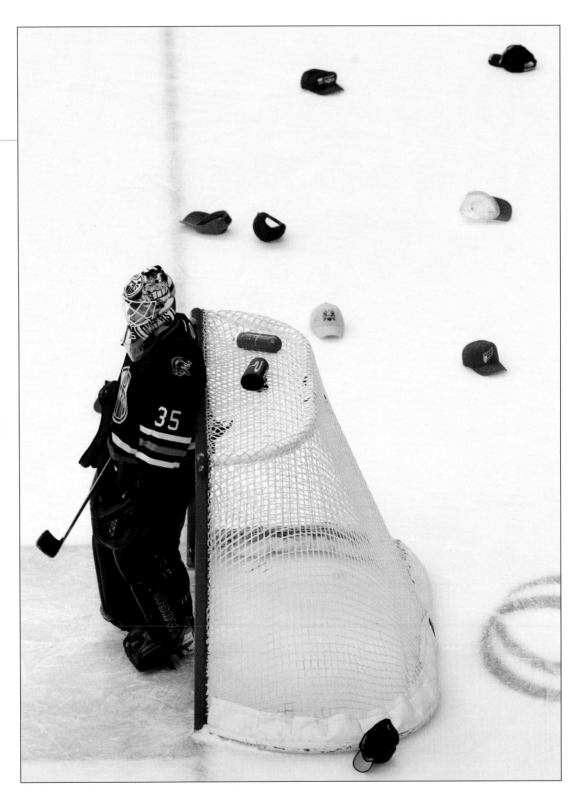

Fan Man drops in on a world title fight
6 November 1993

Gary Hershorn

This is one of the more bizarre incidents in a sport where Las Vegas seems an increasingly appropriate place to stage major fights. Evander Holyfield and Riddick Bowe stand transfixed as a man in a parachute with a fan on his back crashes on to the ropes early in their 1993 world heavyweight bout. The referee is also clearly at a loss.

The intrusion by the night invader, instantly nicknamed the Fan Man, was made possible because the fight was staged in a temporary outdoor stadium in the parking lot of Caesars Palace Hotel. Through the good fortune often necessary to seize great images, Gary's shooting position was on a side of the ring allowing him to see Fan Man flying through the sky.

'That allowed me to be prepared for the moment of impact when he got his legs tangled in the top rope and the parachute stuck in the lights about the ring.'

Several of the overhead lights were turned off as a precaution while the parachute was cut down and the fight was stopped for at least 20 minutes. A spokesman for the promoters said the parasailor had landed in the ring as a protest but added he did not know what the protest had been about.

Holyfield outpointed Bowe to regain his World Boxing Association and International Boxing Federation titles. He was only the third heavyweight champion after Floyd Patterson and Muhammad Ali to regain a world title.

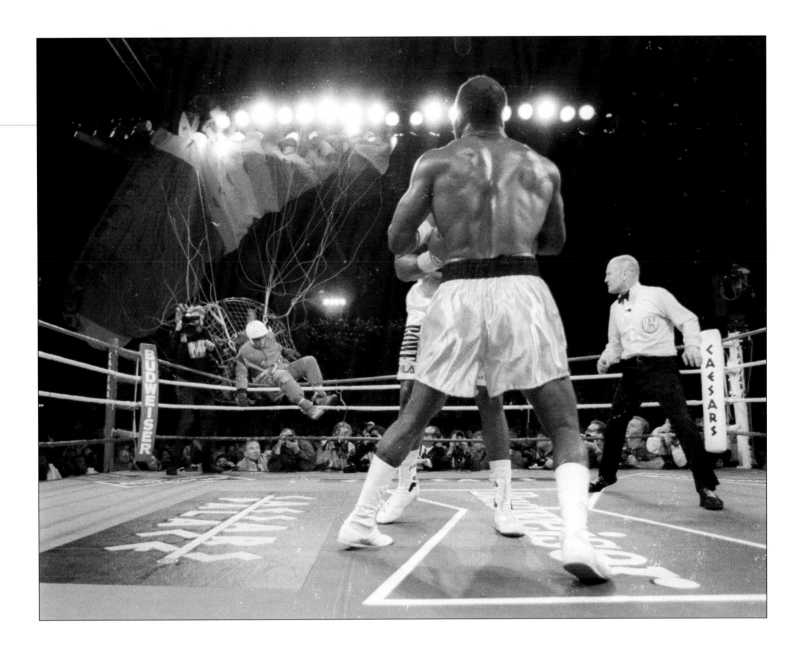

A young England fan
21 June 2002

Kimimasa Mayama

England qualified for the World Cup 2002 quarter-finals after a tough victory over Argentina and an emphatic second-round win over Denmark. Thousands of fans gathered from midnight to watch the quarter-final match against Brazil on television in London's Trafalgar Square and the national mood was euphoric. On the morning of the match, the cover of the *Daily Mirror* newspaper showed only the flag of St George and the caption: 'This page is cancelled. Nothing else matters.'

Sadly for all England fans, the apprehension on the face of this young Japanese England supporter proved to be fully justified and Brazil's performance made their win seem as if it had always been inevitable.

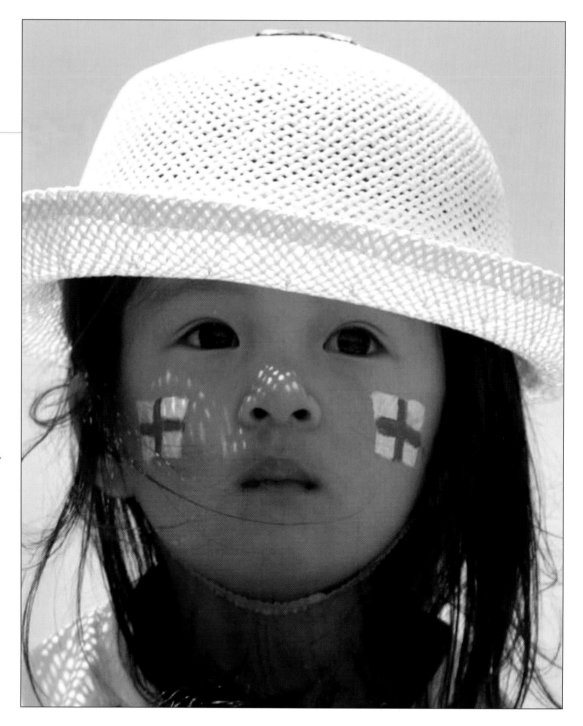

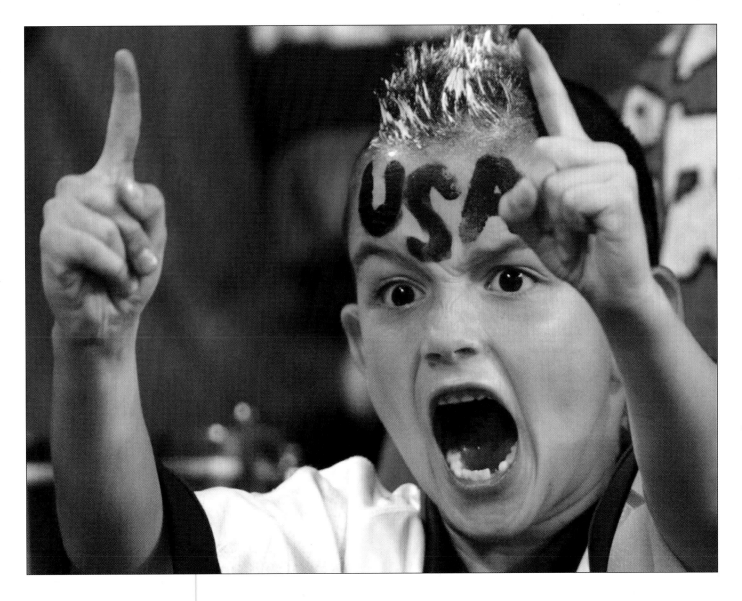

A US fan gets stuck into soccer
21 June 2002

Petar Kujundzic

Germany finally brought the US's spirited World Cup run to an end in the quarter-finals with a typically clinical 1–0 win.

The Germans won each of their knockout games 1–0 but needed another virtuoso display from captain and goalkeeper Oliver Khan to stay in this match, with the US pushing them all the way.

'We showed the world we can play,' said US coach Bruce Arena. 'We haven't arrived but there's a bright future for the game in the United States.'

Els peers over a bunker
6 March 1999

Colin Braley

A perennial challenge for the sports photographer is finding a different shot of, or approach to, essentially repetitive pursuits. Colin Braley succeeds admirably with his shot of South African golfer Ernie Els peeking over the edge of a bunker as he watches his ball head for the hole on the ninth green.

'Tee shots, bunker shots and an occasional emotional outburst are the typical images you get,' said Colin. 'Those can make nice, solid pictures but most photographers who cover golf on a regular basis strive to look for that different image. Utilising the terrain and anticipating the angles of how the ball is played is just one way of making a typical golf picture different.'

Eyes on the ball
23 June 1999

Dylan Martinez

Australian Andrew Illie gazes intently at his target as he lines up a return during a Wimbledon second round match against Sjeng Shalken of the Netherlands.

Australians have played a distinguished part at Wimbledon both before and after the first open professional tournament in 1968. The greatest of them all was the red-haired Queenslander Rod Laver, who won the title four times, twice as an amateur and twice as a professional, part of an enduring affinity between the world's top players and the All England club.

They may grumble about the weather, moan at the eccentricities of a surface which disproportionately rewards the serve-and-volley exponents and complain about linecalls. But the world's best know they need to win Wimbledon to be ranked among the truly great.

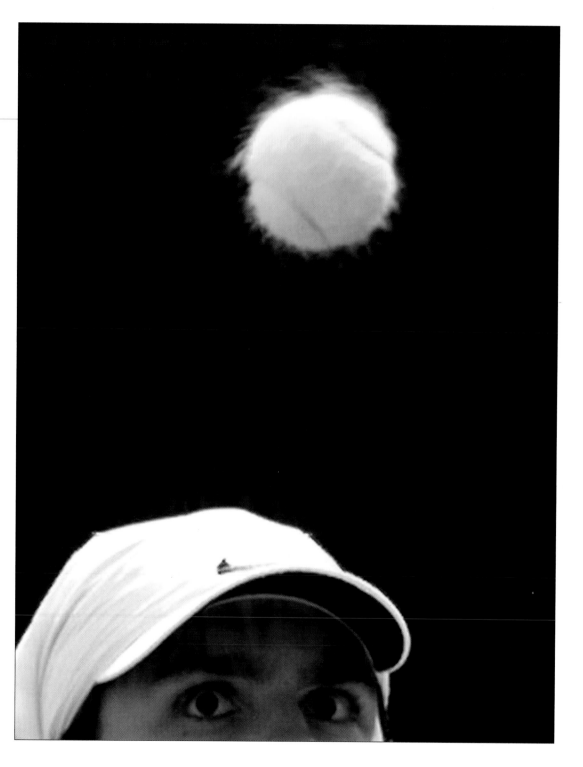

A lone athlete in training
8 March 2001

Jose Manuel Ribeiro

A lone runner trains on the eve of the 2001 Lisbon world indoor championships. Indoor athletics is confined essentially to northern Europe, the US and Canada when the winter forces track and field athletes inside.

The World Indoor Championships are staged every four years, approximately six months before the outdoor version, which attracts far more people and publicity. Indoor athletics has its own rules and restrictions. Because the stadiums are smaller, the short sprint events are 60 instead of 100 metres. The track is 200 instead of 400 metres, bringing its own problems with the tighter bends. Because of the danger to spectators, there are no javelin, discus or hammer contests.

Some world-class athletes on the track have flourished on the indoor boards, but others ignore it completely. Although New York's Millrose Games and the world championships are an important part of the calendar, the heyday of indoor competition was in the late 1970s and 1980s, when the old Soviet Union and East Germany sent their top competitors to the European indoor championships as part of the unrelenting political, ideological and sporting war with the West.

Jose's photograph was used on the front page of the Portuguese newspaper *Publico* on the start of the three-day championships.

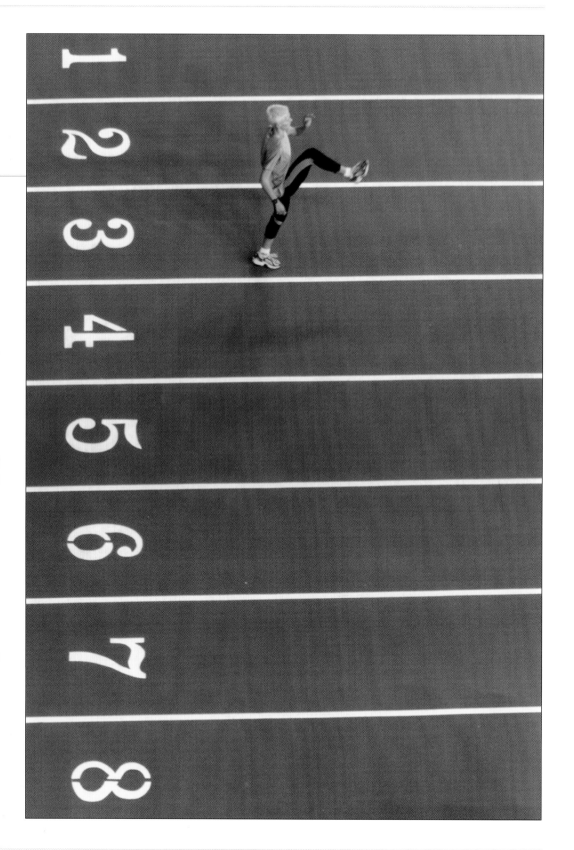

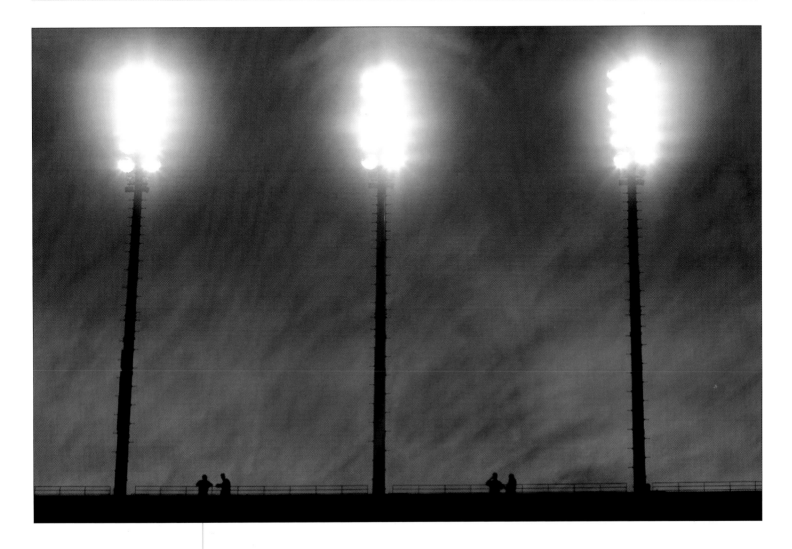

Tennis fans watch the night sky
30 August 1999

Kevin Lamarque

Fans climb to the top of the Arthur Ashe Stadium to view the setting sun before the start of play at the night session of the US Open.

The lurid and dramatic New York sunsets are one of the city's glories. Flushing Meadows, venue for the last of the year's four grand slam tennis events, is as quintessentially New York as is this night sky. Jets fly unceasingly overhead, the peanut vendors ply their raucous trade and the crowds make their feelings known in an uncompromising fashion, disconcerting to players unaccustomed to the direct relationship between American spectators and players.

Arthur Ashe Stadium honours one of those rare sports people whose significance transcends their sport. Ashe, who died tragically of complications due to AIDS after receiving a polluted blood transfusion, was a black American who rose above ingrained racial prejudice to make his way in a sport largely restricted to the white middle classes.

In purely sporting terms, Ashe's 1975 Wimbledon final win over Jimmy Connors was similar to Muhammad Ali's upset of George Foreman in the previous year for the world heavyweight boxing title. Ashe, outwardly as calm as a Zen Buddhist, sowed identical seeds of doubt in the mind of the seemingly unconquerable Connors, taking the speed off the ball and forcing the brash left-hander into a series of errors.

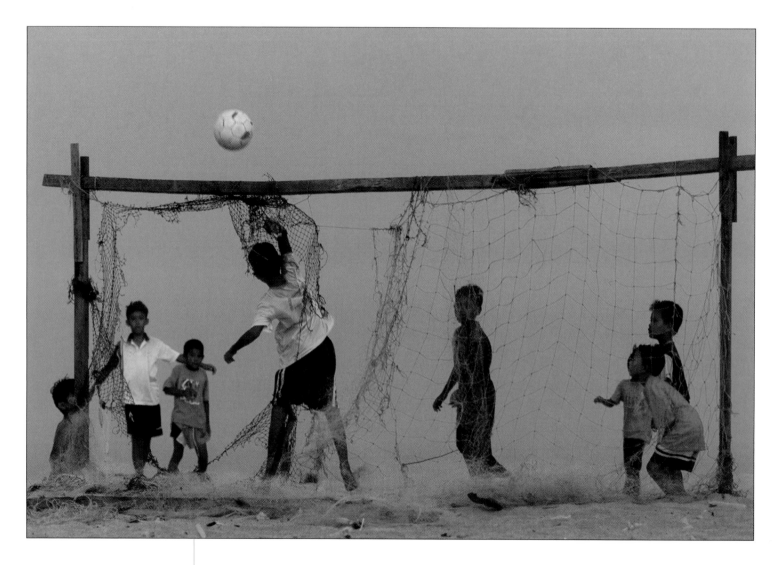

Beach soccer in Malaysia
17 August 2001

Bazuki Muhammad

Using a tattered fishing net as part of their goal, youngsters of the Batu Burok fishing village play beach soccer at sunset in Kuala Terengganu, about 500 km north-east of Kuala Lumpur. Batu Burok is a small village facing the South China Sea, comprising about 500 families whose main source of income is fishing.

'I was in between assignments in the north-eastern part of peninsular Malaysia when I noticed a group of youngsters from a fishing village playing soccer,' said Bazuki. 'The goal net, the remains of an old fishing net, had created a special charm. I decided to wait until the right moment at sunset, waiting with my long lens then, click. I knew I had the picture.'

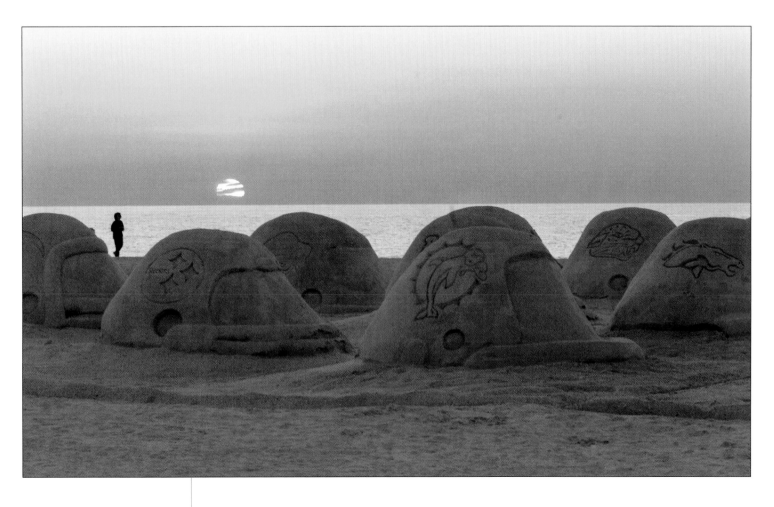

Superbowl in the sand
24 January 2001

Joe Traver

A pedestrian walks past sand sculptures shaped like football helmets on a beach before the 2001 Super Bowl. The sculptures were created as part of Super Bowl festivities in the area.

Inspired by linebacker Ray Lewis, a year after he had been arrested in connection with a double murder of which he was later cleared, the Baltimore Ravens defeated the New York Giants 34–7 in Super Bowl XXXV.

Pursuit cycling
26 October 2000

Dan Chung

The military precision of pursuit cycling is frozen by Dan Chung in a picture so perfect in its detail and perspective that it could have been posed. The blurred background is the give-away, illustrating the speed the riders attain.

'There is no room for error, the slightest deviation can cause not only individual disaster but team disaster as well,' noted Dan.

The picture depicts the British team tracking their French rivals at the 2000 world track cycling championships in Manchester, England.

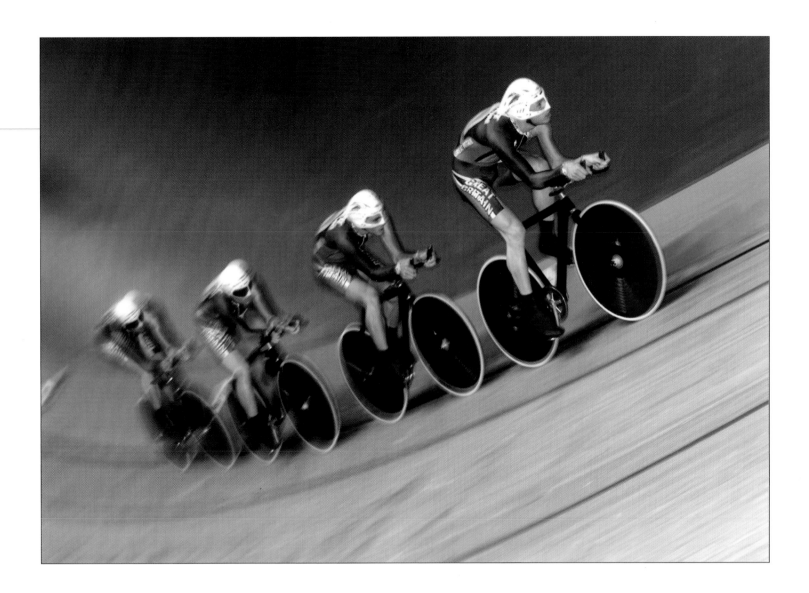

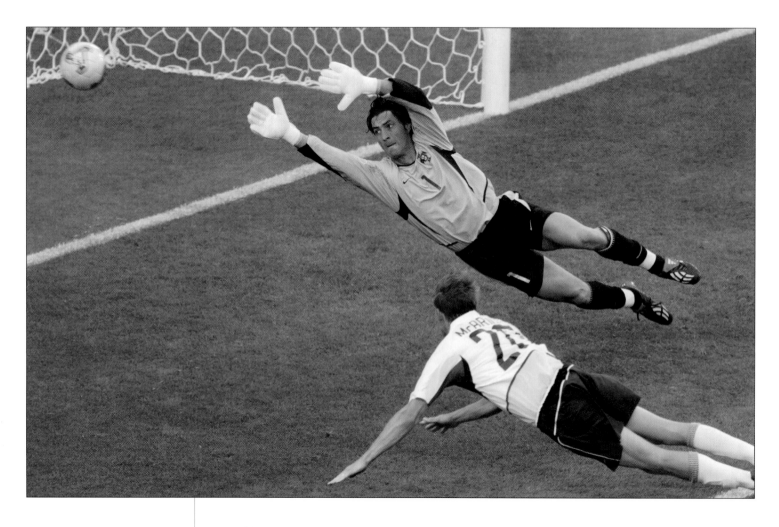

Practise makes perfect
5 June 2002

Jason Reed

Upset followed upset at the 2002 World Cup in a tournament that brought a new surprise every day. While Senegal's 1–0 victory over defending champions France remained the biggest upset, it was followed closely by the US's 3–2 win over European aristocrats Portugal.

The pick of the goals was a header from Brian McBride nine minutes from halftime after a cross from Tony Sanneh. McBride later revealed the pair had pulled the same trick time and again for the Milwaukee Rampage team when both were fresh out of college in 1994. 'I can't remember how many goals on assist we each had,' he said. 'We were both joking about it at halftime that it was very similar to some of the goals we scored back in Milwaukee. All I had to do was nod it in. It was just an incredible goal.'

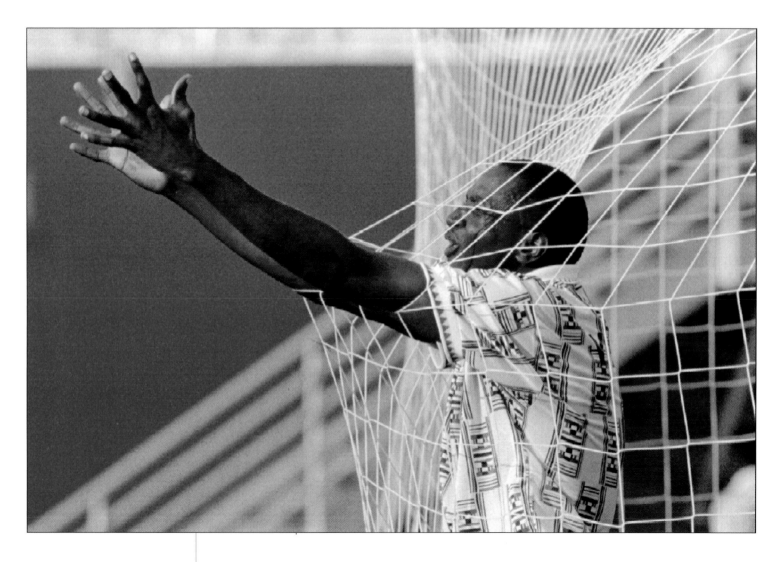

A Nigerian celebration
21 June 1994

Oleg Popov

Bulgaria had the dubious honour of losing their first and last games of the 1994 World Cup in the US. The first was a 2–0 defeat by Nigeria, during which this photo of Nigeria's Yekini – celebrating his first goal in the net of the Bulgarian team – was taken. The last was a 4–0 defeat by Sweden in the third-place play-off.

However, the Bulgarians enjoyed their most successful World Cup ever: before 1994 the Bulgarian team had never won a match in the competition; in 1994 they came fourth, beating Argentina and Germany along the way, before being knocked out in the semi-finals by Italy.

Brazil won the World Cup, beating Italy in the final, in the first tournament ever to be won on penalties.

Unrestrained Jamaican celebrations
21 June 1998

Jean-Christophe Kahn

Soccer's claim to be the world's only truly global team sport was enhanced notably in the 2002 World Cup but also in 1998 when Japan and Croatia appeared for the first time and Jamaica brought Caribbean rhythm to France.

The Reggae Boyz, supported here by a trio of exuberant fans before a group match against Argentina, were bolstered by a core of Anglo-Jamaicans and astutely guided by Brazilian Rene Simoes. After losing to Croatia and being outclassed by Argentina they took on their fellow debutants Japan in pelting rain in Lyon. Midfielder Theodore Whitmore, scored twice for Jamaica while Japan could get only one in reply.

Jamaica remain the only West Indies island to take part in the soccer World Cup, although one West Indian has made a singular contribution to World Cup history: Viv Richards, one of their most destructive batsmen on the cricket pitch, played in four cricket World Cups and also took part in a soccer World Cup qualifier for his native Antigua.

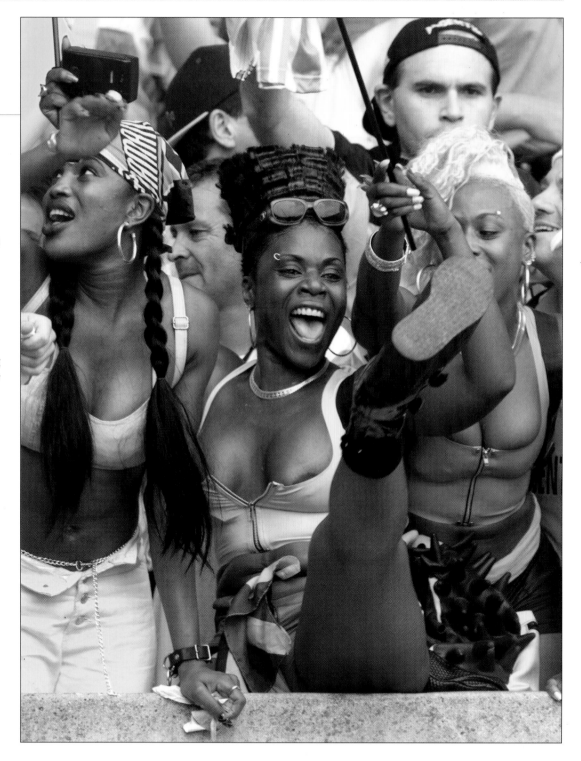

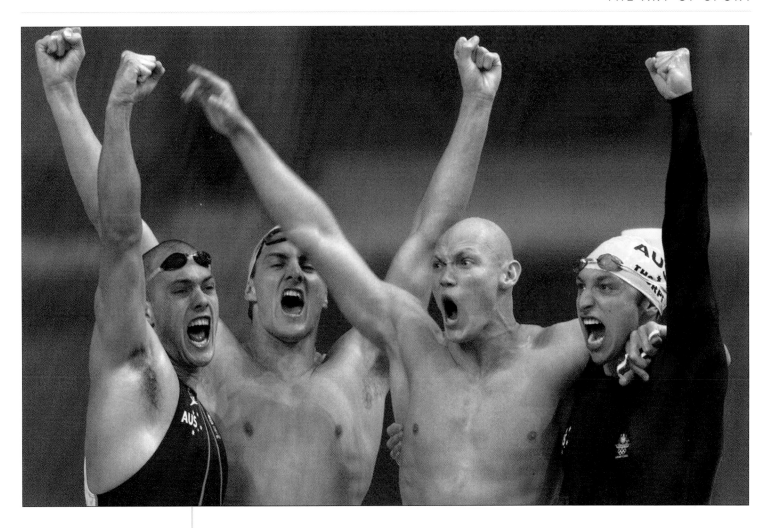

Thorpe wins again
16 September 2000

Michael Leckel

An Australian swimming coach once remarked: 'If you are going to do a Frankenstein and put a swimmer together from scratch, you would build Ian Thorpe.' Hardly a flattering image but one that aptly describes a man born to swim.

Despite an initial adverse reaction to chlorine, which would have halted most swimmers' careers before they had properly started, Thorpe (far right) was exceptional from an early age. In 1997, at the age of 14, he won 10 gold medals at the New South Wales short-course championships. A year later he became the youngest male world champion and won four gold medals at the Commonwealth Games in Kuala Lumpur.

At the 2000 Sydney Olympics, Thorpe delighted his sports-mad nation with three gold medals and two silvers, including the 400-metres freestyle individual title. In 2001 he became the first person to win six gold medals at a world championships. Later that year, Thorpe was again in the headlines, but this time as a witness to, not a creator of, history.

Thorpe was on his way to the World Trade Center on the morning of September 11. He then asked his taxi driver to turn back because one of his friends had left a camera in the hotel. In the time he was delayed the first hijacked plane crashed into the Twin Towers. 'I was so fortunate and lucky not to be involved,' said Thorpe. 'It certainly made me stop a little and think and reassess my life.'

Here Michael has caught Thorpe celebrating with (left to right) Ashley Callus, Chris Fydle and Michael Klim after the quartet had broken the 4×100 metres freestyle world record in Sydney. 'I cut off their hands on the first frame but the second fitted perfectly,' Michael said. 'The picture fronted several newspapers.'

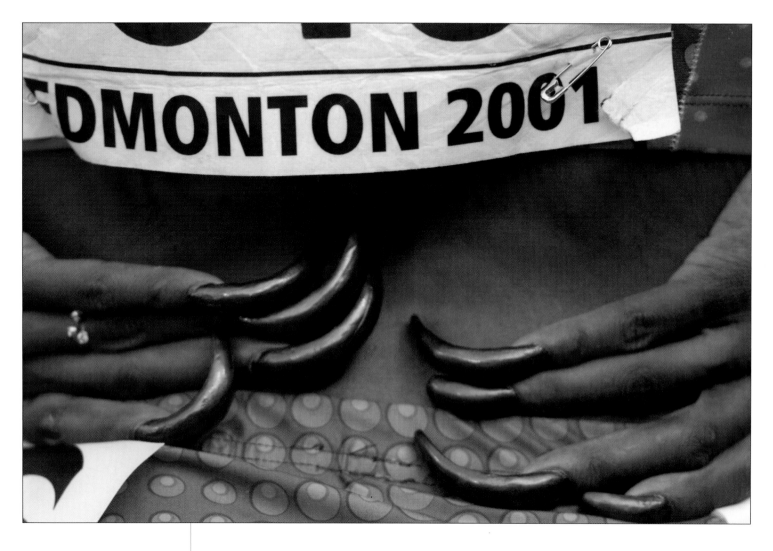

**Devers exhibits her
painted fingernails**
10 August 2001

Gary Hershorn

For years Gary has been trying to capture the perfect picture of US sprint hurdler Gail Devers' elongated painted fingernails. He finally succeeded at the 2001 world athletics championships in Edmonton.

'After finishing one of her heats, Devers turned around and looked at the television screen at the other end of the stadium while resting her hands on her waist, allowing me to shoot this picture. It was just what I had wanted to photograph for years,' said Gary. The fingernails have become a Devers trademark a decade after the late Florence Griffiths Joyner drew attention to herself in a similar style. Like the late Flo-Jo, Devers has no need of gimmicks. She is the finest sprinter-cum-hurdler in athletics history with consecutive Olympic 100 metres titles and four successive world 100 metres hurdles titles.

Perrotta signals to her partner
18 September 2000

Kevin Lamarque

Italian Lucilla Perrotta signals to partner Daniela Gattelli during a beach volleyball match against a Japanese duo on Bondi Beach at the 2000 Sydney Olympics, a gesture of tactical acumen which may or may not have been appreciated in purely sporting terms by the red-blooded Australian males who queued each day to watch one of the latest Olympic sports.

Whatever the purience factor in watching women in scanty bikinis hurling themselves into the sand, beach volleyball has proved its right to be accommodated in the modern games along with such winter sports as snowboarding. The contestants are genuine athletes in a sport that demands both high fitness levels and ball skills. Action is continuous and often spectacular, the scoring is simple and few spectators go home disappointed.

'It was another tough day at the office,' recalled Kevin. 'Beach volleyball has got to be one of the best assignments one could draw at the Olympics, but to cover it at Bondi Beach had to be the icing on the cake. Talk about fun. Why not have a little fun with the photos too?'

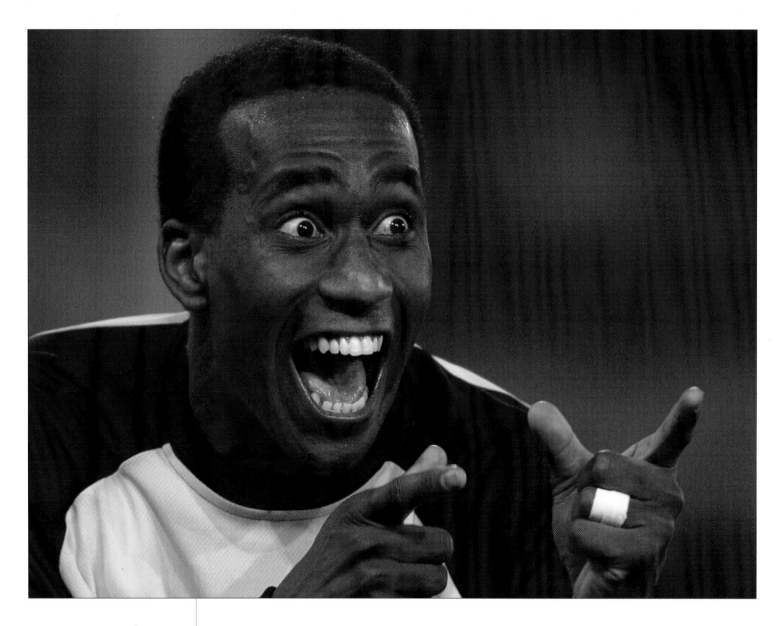

Evanilson points the way
17 March 2002

Kai Pfaffenbach

Borussia Dortmund's Brazilian import Evanilson celebrates his club's fourth goal against SC Freiburg in the German Bundesliga on 17 March 2002.

Brazilian footballers, including two of their 2002 World Cup heroes Rivaldo and Roberto Carlos, bring their sumptuous ball skills and flair for the unexpected to most of the world's major leagues, although footballing expats are sometimes regarded with great suspicion back home in Brazil.

Maradona cools down
10 November 2001

Andres Moraga

Diego Maradona refreshes himself during a break while playing for the Argentine national team in his farewell match against an international selection before 50,000 fans at the Boca Juniors stadium in Buenos Aires.

Although only 41, Maradona's pudgy body hints at the serious ill-health he was already suffering after a professional career that began when he was 15 years old. Hacked mercilessly by defenders aiming to blunt his phenomenal dribbling skills, Maradona needed painkillers to play and resorted to harder, recreational drugs during a career which took him to Barcelona then Napoli. His finest moments came at the 1986 World Cup in Mexico where his skills, pace and vision were exhibited at their best on the biggest stage.

He plumbed the depths with his fisted 'Hand of God' goal against England before scoring a wonderful and legitimate goal in the same match. Maradona bettered that effort against Belgium, dancing around four defenders on the edge of the box to score. Argentina deservedly won the final against West Germany but after that the decline was steady. Maradona was sent home in disgrace from the 1994 World Cup after testing positive for an assortment of drugs, and was later treated in Cuba for a serious heart complaint exacerbated by his drug abuse.

Andres said that after the match Maradona had apologized for his drug use. 'I made a mistake and paid but the fact that a footballer makes a mistake doesn't mean that the football is tarnished,' Maradona said with tears in his eyes.

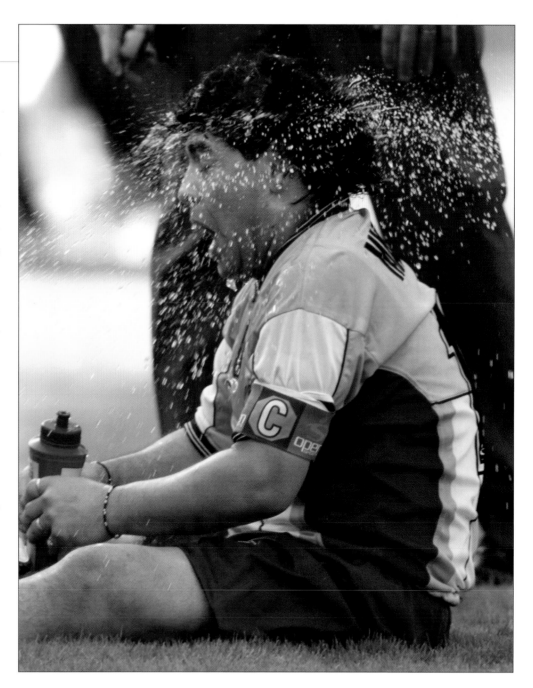

A gymnast balances on the bar
17 September 2000

Mike Blake

All the poise, balance and agility of an Olympic gymnast is captured in this frame as a young Spaniard, with a hole in the bottom of her shoe, balances on the beam at the 2000 Sydney Olympics.

Women's gymnastics has been immensely popular since it was introduced to the modern games in Helsinki in 1952 and, as in swimming, multiple gold medallists have abounded. Hungary's Agnes Keleti won 10 Olympic medals in 1952 and 1956, including five golds and Ukrainian Larysa Latynina, competing for the old Soviet Union, won an unprecedented 18, including nine golds in three games.

The first female gymnast to make a truly global impact was not even the most accomplished athlete in her team. Olga Korbut, a tiny 17-year-old from Grodno in Belarus, finished second in the all-round championships to Lyudmilla Turischeva at the 1972 Munich Olympics. However, Korbut had captured the attention of hundreds of millions watching on television with a dazzling display on the uneven parallel bars.

Twenty hours later, Korbut was an international sensation as she returned to compete on the four individual apparatuses. She won the gold medal for both the balance beam and the floor exercises and her fame became such that a special postal clerk was appointed in Grodno to handle her fan mail. Four years later it was the turn of Romanian Nadia Comaneci who made Olympic history with the first perfect scores of 10 for her performances on the uneven bars and the balance beam in Montreal. In all, Comaneci recorded seven 10s.

Both Korbut and Comaneci eventually escaped increasingly restrictive regimes by emigrating to the US. Comaneci's clandestine exit was the more dramatic. She defected after a night-time journey on foot to neighbouring Hungary accompanied by Romanian émigré turned Florida roofer, Constantin Panait.

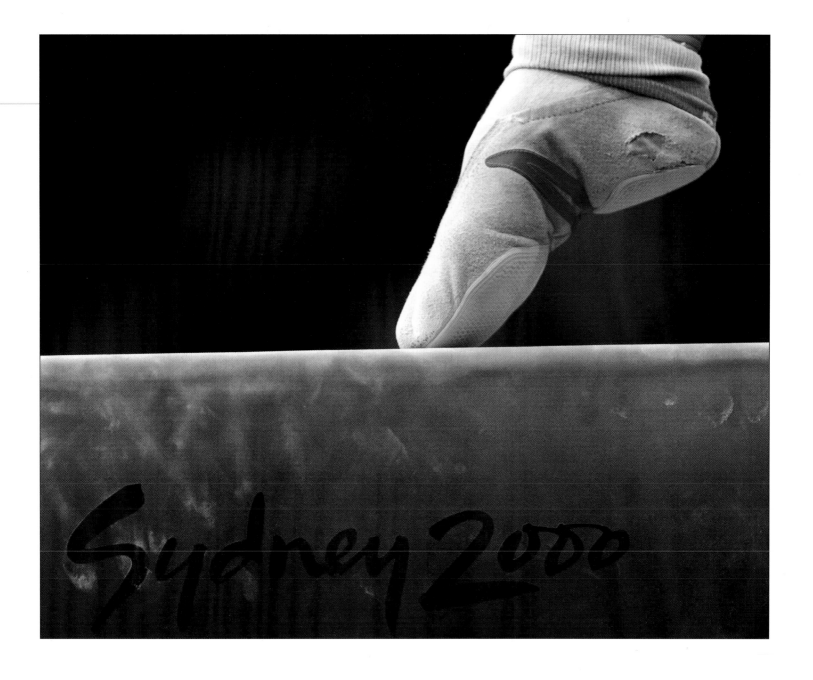

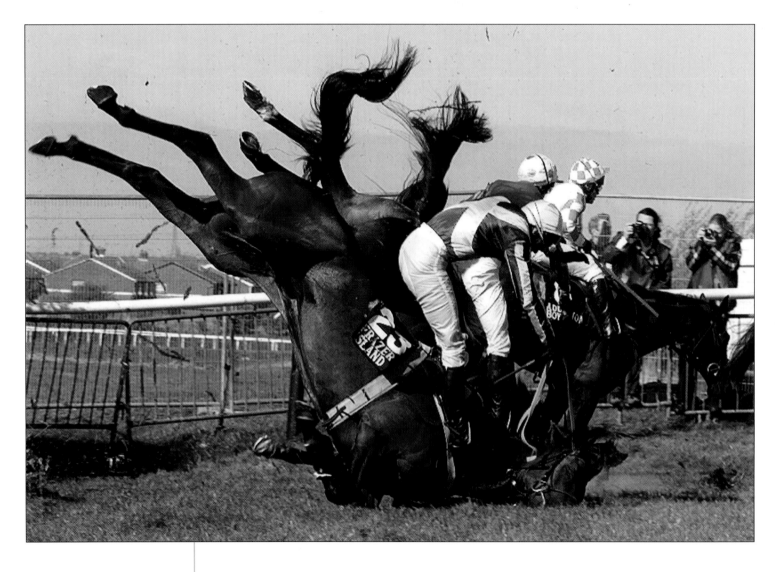

Horses and riders crash at the Grand National
10 April 1999

Ian Hodgson

Frazer Island partnered by Richard Guest in the foreground, tumbles in a pile-up at Becher's Brook in the 1999 Grand National at Aintree. The most famous steeplechase in the world has been bedevilled by problems in recent years, including a false start, a bomb threat and protests by animal rights activists.

The horses had come around for the second time and on this occasion three horses stumbled on landing. Frazer Island landed nose first, throwing Guest from the saddle. Eudipe, partly obscured by Frazer Island, also fell heavily and was so badly injured that he had to be put down.

'It was the second time I had covered the Grand National for Reuters and I wanted a picture which symbolized the race for me,' said Ian. 'Other Reuter photographers were covering the winning post and winner's enclosure so I needed to get a strong action picture. As Becher's Brook is the most notorious fence on the course, I decided that was the place to be. Fortunately for me the decision paid off and I was in the perfect position to capture the dramatic and tragic moment when the three horses fell to the ground.'

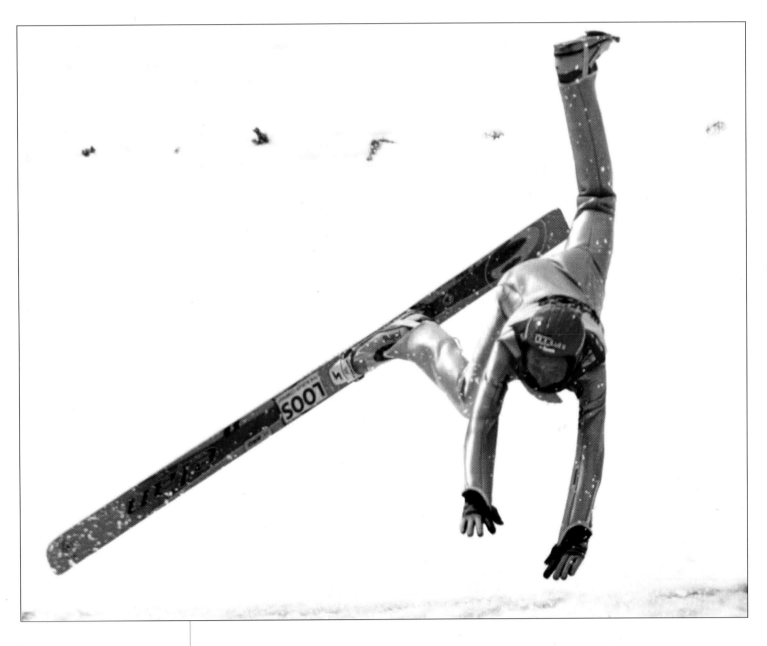

Ski-jumper tumbles

22 March 2002

Srdjan Zivulovic

Thomasz Pochwala of Poland has lost one ski and twisted his right leg awkwardly in a painful fall during official practice for a World Cup ski-jumping competition in Planica.

The first ski-jumping contest was held in Trysil, Norway in 1862. Jumps are scored according to distance and style with five judges deciding on the latter. In 1964 the jump was divided into normal and large hill events.

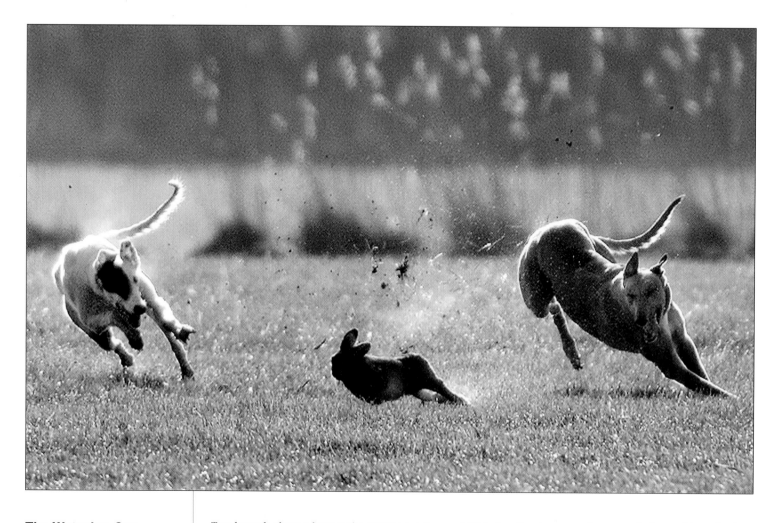

The Waterloo Cup
22 February 2000

Dan Chung

Two hounds chase a hare at the controversial annual Waterloo Cup hare-coursing event in Lancashire, a high-profile target for animal rights campaigners.

Wild hares from the surrounding countryside are forced by teams of beaters into a field where the dogs are waiting. When a hare comes down the course, a pair of dogs is released and bets are placed on which one will catch the hare. If the hare reaches the end of the field into the rough without being caught, it is left to escape.

'It is a difficult event to photograph as there is little telling when a hare will come down the course and the crowd is kept a distance away to prevent the hares being cut off,' said Dan. 'It requires a very long lens, fast reflexes and considerable patience to catch the action and there is no way of knowing which way the dogs and their quarry will turn.'

The event often causes tension between animal rights campaigners and the pro-blood sports lobby. It has become a focus of attention as debate rages in the British Parliament as to whether blood sports should be banned.

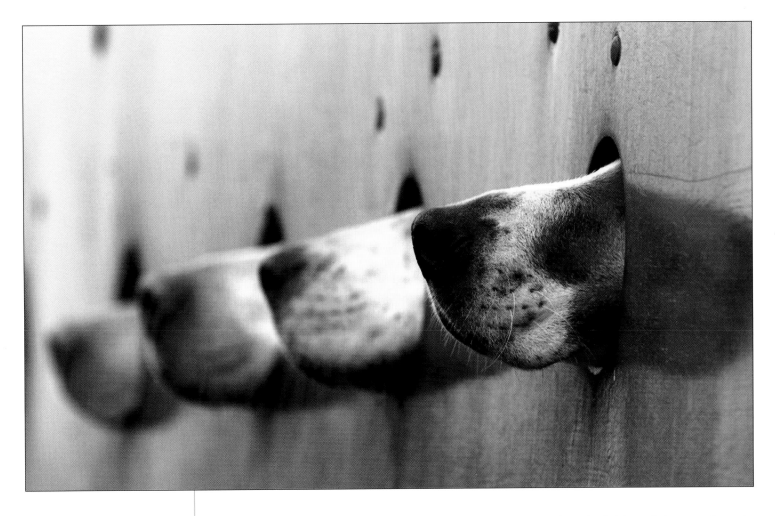

Four hounds wait to be released

16 January 2001

Dan Chung

Four fox hounds, their noses quivering in the cold morning air, wait to be unloaded from their van at the start of a day's hunting in Northumberland, England. At least 30 hounds are transported to the hunt in the back of a trailer.

'On the day I followed the hunt the ground was so frozen that the horses couldn't be used to follow the dogs so the huntsfolk used motorized quad bikes instead,' Dan said. 'I had to ride along trails and up and down hills sitting on the back of one with all my equipment. I had a very sore behind at the end of the day and after all that I didn't even see a fox!'

Fox hunting has been practised in Britain for more than 300 years. Hunters on horses, dressed in bright red coats, chase foxes across fields. Opponents argue the sport is cruel and barbaric. Supporters claim the hunts provide a service to farmers, who regard the fox as vermin, and also maintain thousands of rural jobs.

In March 2002, the British Parliament's elected House of Commons voted for a full ban on fox hunting while the unelected House of Lords opted for an alternative allowing hunting under licence. Rural Affairs Minister Alun Michael said the government would consult all parties over the next six months in an effort to find common ground.

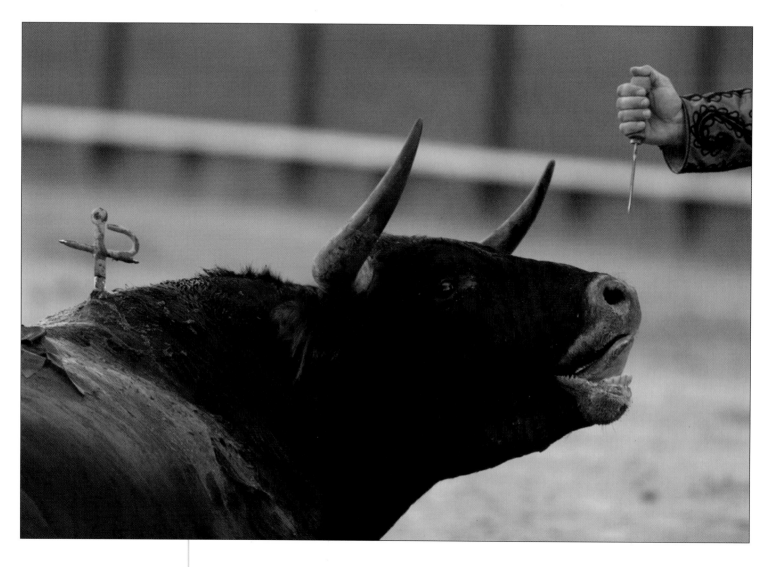

A bull receives the coup de grâce
21 April 2002

Marcelo Del Pozo

Devotees of bullfighting, the aficionados, do not consider it a sport. Nor do they believe it benefits from rational analysis. Instead man and beast perform together an ancient blood ritual delicately balanced between life and death in front of an audience whose reaction is critical.

The matador, a protagonist in the three-act tragedy, is judged on how skilfully he works with his cape in front of the charging bull and the crowds in the amphitheatres can be merciless if they sense they are not seeing the real thing. Ernest Hemingway described bullfighting at length in *Death in the Afternoon* but wrote about it best in his first novel *The Sun Also Rises*.

The many critics of bullfighting consider it a barbarous throwback that should be banned. They are greeted with incomprehension by Spaniards old and young. 'Bullfighting in Spain is an ancestral, artistic expression about the courageous bull and its death,' said Marcelo. 'I was moved by the face of the bull so I wanted to celebrate the animal with this picture. The photograph captures the dying breaths of the bull taken moments before the bullfighter's final blow.'

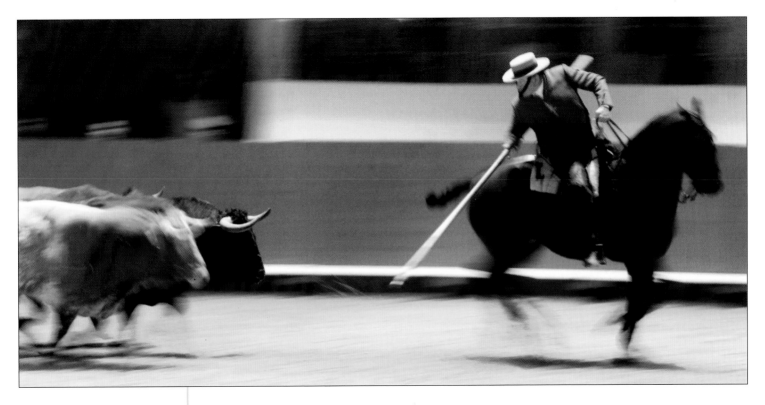

A horseman at the World Bull Fair
7 February 2001

Marcelo Del Pozo

A horseman leads a pack of charging bulls during a show on the opening day of the IV World Bull Fair in Seville.

The fair is an annual event to celebrate the world of bullfighting. The festivities take place both at and away from the bull ring and include demonstrations, conferences, exhibitions and a host of song, dance and drama performances. The celebrations attract spectators and participants from all over the world.

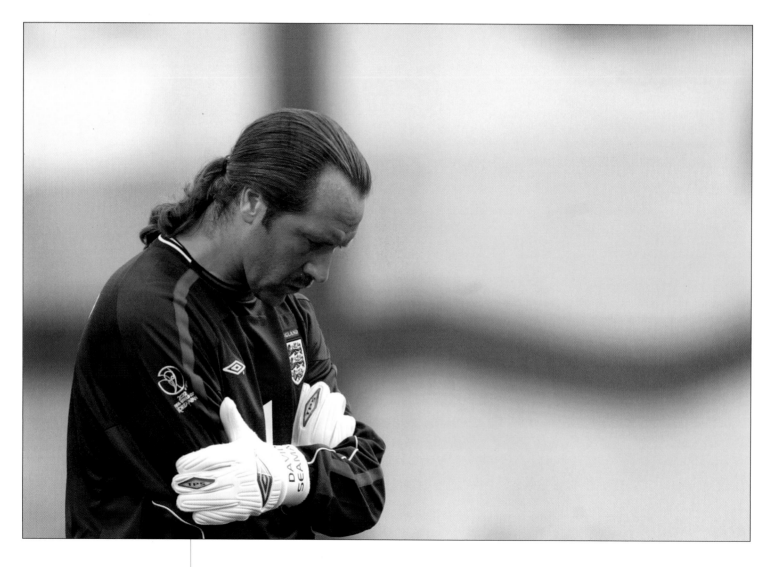

**A devastated
David Seaman**
21 June 2002

Kai Pfaffenbach

David Seaman, agonizing over the mistake that may have cost England their World Cup quarter-final against Brazil, left the pitch in tears after misjudging a Ronaldhino free kick.

The 38-year-old Arsenal and England goalkeeper who has a record of towering performances in 73 matches for England, blamed himself for this loss and briefly contemplated retirement such was his disappointment.

He changed his mind after arriving back in England to find the majority of fans agreed with his team mates' full support of him and said: 'The reception from people has been fantastic. I feel positive and I just want to keep playing for another year if I can keep the quality going.'

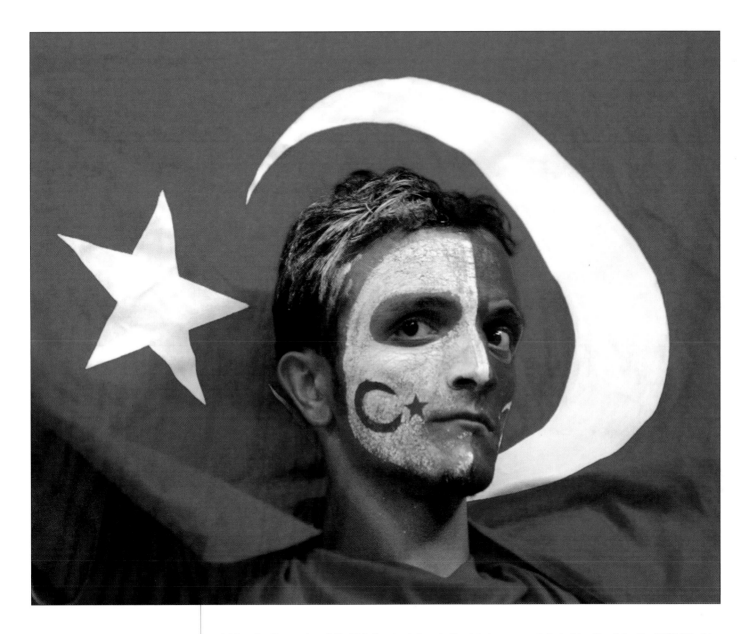

**A disconsolate
Turkish fan**
26 June 2002

Kimimasa Mayama

A bitterly disappointed Turkish fan is pictured after his team was defeated by Brazil in the 2002 World Cup semi-finals. Turkey played well and did themselves full justice throughout the tournament, surviving some close matches and some shameless play-acting from Rivaldo along the way.

Turkey's only previous appearance in a World Cup was in Switzerland in 1954, but their football has improved dramatically in recent years, partly as a result of the influence of players who were born and brought up in Germany before returning to the land of their fathers. Turkey reached the second round of the 2000 European championships and Galatasaray became the first Turkish club to win a European trophy before the current team brought further credit to their nation in South Korea and Japan.

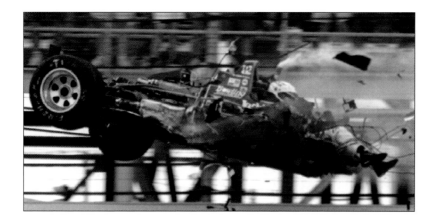

Driver flies backwards through the air
28 May 1995

Peter Kirles (above), Diane Jones (main picture)

Taking pictures of the annual Indianapolis 500 is one of the great challenges facing photographers in the US. The race is staged on Memorial Day and attended by almost 500,000 people. Race day for photographers begins at 6 a.m. when they head to the track for an 11 o'clock race. About 12 photographers are spread out through each of the four corners and another 10 dressed in fireproof suits will spend a long, hot day in the pits. The photographers are in the corners for one reason only: to catch the accidents.

In these 1995 shots, the photographers have captured driver Stan Fox with his legs sticking out from the cockpit of the car as the whole front end disintegrates.

Fox's car had malfunctioned, causing him to crash into another car. Smoke and debris from the collision caused the other crashes and six drivers had to be taken to hospital. Stan Fox suffered severe head and leg injuries and had to undergo emergency surgery.

'The crash happened in "the chute", the straight part of the track between turns one and two,' said editor Gary Hershorn. 'I could tell it was a bad crash so I headed back to the onsite trailer that we use as a darkroom and waited for the film to be developed. When I walked into the trailer the people developing the film were in a state of shock. They described what they saw on television to me and said it was the worst crash they had ever seen.

'We had about 16 rolls of film from the accident and my adrenalin was pumping as I waited to see the images. Believe it or not it took until the very last roll of film that I edited to find the best frame. It was a photograph that virtually all newspapers around the world published.'

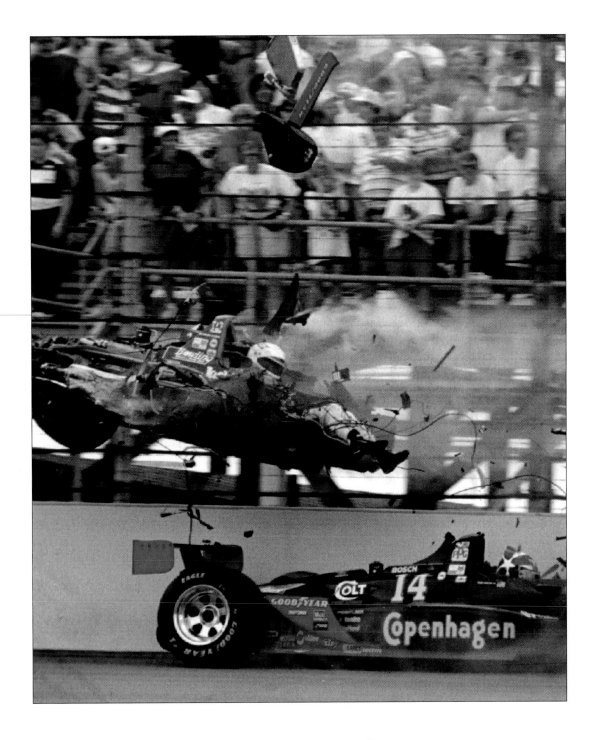

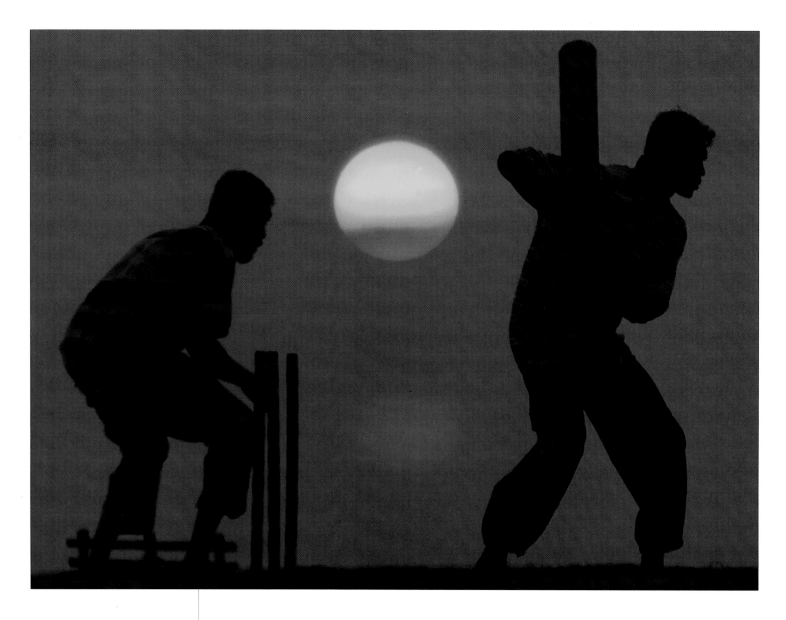

Cricket at sunset
23 February 2001

David Gray

A magical image illustrating the love of the game evident in Sri Lanka. 'The country of Sri Lanka offers an amazing array of picture opportunities, with unusual cricket scenes in abundance,' said David, who shot this scene returning from a day's play in a test between Sri Lanka and England.

'A beautiful 16th century Dutch fort is situated right next to the oval and many games of cricket are played there due to the large open spaces the fort has within its walls. We turned a corner and there it was, a perfectly positioned batsman with a wicketkeeper standing behind the stumps as the sun, diffused by the ever-present smoke haze on the horizon, was setting behind them.

'I tried again for the next three days to get some more pictures of people playing in the same place, but all the elements never seemed to match up quite the same again.'

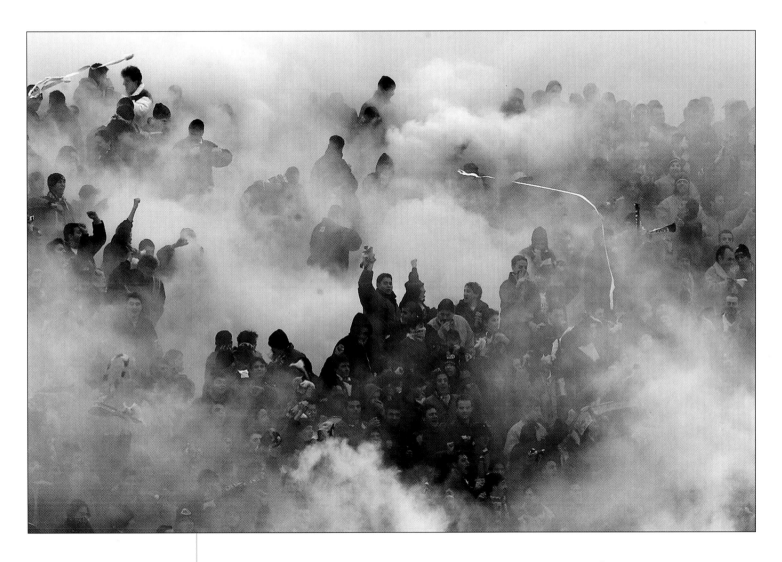

Smoke engulfs the crowd

2 December 2001

Dimitar Dilkoff

Heavy smoke from flares obscures fans of Lokomotiv Plovdiv as they encourage their team during a Bulgarian first division match against Levski Sofia in Plovdiv.

'The game itself was quite boring,' said Dimitar. 'Lokomotiv's supporters are well known as being temperamental and distributed smoke all over the stadium. The audience provided more interesting pictures than the players.'

Two fighting cocks in Colombia
17 February 2002

Eliana Aponte

Spectators gaze intently at two fighting cocks in action during a match at a pit in Aracataca in the northern Colombian province of Magdalena.

Cockfighting, a centuries-old blood sport, was practised in ancient Persia, Greece and Rome and was popular in England for centuries until it was prohibited by an Act of Parliament in 1849. It is now illegal in many countries but still practised in parts of Latin America and Asia. The birds are put on special diets, bred for their fighting qualities and released into a ring with spurs or daggers tied to their feet.

Spanish colonizers introduced cockfighting into Colombia in the 16th century and now it is a staple of rural life. At championships, breeders from across the country descend on towns in cars, buses and on foot laden with hundreds of roosters.

'Cockfighting is held in many rural areas where people attend games that last all night,' said Eliana. 'The birds face off at village festivals in honour of their breeders. With this image I wanted to show how two tiny birds can paralyze an entire group of men and women. Spectators sometimes bet up to $100 on the winning rooster. I took this picture with slow speed as people around me screamed and roared.'

Trainer sucks blood from cockerel
7 February 1999

Patrick de Noirmont

A trainer sucks blood from the head of a fighting cock during a break at the world's first international amateur cockfighting competition in Chonburi, 150 km north-east of Bangkok. The cocks are routinely patched up between fights.

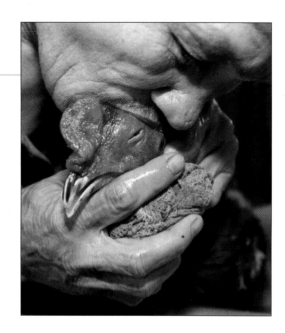

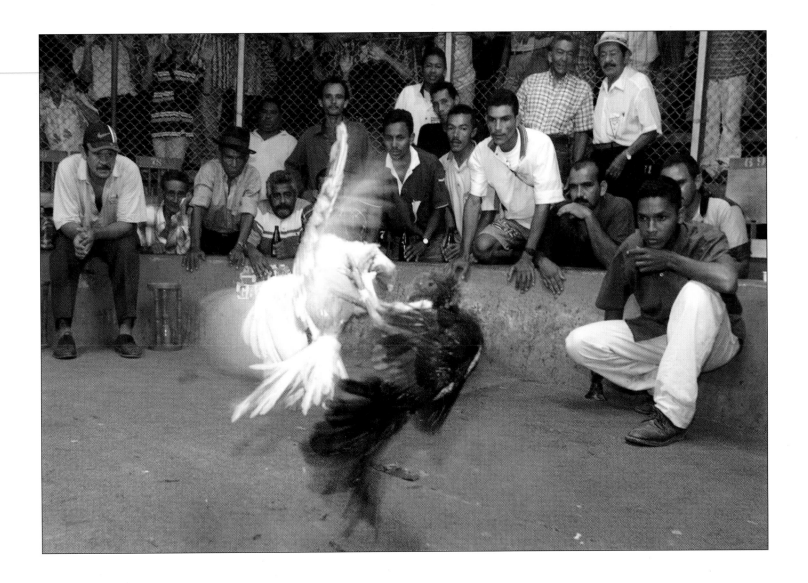

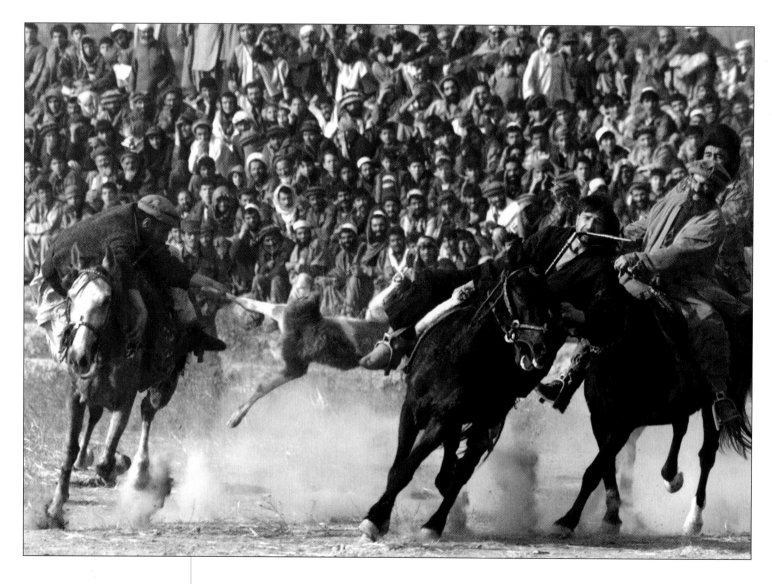

Riders compete for a headless goat
4 January 2002

Erik de Castro

Afghan riders from Kabul and Parwan provincial teams struggle over the corpse of a headless goat in a game of Buzkashi, the national sport of Afghanistan. Riders have to grab the goat corpse, carry it the length of the stadium, and toss it into a chalk circle at one end to score a point. Raucous spectators, most of them armed with rifles and bazookas, bet on each team.

Reuters correspondent Jeremy Page witnessed the first game after the fall of the Taliban.

'There are virtually no rules, the teams and the pitch vary in size and nobody seems to know who is playing who, let alone the score,' Jeremy reported. 'The result is total mayhem for a full two hours.

'The horsemen thronged around the carcass, still dripping blood, then stampeded across the dusty patch and ploughed into the crowd, trampling a few unfortunate spectators as thousands of others sprinted for safety. Every so often, a triumphant cry erupted and a player paraded in front of the crowd and galloped to the commentator's truck to claim a cash prize for a point scored.

'After half an hour, the score was 4–0 to the greens. Or was it 3–1 to the reds? Not even the commentator knew.'

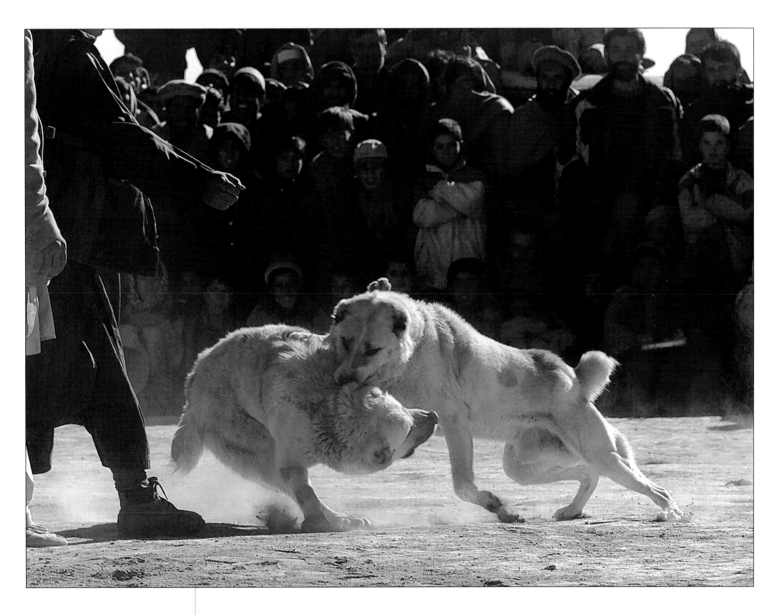

A dog fight in Kabul
18 January 2002

Oleg Popov

Afghan spectators watch as two dogs fight in a Kabul suburb. Dog fighting is a traditional sport in Afghanistan that was banned during the five-year rule of the Muslim fundamentalist Taliban. The Taliban fell in November 2001 after the 11 September strikes on New York and Washington. Traditional pastimes such as dogfighting have recovered their popularity surprisingly quickly.

A Slovakian fisherman at dawn

11 November 2001

Joe Klamar

Anton Trencan was one of several dozen fishermen who braved freezing temperatures at this popular Slovakian fishing spot on the Liptovska dam near the city of Liptovsky early one Sunday morning.

'I went out fishing around 6.30 a.m. and I was driving around the dam for approximately 30 minutes when I saw the fog spreading all over the water with a stunning sunrise,' said Joe.

'I parked near the pier and was surprised to see so many fishermen lining the shore on such a freezing morning. As I like to fish alone, I started to figure out how to take a picture of the foggy sunrise.

'When one guy paddled his rubber boat 20 metres away from the pier looking toward the sun and fixing his gear, I knew immediately what I was looking for. When I looked at the display on my camera, the picture reminded me of Hemingway's novel *The Old Man and the Sea*.'

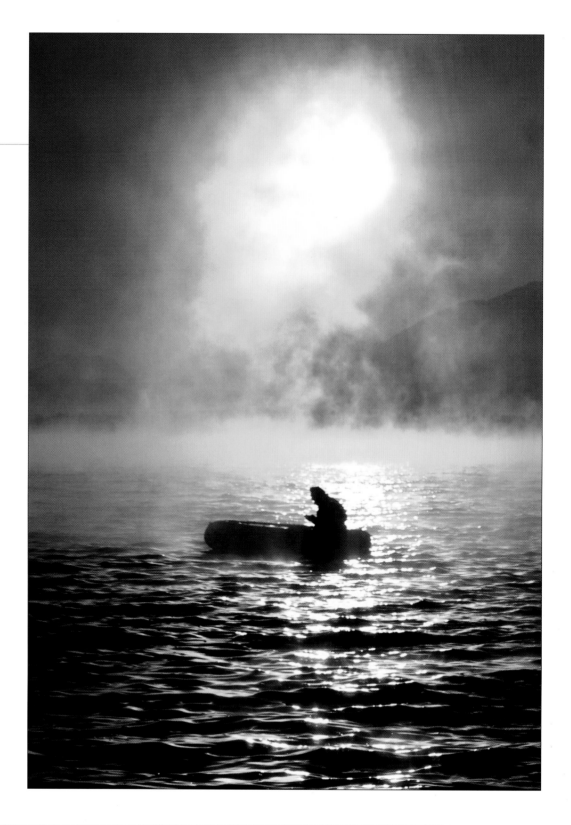

A Kazakh hunter releases his eagle
1 February 2002

Shamil Zhumatov

A Kazakh hunter, poised on top of a hill, releases his specially trained eagle. Eagles are used to hunt for small animals and are also used for fox hunting at the annual national Sayat championship.

Few people were present at the 2001 championships at Elan Tau, about 150 km from Kazakhstan's main city of Almaty, but photographers and camera crews came in their droves, reported Reuter correspondent Sebastian Alison. 'Since ancient times Kazakhs have followed this sport, this art, and we continue to support it,' said 82-year-old Sailybekuly Zhunis, who still rides with a 6 kg eagle perched on his arm. 'I have been raising eagles since I was a young man.'

Sayat master of ceremonies Omizak Zholombet said Kazakhs once hunted with eight different types of birds of prey, of which the eagle was just one, but he said the days have passed when the steppes could sustain the huge wildlife population needed to support the immense birds. Zholombet said that Kazakhstan had once been home to three million wild antelope but now just 150,000 remain. The rest had fallen victim to hunger, rifles, and a loss of habitat through the industrialization and pollution characteristic of the Soviet era.

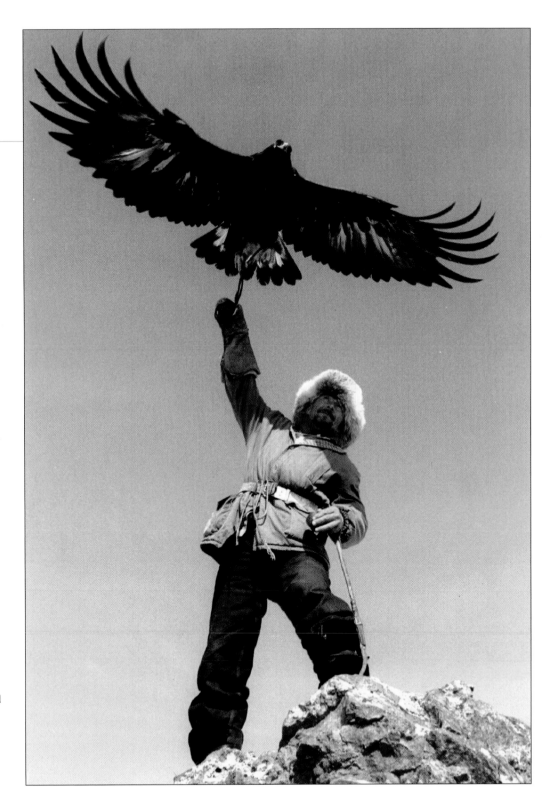

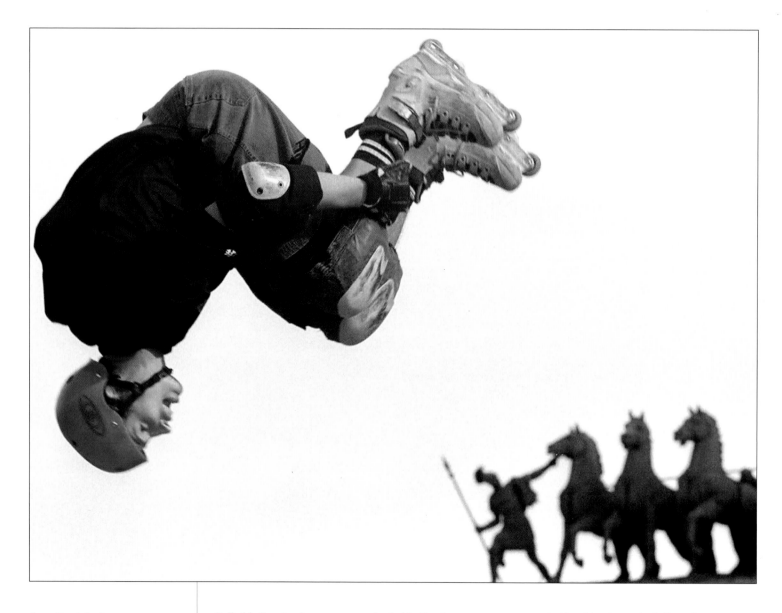

**A rollerblader
somersaults in
St Petersburg**
29 August 1999

Alexander Demianchuk

Rollerblading has become a popular fad in Russia among young people. For this picture in St Petersburg, Alexander lay on the asphalt to catch a teenager doing an aerial flip in Dvorzhovay Square. 'I wanted to show the jump against a background of beautiful architecture,' he said.

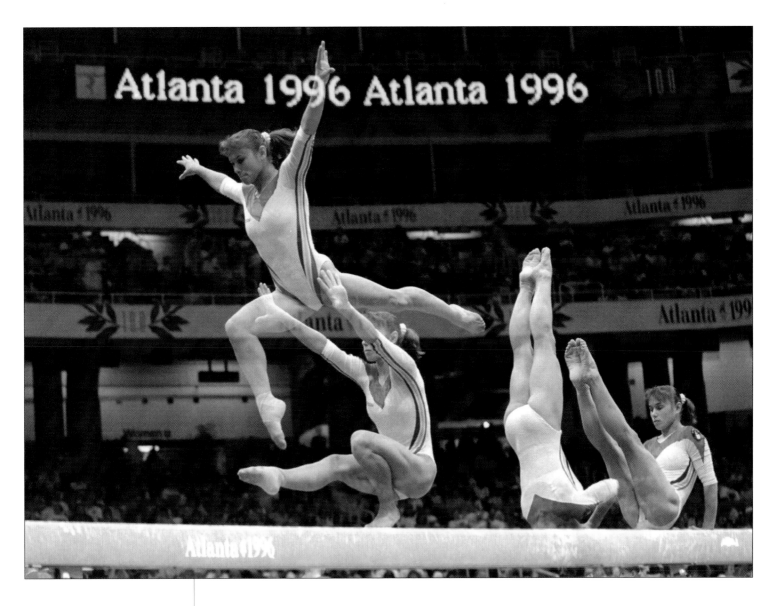

**Milosovici goes through
her routines**
16 July 1996

Mike Blake

This is a multiple-exposure photograph of Romanian gymnast Lavinia Milosovici preparing for the 1996 Atlanta Olympics. Milosovici, an individual all-round world and Olympic bronze medallist who helped Romania to silver in the team competition at the 1992 Barcelona Games, had sprained her ankle six weeks earlier and missed about a week's training.

'This was the last summer Olympics that Reuters shot film,' said Mike. 'There was a mix of digital and film but shooting gymnastics was not ideal for the early digital cameras so I stuck with film. Film is the only way you can get this effect.'

'When any photographer arrives at a new venue, the first thing he will look at is the light, the next thing is the background. This venue was so big that the light fell off in the background, allowing you to shoot a number of exposures on the same frame of film, as long as the athlete was in a new part of the frame and you kept the camera still.'

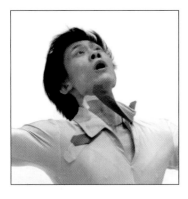

A Chinese pair perform their free routine
11 February 2002

David Gray

Figure skaters have always seemed faintly risible to certain sports fans, with their Disneyland costumes and showy routines performed to music apparently chosen by the people who compile selections for elevators and shopping malls.

In addition the judging system, now being reformed after the 2002 Salt Lake City Olympics scandal, is based primarily on subjective opinion. Notwithstanding these reservations, there is genuine athleticism and artistry in figure skating and the viewing figures at the Winter Games testify to the sport's attraction.

David has caught China's Tong Jian watching as his partner Pang Qing flies through the air at the Salt Lake City Games during their free routine.

'Capturing such a fleeting moment requires knowing exactly when to press the trigger so that both the skaters' faces, particularly the one in the air, are seen,' said David. 'A shot with just one face does not show both competitors properly.'

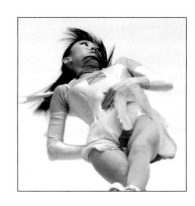

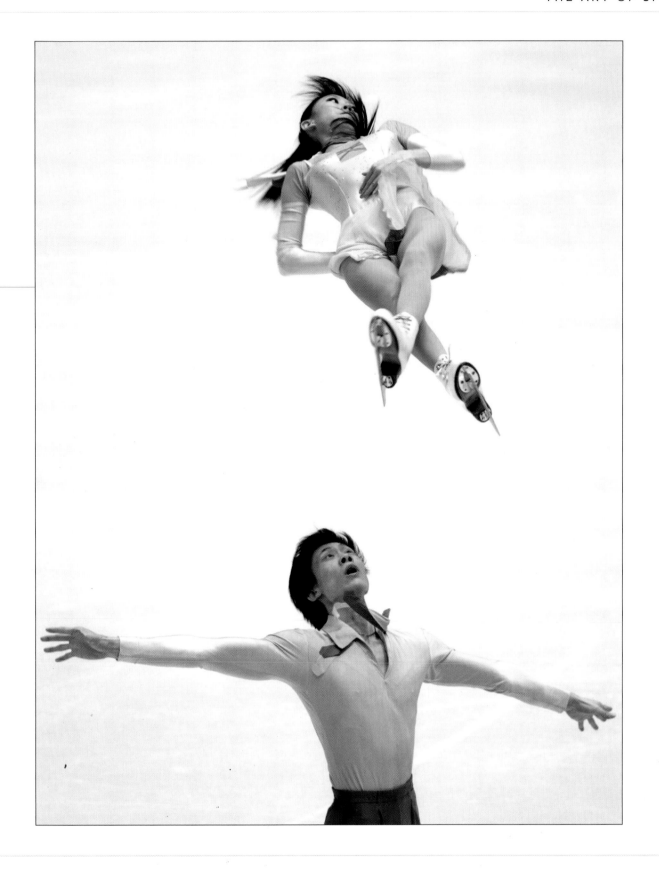

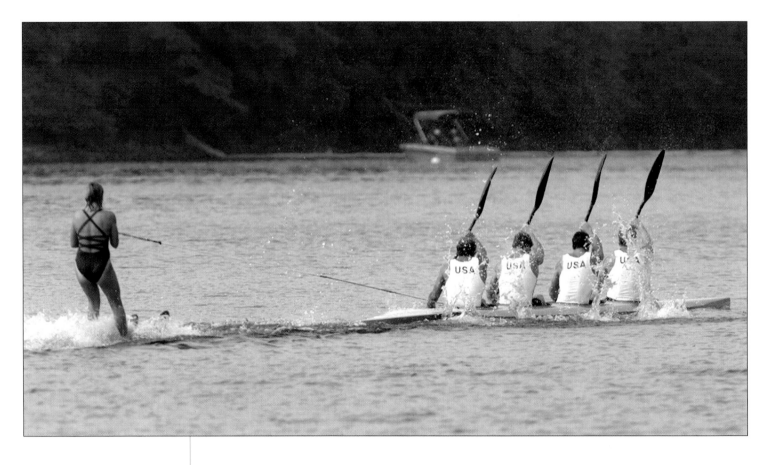

Four kayakers tow a water-skier
July 1996

Andy Clark

'Always look over your shoulder, the best picture may be behind you.' a veteran photographer once told Andy. The advice paid off at the 1996 Atlanta Olympics.

'While waiting for the day's competition to get under way I just happened to look over my shoulder,' Andy recalled. 'I saw the US four-man team about to pull a team-mate on water-skis.

'It took a couple of tries but they actually succeeded as can be seen in the photo, though not for long. The veteran's advice was true. It was the best picture of the day for me.'

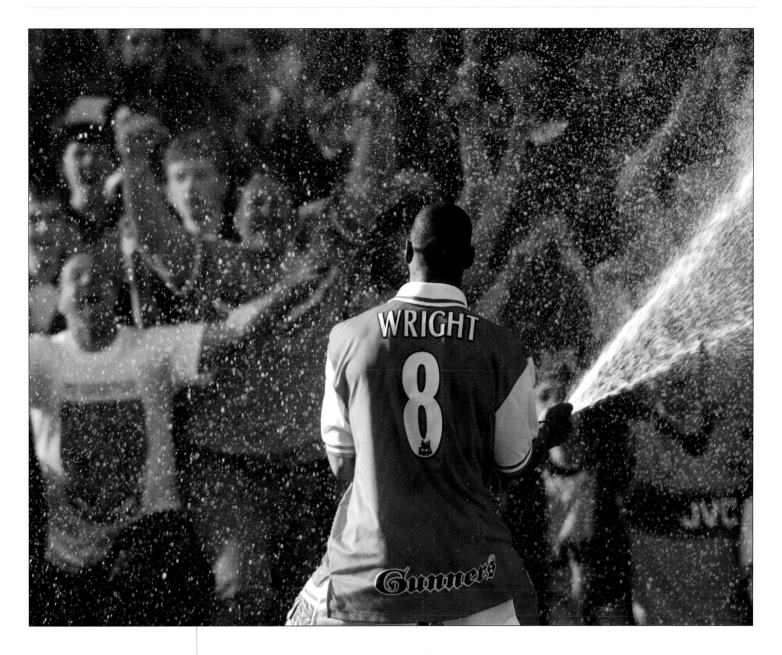

Ian Wright sprays the crowd
3 May 1998

Paul Hackett

Arsenal striker Ian Wright sprays ecstatic fans with champagne after his team win the premier league.

The north London side also won the FA Cup in a triumphant season for their French-born manager Arsene Wenger, the first foreign manager to win the championship. Wenger brought a cerebral, disciplined approach to Highbury plus a galaxy of overseas talent.

He was careful to integrate the foreign players' attacking instincts with the renowned Arsenal defence and created an exciting and successful side.

As a result of his efforts, other foreign coaches were quickly recruited in the premier league and a Swedish coach, Sven-Goran Eriksson, took charge of the national team. After finishing behind Manchester United in ensuing seasons, Arsenal again clinched the double in the 2001–2002 season.

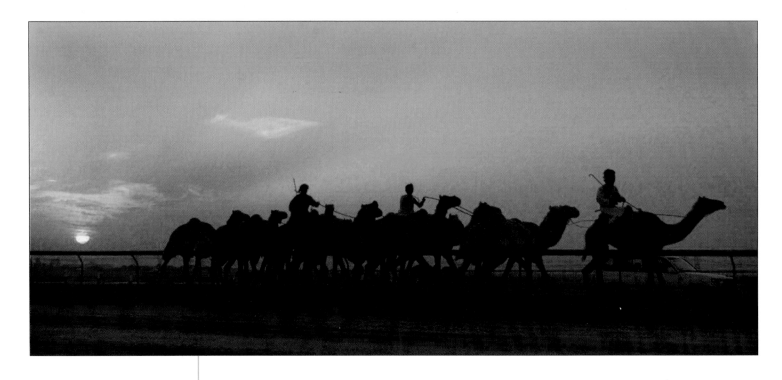

Racing camels in Dubai
20 March 2002

Russell Boyce

Racing camels are led along a racecourse in Dubai shortly before the world's richest horse race, the Dubai Cup.

'I wanted to shoot a feature picture to illustrate the country's enthusiasm for racing and spotted the racing camels making their way to the tracks during the day,' said Russell. 'I decided to return to the spot once the light had softened.'

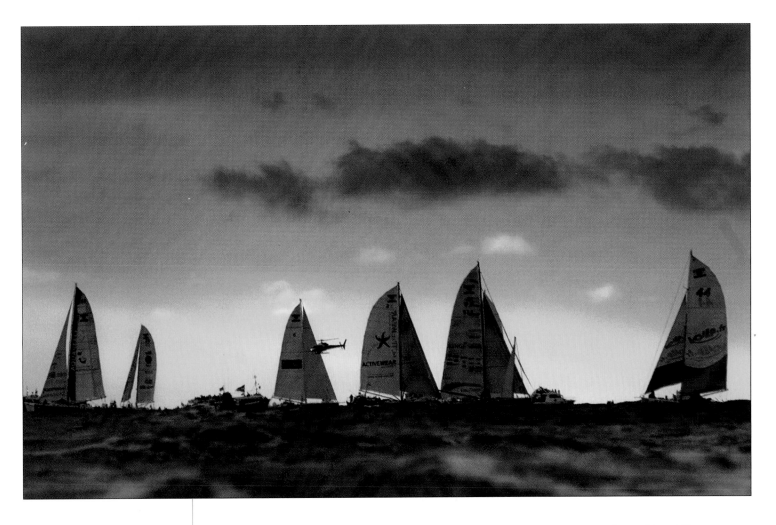

Sails at sunset
9 November 2000

Daniel Joubert

Vessels in the fourth Vendee Globe solo round-the-world race cross the start line off Les Sables D'Olonne harbour on France's Atlantic coast. Twenty-four skippers took part in the 2000 event, a non-stop 25,000 nautical mile race lasting at least three months.

Frenchman Michel Desjoueaux was the winner, completing the race in 93 days, three hours, 57 minutes and 32 seconds, breaking the previous record held by compatriot Christophe Augin.

He was greeted by a huge crowd and a fireworks display that lit up the sky.

The face and ear of Evander Holyfield
28 June 1997

Gary Hershorn

Wounded warrior Evander Holyfield after one of the most debased incidents in any sporting arena. The world heavyweight champion walks back to his corner minus a piece of his right ear after his 1997 title defence against Mike Tyson.

Tyson was disqualified and banned for a year after biting Holyfield's ear in the third round. Holyfield received 15 stitches for the wound and later required reconstructive surgery.

'It was truly one of the most bizarre moments to have ever taken place during a sporting event,' said Gary. 'Tyson was upset that the referee did not penalize a head butt which opened a cut on his face so he took matters into his own hands. I was in my usual ringside position shooting through the ropes when Tyson bit Holyfield's ear.

'No one at ringside had a clue what had happened when Holyfield started jumping up and down and holding his ear. When we saw blood and a small piece of flesh on the mat it became apparent that his ear had been bitten. When Tyson was disqualified all I remember doing was jumping up on the apron of the ring and thinking I had to get a picture of the ear.'

The incident effectively discredited Tyson as a serious fighter. A genuinely awesome boxer in the previous decade when at 20 he became the youngest heavyweight champion ever, Tyson was never the same after serving a prison sentence for rape, and his performances deteriorated as his behaviour became increasingly unbalanced.

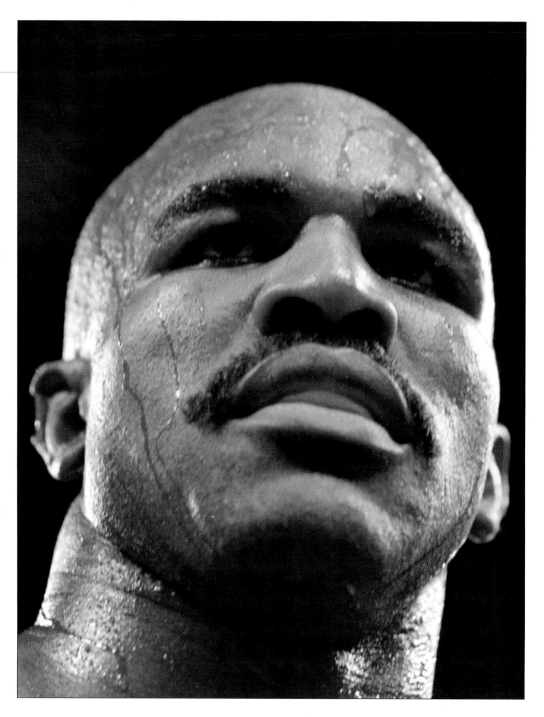

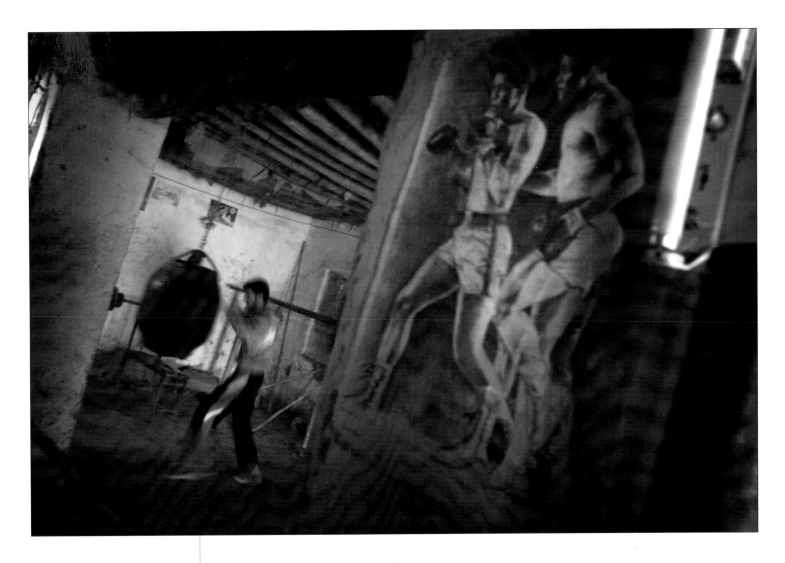

Afghan boxer works out under Ali poster
24 November 2001

Damir Sagolj

An Afghan boxer exercises under a poster of Muhammad Ali in a small Kabul boxing club after the fall of the Taliban. Under strict Taliban rules, boxing was condemned and fighters worked out behind closed doors.

The Taliban regarded just about every leisure pursuit imaginable as anti-Islamic, including kite flying, cinema, photography, music and radio as well as boxing.

Ali, at the height of his fame during the 1960s and 1970s, could rightly claim to be the best-known person on earth. As the picture shows, his influence remains.

'This is one of my favourite pictures from post-Taliban Kabul, showing a group of enthusiasts training in a humble club just a few days after the fall of strict Taliban rule,' said Damir. 'This shows very well how, after many years of life under military rule, people enjoy small things and want to become part of the rest of the world as soon as possible.'

Husky team trains alongside Loch Morlich
20 January 2000

Jeff J. Mitchell

Between 10,000 and 15,000 years ago, hunters tamed wild wolves in northern America to pull sleds across the frozen wastes. Huskies, dogs bred with special speed and endurance, enabled the great explorers Byrd, Peary and Amundsen to explore both polar caps and brought civilization to the world's snowbound land masses.

Sled dogs are not integral to survival now but their importance has been recognized with the advent of sled dog racing, including the so-called greatest race on earth, the Iditarod in Alaska. In 1925 the Iditarod Trail was the life-saving route for the town of Nome where diphtheria threatened and the temperatures were brutal at minus 50 degrees Celsius.

Husky racing has spread, as the pictures indicate, with wheeled rigs commonly used because of a shortage of snow. Jeff has shot Jon Gardner and a team of Mikalya huskies running along the banks of Loch Morlich in Scotland. 'Two hundred sled dog competitors annually attend a rally at Aviemore in Scotland,' Jeff said, 'and each year I have covered it there has been no snow.'

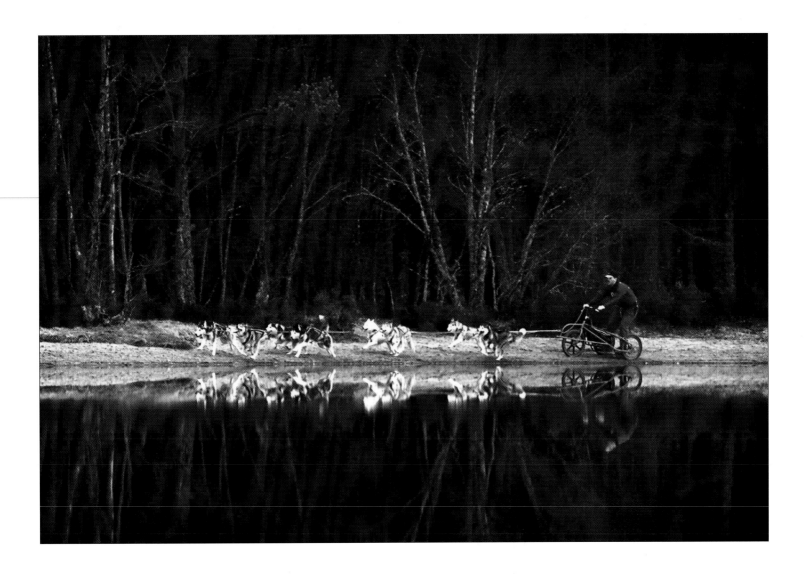

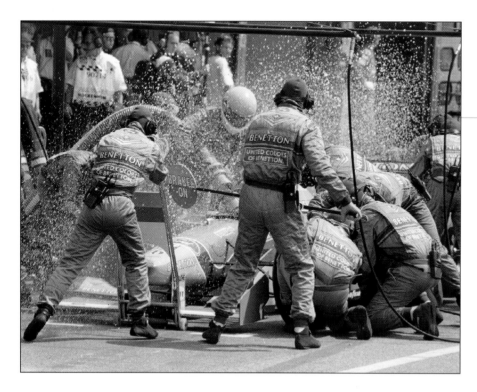

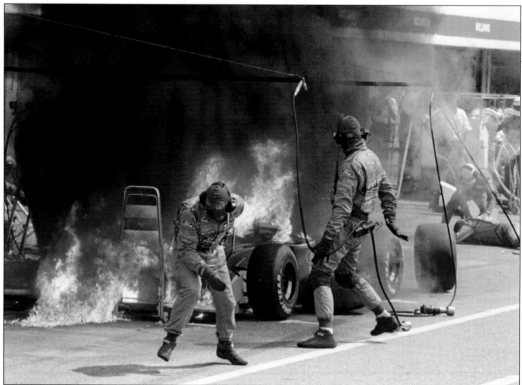

THE ART OF SPORT

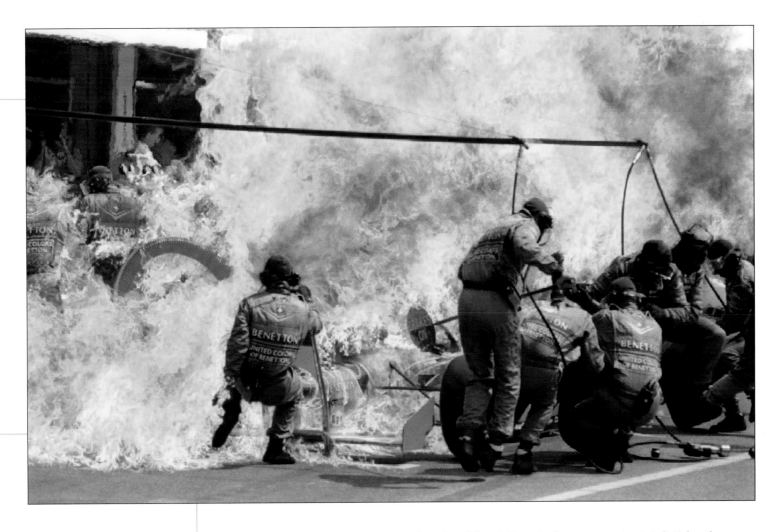

Benetton Ford catches fire

31 July 1994

Joachim Herrmann

This terrifying sequence of photographs show that although Formula One motor racing is infinitely safer now than even 20 years ago, thanks to stricter safety measures and improved technology, it still holds potentially fatal dangers.

In the first frame from the 1994 Hockenheim Grand Prix, petrol sprays on to the car of Dutch driver Jos Verstappen during refuelling. In the main picture, the Benetton Ford crew recoil as flames erupt, and in the third the fire is doused. Verstappen stepped out of the inferno unharmed.

Joachim said it was the first time to his knowledge that provision had been made for a special position for photographers immediately between the paddock and the racetrack.

'As I tried to shoot a normal refuelling situation, I saw petrol spraying around the car and a sudden conflagration,' he said. 'After four or five seconds had passed I had this dramatic series of photographs: the petrol around the car, the car in flames, the fire being extinguished and Jos Verstappen getting out remarkably unscathed. After this incident, new and more stringent refuelling regulations were established.'

The Redskins coach enjoys a Gatorade bath

26 January 1992

Gary Hershorn

After a Formula One Grand Prix, the winning driver ritually douses anybody within range with Champagne. Here Washington Redskins coach Joe Gibbs stoically endures a traditional cascade of the sports drink Gatorade after defeating the Buffalo Bills to win the Super Bowl in Minneapolis in 1992.

'At a point where it appeared the clock was ticking down for the final seconds, I sprinted on to the field of play and positioned myself to photograph the coach,' said Gary. 'Unknown to me a whistle was blowing stopping the clock with about two seconds left in the game.

'A referee noticed I was actually on the field for the last play of the game and physically pushed me into the bench area, and as luck would have it, right into Redskins coach Joe Gibbs. Just as I got there a group of players came up from behind the coach and dumped the cooler full of Gatorade on him. I quickly raised a camera to my eye and just got off one frame of the splash.'

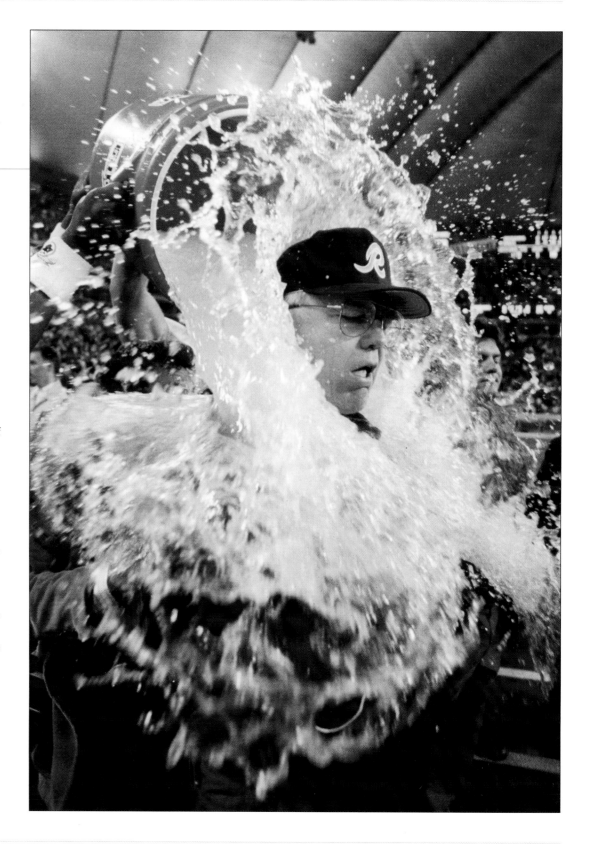

A surfer heads out into the waves
2 June 2000

Mark Baker

A surfer disappears as a wave crashes over a wall while he waits to enter the ocean on one of Sydney's northern beaches.

'It was a very slow day in the bureau, so I decided to chase up a feature picture and went to Dee Why beach on Sydney's north shore during a day when there was a good-sized swell hitting this popular surf beach,' said Mark.

'This guy decided the quickest way out to the waves was not to paddle through the surf but to jump over rocks where a pool was. He was engulfed by a larger-than-expected wave but fortunately for him there was a safety chain to hold on to.'

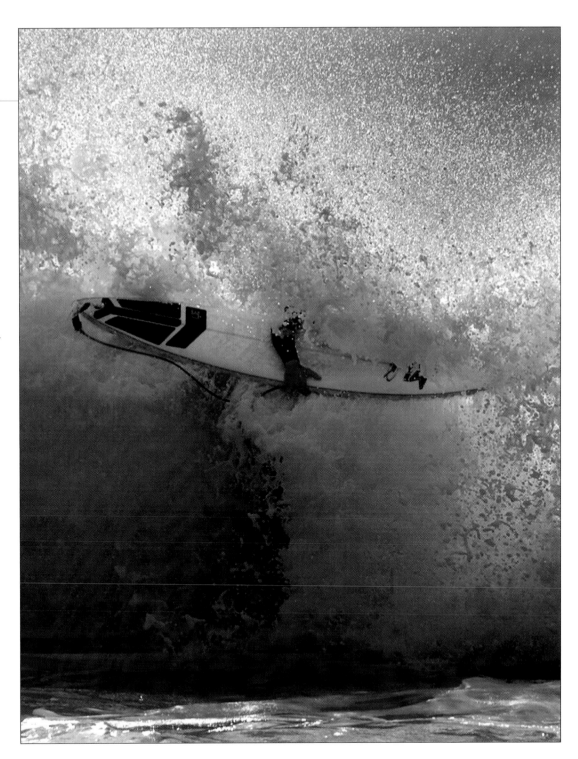

A gymnast loses her head
13 December 1998

Tom Szlukovenyi

Tom is rightly proud of this remarkable shot of a gymnast apparently competing without a head.

'I had a good day at the 1998 Asian Games and ended up with a number of good shots from the rhythmic gymnastics event, which is one of my favourite events to photograph.

'This shot shows the Chinese gymnast Zhou Xiaojing who appears to be headless as she bends backwards during her clubs routine. She, too, had a good day and went on to take gold.'

Rhythmic gymnastics was introduced into the Olympics at the 1980 Moscow Games and represents one of the borderline sports events where subjective judging plays a large role. Gymnasts perform 60–90-second routines using hoops, ropes, clubs, balls and ribbons. Ten judges score each routine, five for composition and five for execution.

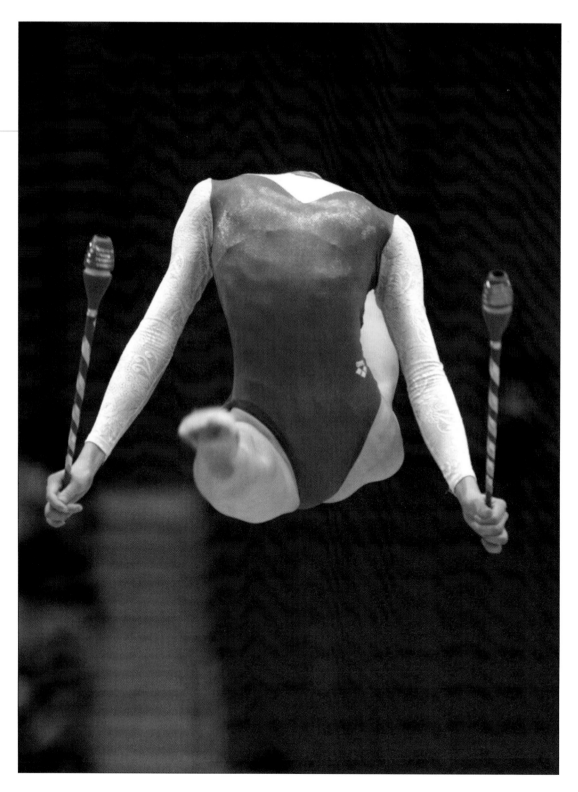

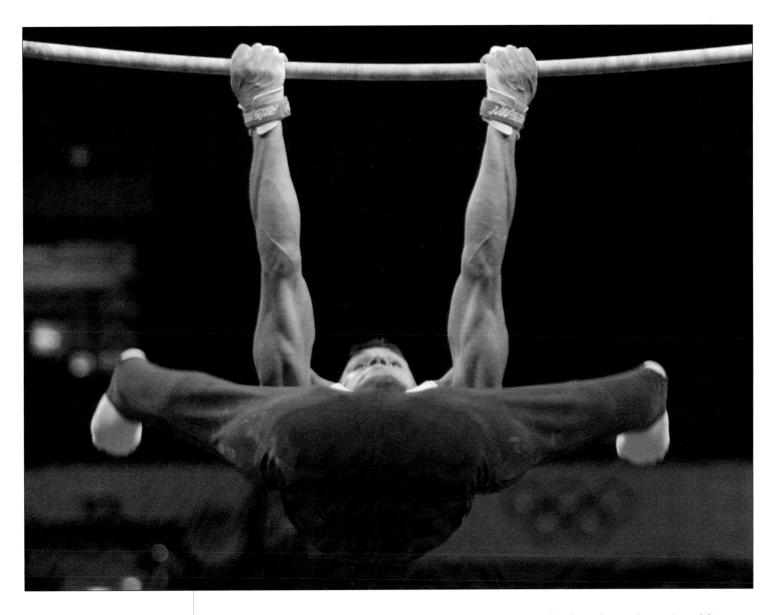

**A gymnast performs on
the horizontal bar**
16 September 2000

Mike Blake

American Blaine Wilson contorts his body into an apparently impossible shape during the men's qualifying round at the 2000 Sydney Olympics gymnastics competition. The muscle definition could be used in an anatomy textbook.

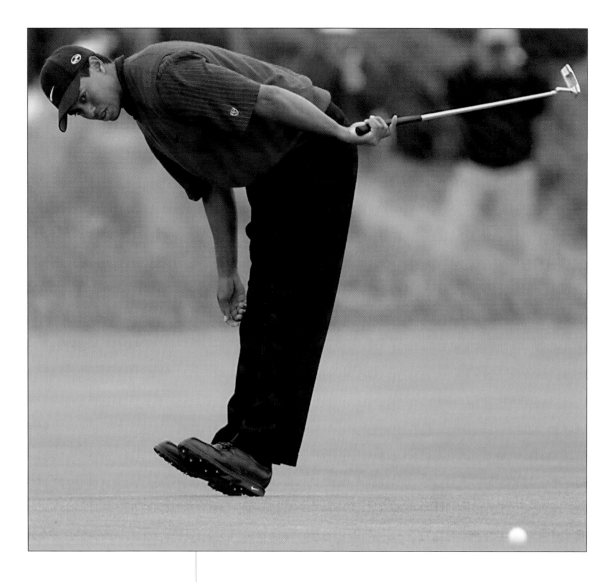

Face of the Tiger
23 July 2000

Jeff J. Mitchell

Possibly the most famous sportsman on the face of the planet, pictured here in the final round of the 2000 British Open at St Andrews. The Open was the second leg of an unprecedented run culminating in the Masters of the following year, when Tiger Woods became the only person to hold all four grand slam titles simultaneously.

At his best, Woods plays a different game from his contemporaries. Nothing is left to chance, including a physical training routine that would have shocked some of the old- timers, and Woods believes there is no aspect of his game that cannot be improved. After his Masters win at Augusta in March 2001, Woods unwittingly exposed the difference between himself and the rest of the world as he reflected on saving par at the 10th.

'I hit a good three-wood off the tee,' he said. 'Unfortunately I had some mud on my ball and it was on the front right of the ball. And I was thinking, well, if I hit it on the front right part of the ball it usually makes it go a little bit left. And I tried to hit a cut shot to hold it but it took off and it tumbled.' If genius is an infinite attention to detail, Tiger deserves the accolade.

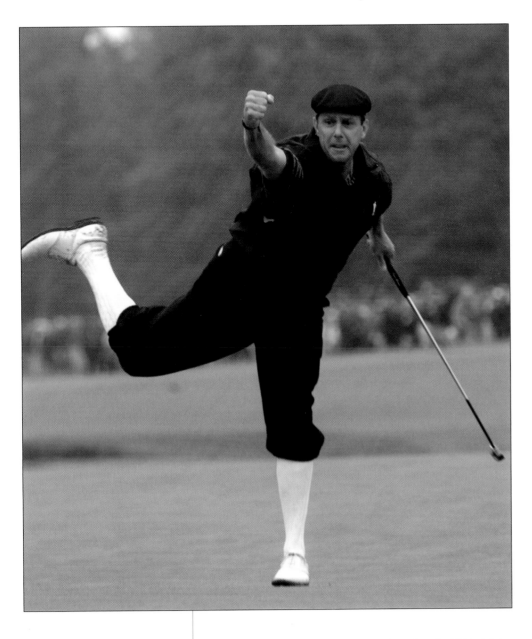

Payne Stewart wins the US Open

20 June 1999

Kevin Larmarque

'If golf is an art, Payne Stewart was the colour,' said Paul Azinger at the funeral of his friend and rival, who was killed in a plane accident in 1999 at the age of 42.

Stewart, seen here celebrating the putt which gave him victory in the US Open of the same year, was a flamboyant character who played in old-style baggy knickerbockers dubbed 'plus-fours' and a distinctive cap.

'The photo means a lot not only because it was a great victory but because it was his last great victory,' Kevin said. 'The photo was taken in the early evening in very dim light on the 18th hole. It was eerily quiet and dark as Payne approached his crucial putt. No one expected this explosion of emotion as the ball rolled into the cup. It was a great sporting moment.'

The large and the small
6 April 2002

Petr David Josek

American Emanuel Yarbrough, credited with being the heaviest sumo wrestler ever at 350 kg, fights below his weight at the 2002 Czech Sumo Open in Prague.

Petr explains: 'It was supposed to be a top-flight Sumo tournament but as far as I know, nobody in Europe cares much about the sport, so I focused on Emanuel. He came here for four exhibition matches and I knew that getting an image to capture his size was important. I was quite pleased when I found out that two matches would be against kids.'

To the delight of the spectators, Yarbrough lost to a young boy, pictured here pointing at his victim. 'He came close to him and the whole audience understood that no matter how big you are you don't mess with kids,' Petr reported. 'Yarbrough understood.'

The object of sumo wrestling, Japan's national sport, is to force an equally massive opponent out of a circular ring. Any hold is allowed. Much ritual surrounds the sport with purifying salt flung into the ring and theatrical glaring and pounding of fists by the contestants before the fight. Sumo wrestlers are trained from youth with a rigorous selection process and a special diet, including huge amounts of rice. The highest position possible is yokozuna or grand champion.

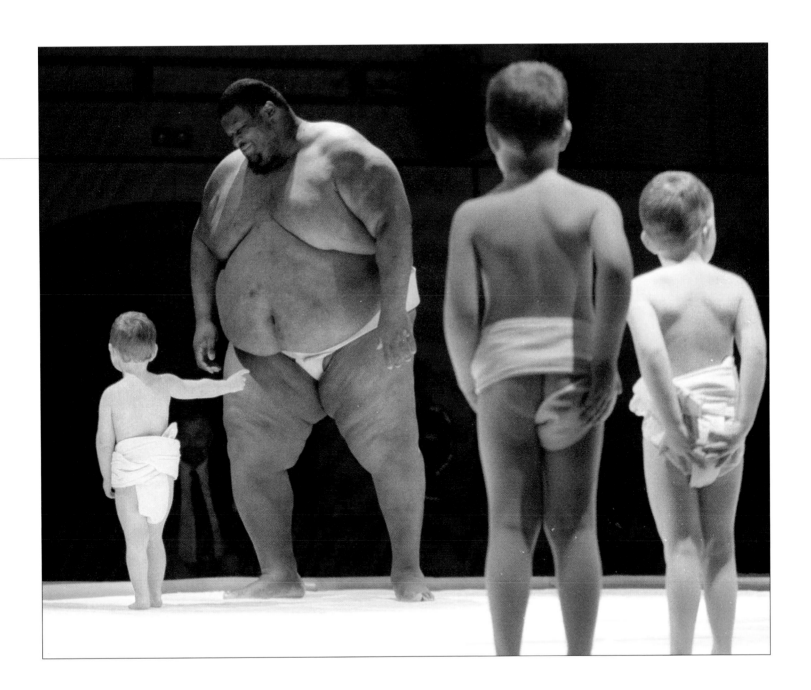

A Nigerian fan, World Cup 1998

9 July 1998

Oleg Popov

A solemn Nigerian fan, his face painted in his country's colours, awaits the appearance of his team on the pitch for a group match against Bulgaria in Paris at the 1998 World Cup.

'I was positioned next to the Nigerian fans, who sang and danced through the match. Only this man was quiet,' said Oleg.

Bulgaria failed to win a match at the tournament; Nigeria's 'Super Eagles' beat them 1–0 and qualified for the second round as winners of their group. They were knocked out in the next round, losing 4–1 to Denmark.

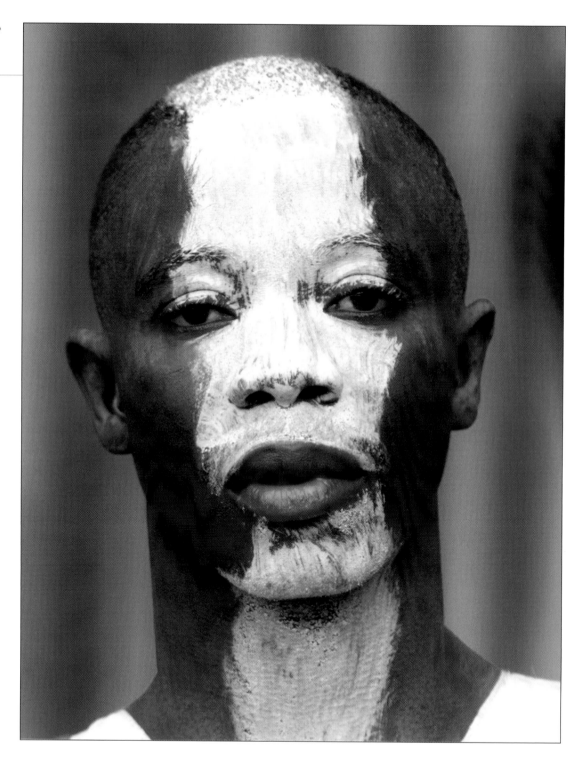

An English fan, European Championship, 2000

12 June 2000

Damir Sagolj

An English fan, with his face painted in the colours of the cross of St George, sings in Eindhoven before a group match against Portugal in the 2000 European championship.

Despite the best efforts of the police, English fans turned Marseille into a battle field during the 1998 World Cup and brutal German thugs almost killed a gendarme in Lens. At the 2000 championship hosted jointly by The Netherlands and Belgium, there were further ugly scenes, again featuring English and German supporters, in the Belgian town of Charleroi.

'Hooliganism was the big story of the championship,' said Damir. 'The idea was to have another close-up of a face – but also not to make it nice and smiling.'

Mindful of the possible threat, an unprecedented international security operation was laid on at the 2002 World Cup in South Korea and Japan. English supporters with records of soccer-related violence were banned from travelling the high cost of travelling east deterred many potential visitors and there was a prominent police presence in both countries. As a result there was virtually no hooliganism.

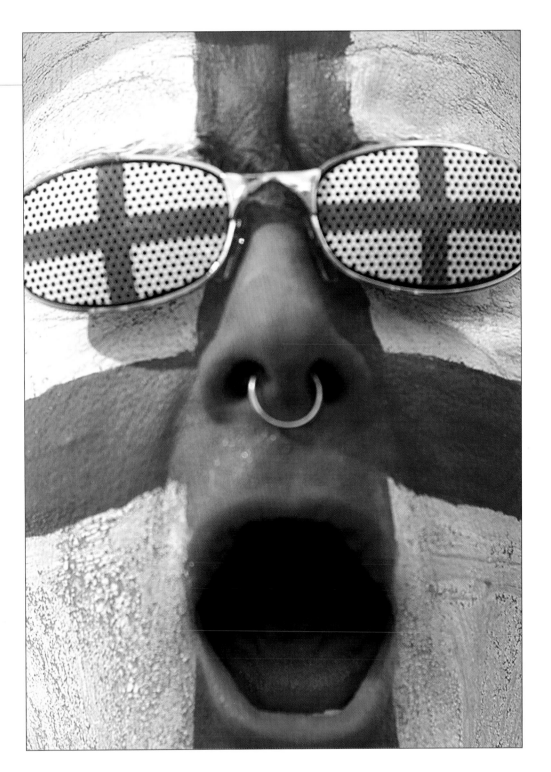

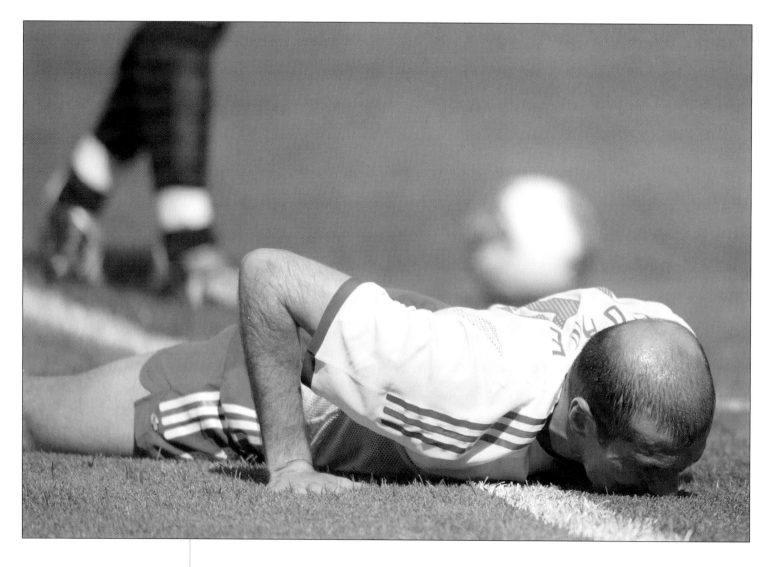

Zidane lies prostrate
11 June 2002

Jerry Lampen

In 1998, Zinedine Zidane was indisputably the player of the World Cup, capping his tournament with two goals in France's 3–0 win over Brazil in the final before an ecstatic Parisian crowd. Four years later at the 2002 World Cup, events could hardly have turned out worse for both Zidane and his team.

A torn left thigh muscle meant he was not fit for the opening match against Senegal or the following match against Uruguay. With France still goalless it was clear that Zidane would finally take the field against Denmark, even if he needed crutches.

Despite some delightful touches, he was clearly well short of full match fitness and was unable to prevent the Danes from taking a decisive 2–0 victory. France became the first defending champions to leave a World Cup without winning a game or scoring a goal.

An abandonned test match cricket pitch

29 January 1998

Kieran Doherty

Four men appraise a red earth mosaic masquerading as a cricket pitch. In unprecedented circumstances, the first test between West Indies and England was called off because the pitch was simply too dangerous.

England opted to bat at Sabina Park in Kingston because captain Michael Atherton believed the pitch could only get worse, but after three quick wickets had fallen it was apparent that a serious injury was only a matter of time. Alec Stewart was hit three times before umpires decided the match could not continue and after only 56 minutes the test was over. Sixty-one balls were bowled making it the shortest test on record.

The International Cricket Council decided the test should count as an official international but took steps to ensure such a situation never happened again. 'I saw these four Brits inspecting the cracked pitch but had to wait a couple of minutes before other people's shadows moved away to take this shot,' Kieran said.

Barrichello throws
up spray
14 July 2001

Ian Waldie

Brazilian Ferrari driver Rubens Barrichello powers along the home straight in the wet on the second day of practice for the 2001 British Grand Prix at Silverstone. Barrichello finished the season in third place in the drivers' championship.

Barrichello was embroiled in controversy at the 2002 Austrian Grand Prix when his team ordered him to slow down over the final metres to allow defending world champion Michael Schumacher to win. As spectators booed and jeered, the drivers switched positions on the podium and Schumacher insisted his team mate take the trophy.

Ferrari and the two drivers were fined a million dollars but escaped any further sanctions. Later in the season Schumacher was ordered to stay behind Barrichello in another Ferrari one–two at the Nuerburgring Grand Prix.

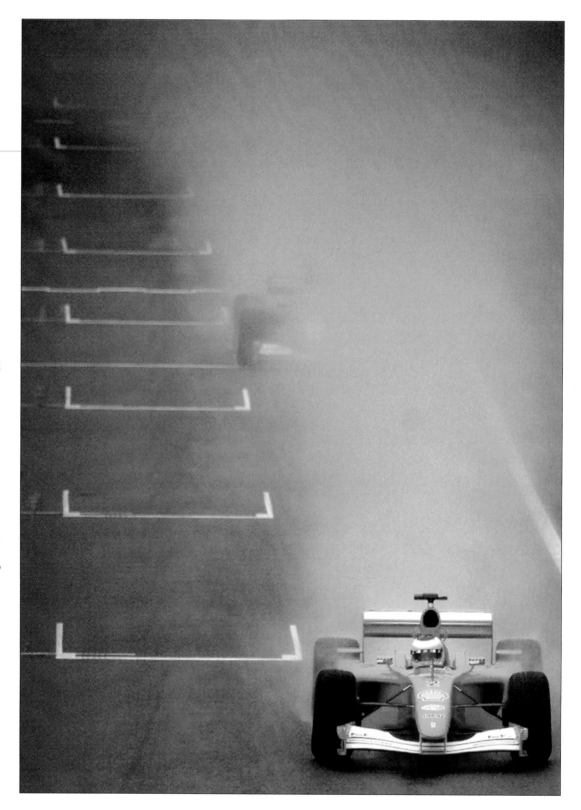

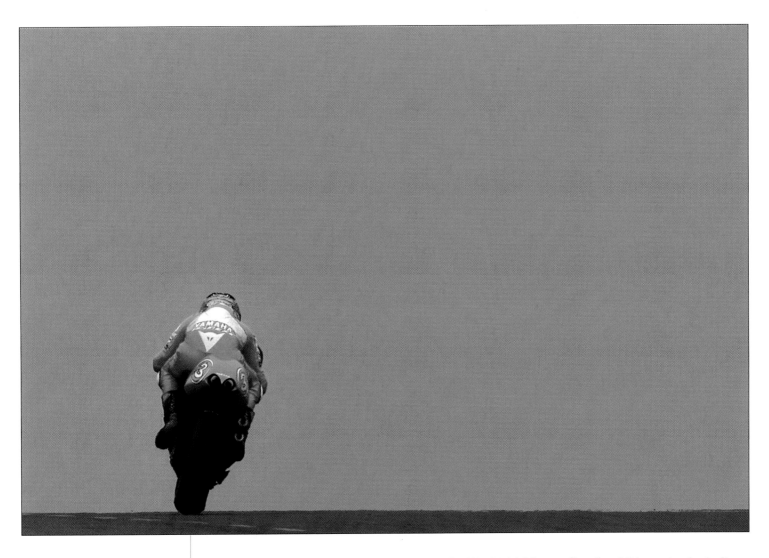

Biaggi crests a rise
7 July 2001

John Pryke

John Pryke had all the background he needed at the 2001 British Motorcycling Grand Prix: a grim, foreboding sky at the Donnington Park circuit. Accordingly he lined up his camera on the Melbourne hairpin and waited for the appropriate image. Over the rise came former 250-cc champion Max Biaggi astride a 500-cc Yamaha and John had his picture.

'I like the almost lonely feel of the picture which goes along nicely with the form slump that Biaggi had been going through at the time,' John said.

Motorcycling, which attracts a specialized but impressive spectator support, exploded in popularity during the late 1950s when the flourishing Japanse industry, headed by Honda, launched a worldwide sales promotion. Honda took command of 250-cc racing before other companies realized the publicity potential. After that the sport soon became truly international.

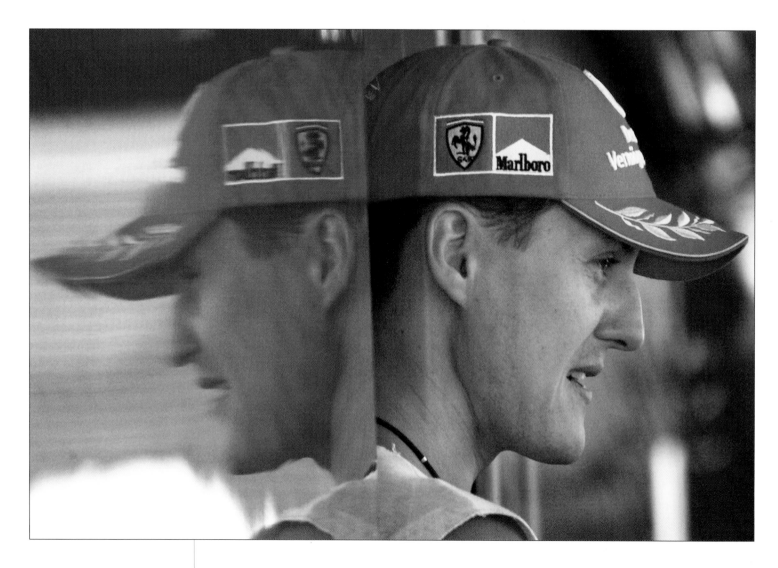

The faces of Schumacher
19 August 2001

Balazs Gardi

The ultimate nightmare for any Formula One driver: competing against two Michael Schumachers. Balazs obtained this unusual shot of the outstanding Formula One driver's reflection in the Ferrari motor home before the 2001 Hungarian Grand Prix.

Schumacher gave Balazs an early break at the 1996 Hungarian Grand Prix when he dropped out with just a few laps to go.

'At the time I was a rookie without an official accreditation so I skipped over the fence to get close to the track,' he said. 'Before the race Laszlo Balogh, the Hungarian Reuters photographer, asked me whether I could stay in a special corner of the track.

'That was a really boring place to stay, maybe that's why I was the only photographer there when Michael Schumacher dropped out just a few laps from the end of the race from the leading position. I shot a few frames and went back to the office where everybody was nervous because none of them had the shot. I can clearly remember that all the other photographers were really concerned and that they all wanted to buy a few frames.'

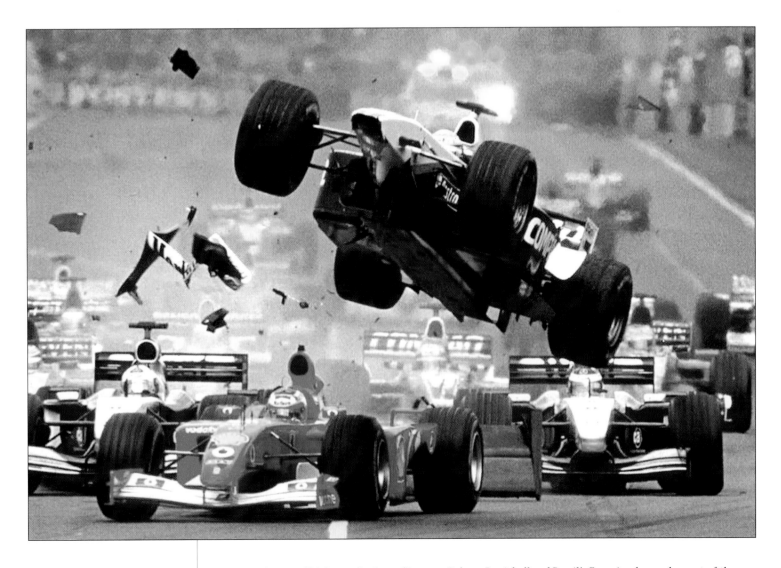

Ralf Schumacher crashes out in Melbourne
3 March 2002

Joe Mann

Williams driver Ralf Schumacher's car flies over Rubens Barrichello of Brazil's Ferrari as he crashes out of the Australian Formula One Grand Prix in Melbourne in 2002.

Joe said: 'I was assigned to cover the start of the race from the grandstand at the end of the first straight. As the cars slowed to make the very first right hand turn I started to shoot. I saw Ralf Schumacher's car just taking off over the other vehicles so I kept my finger on the button.

'I wasn't sure what I had until the film came back a long two hours later. Needless to say I was really excited when I saw the results.'

Ralf's brother Michael Schumacher went on to win the race ahead of Montoya and Raikkonen.

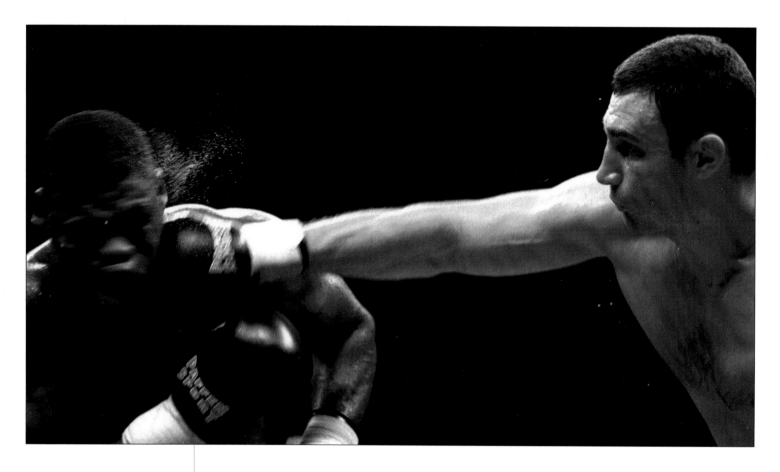

A jolting right hand
11 December 1999

Christian Charisius

World Boxing Organization (WBO) champion Vitali Klitscko lands a solid right on the jaw of American Obed O'Sullivan during a world title fight in Hamburg. Klitscko stopped Sullivan in the 10th round.

Although Klitscko is a good fighter and perfectly entitled to call himself a world champion, in reality the WBO title is practically meaningless, as is the International Boxing Federation version. In the chaotic world of professional boxing, the two titles generally accepted as having validity are the World Boxing Council and World Boxing Association belts.

Super-cool Lewis
13 July 2000

Ian Waldie

Cool, remote and in control. Lennox Lewis removes his sunglasses at the official weigh-in for his World Boxing Council and International Boxing Federation defences against South African Frans Botha.

Lewis predictably disposed of Botha, as he did all but two of his opponents before his career-defining fight against Mike Tyson. When roused, Lewis could be brutal. But mostly, in keeping with his well-publicized love of chess, he was content to out-think and outpoint his opponents, keeping them at bay with a probing left hand. Lewis had struggled to gain the respect of the fight fraternity in the US with sceptical Americans pointing to his two professional defeats, results of underestimating his opponents and neglecting his defence.

Lewis was born in London's East End to Jamaican parents but won an Olympic gold medal for Canada. His supporters argue that he was truly a world-class fighter in a devalued category who would have been a success in any era and history is likely to vindicate the pro-Lewis camp.

Lewis defeated Evander Holyfield, the man who demolished Tyson, and went on himself to destroy Tyson and the myth surrounding the ravaged former champion in 2002. Even the sceptical Americans agreed that although Lewis might not rank with Jack Johnson, Jack Dempsey, Joe Louis and Muhammad Ali, he was equal to any other heavyweight champion in history and unquestionably the best of his era.

Australians and Chinese share the pool
29 September 2000

Blake Sell

Synchronized swimming strains the crediblity as an Olympic sport, although its defenders argue that it is more physically demanding than activities such as shooting or dressage.

The sport was introduced to the Olympics at the 1984 Los Angeles Games with a solo and duet event. Both were dropped after the 1992 Barcelona Games and replaced by a team event with eight swimmers on each team. A technical routine accounts for 35 per cent of the total score and a free routine for the remaining 65 per cent.

During the 2000 Sydney Olympics Blake tried successfully for a different view from the standard photographs by going underwater. 'The opportunity for this picture was provided by small viewing holes placed about two metres above the surface of the pool,' he said. 'Technically getting any sort of image was a challenge and, frankly, a bit of luck. The thick window cast a yellow haze across the image and the water, though clear to the eye, appears very murky on film.' Blake said he had been wondering whether he had been wasting his time when the Chinese team came into the pool at the end of the Australian practice session.

'It was all just a jumble of shapes and stirred up water until the two teams crossed,' he said. 'I knew the moment I pressed the shutter button that this was going to be my picture. So much about sports photography is luck. But to take advantage of that luck, first you have to know where to be.'

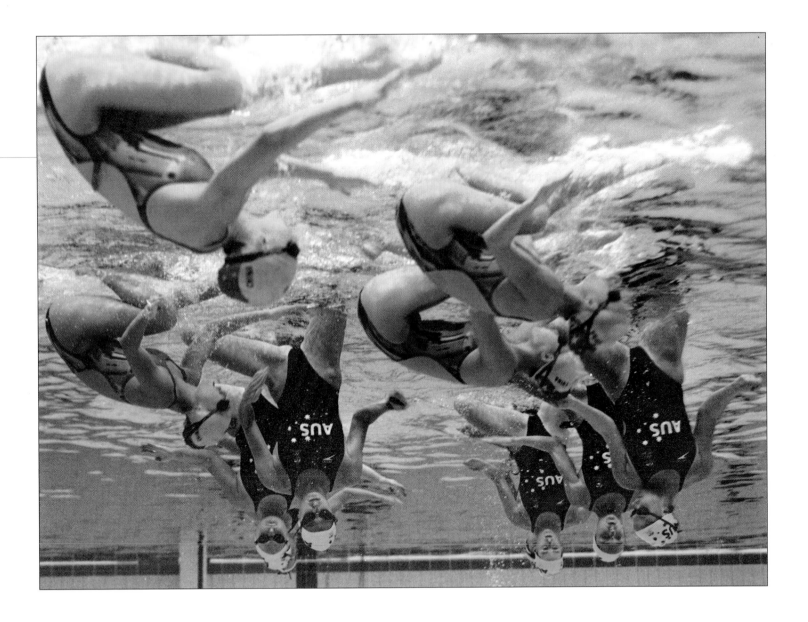

A horse does the splits
29 September 2000

Jim Hollander

American rider Susan Blinks rides Flim Flam in the dressage competition at the 2000 Sydney Olympics. David Wallechinsky, chronicler of the modern Olympics, has commented acerbically: 'Unless knitting is added to the Olympic programme, dressage will remain the least action-packed of Olympic events.'

Against this unpromising background, Jim has extracted a memorable photograph of a horse going through a series of pre-arranged movements at the rider's command.

'In most sports photography one looks for those moments that might reveal some aspect of a sport which is hardly seen, seen but not recognized, or even at times never seen. Still photography with its high shutter speeds is the best vehicle or medium to capture these nuances,' he said.

'In the equestrian dressage events the horse is as much a competitor as the rider and men and women compete in the same events. The horse must cross a field and change their gaits at certain specific points.

'It is elegance on four legs, sometimes set to music scores, and I was captivated trying to capture the instant of changing gaits. In this photograph, the flick of the horse's tail adds movement to the photo and the placement of the two judges at the far end of the field, along with the judging stand's upright bars, adds an unexpected element to the composition which I think makes the photo stand out.'

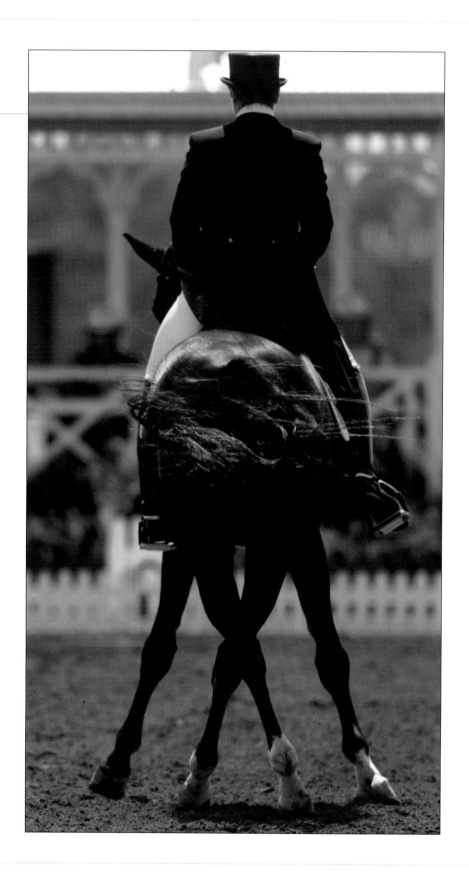

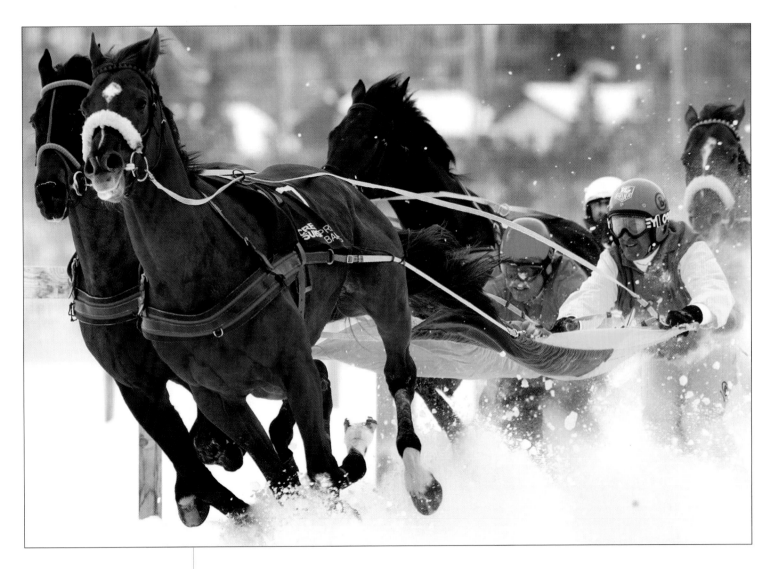

St Moritz skjoering race
10 February 2002

Andy Mettler

Thundering hooves, flying snow, bright sunshine and colourful clothing. Nine men and nine horses race over the frozen lake at the Swiss resort of St Moritz.

'It is a challenge for all photographers because horse races are fast and sometimes dangerous,' said Andy, 'but the white turf in St Moritz is a fascinating event because a photographer finds such a rich selection of excellent features.'

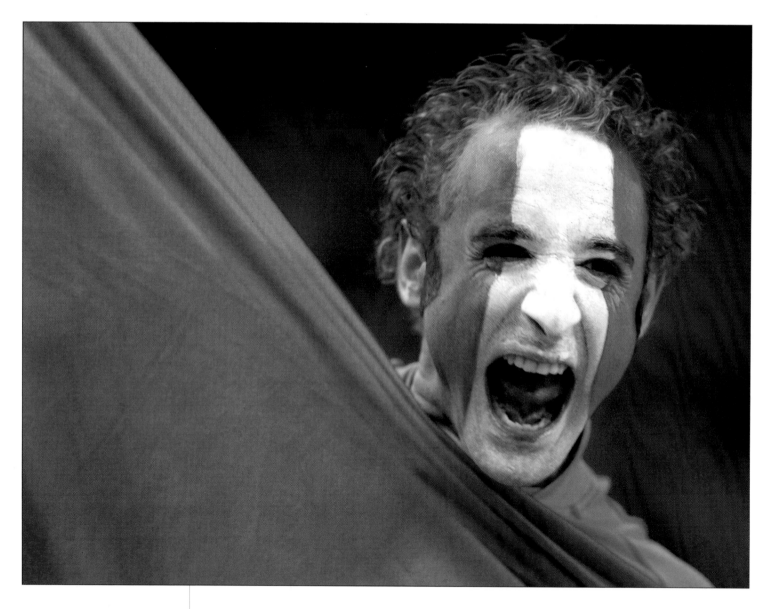

Pre-match excitement
3 June 2002

Paolo Cocco

An Italy fan cheers for his team before their opening 2–0 victory against Ecuador at the 2002 World Cup. Italy's composure and skill made them one of the early favourites, but they were to become another of the European giants to make an early exit.

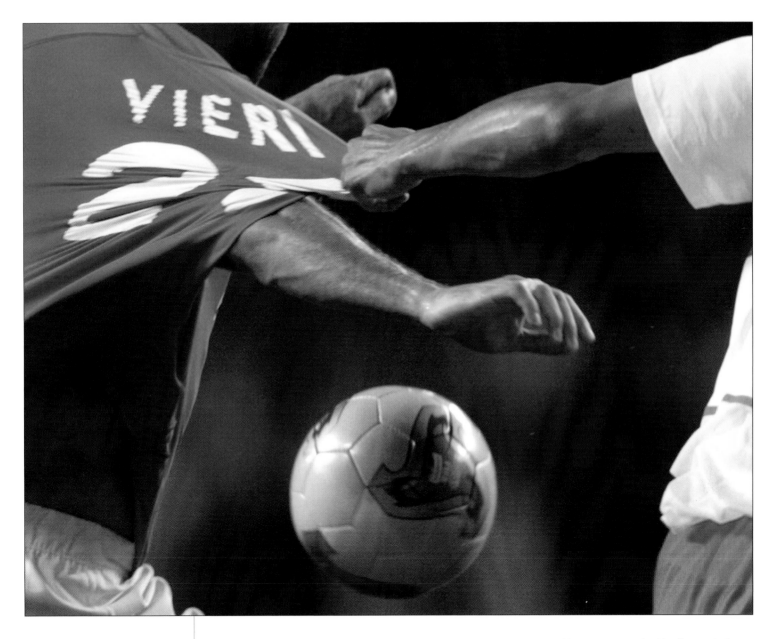

**Shirt-pulling,
South Korea vs Italy**
18 June 2002

Desmond Boylan

South Korean elation at their 2–1 second-round victory in the 2002 World Cup was matched by fury in Italy at the standard of refereeing decisions after the Italians controversially had one man sent off and a goal disallowed for offside.

Italians accused Korea of stealing the game. The state radio broadcaster RAI's commentator Bruno Pizzul was disgusted, saying, 'that was robbery,' and his anger was shared at all levels of Italian society, with Italy's Minister for Public Office Franco Frattini adding, 'The referee was a disgrace, absolutely scandalous. I've never seen a game like it.' The backlash even extended as far as Perugia threatening to sack Ahn Jung-hwan, the South Korean goalscorer, for betraying his Italian club.

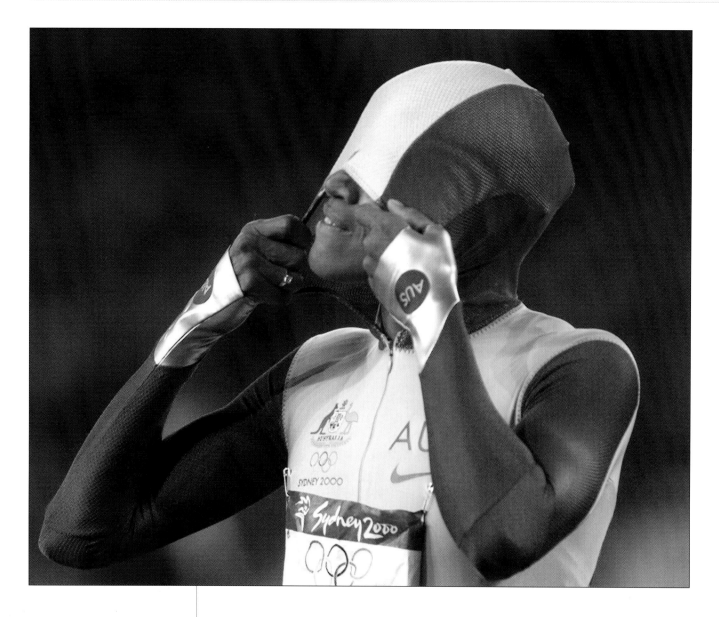

Freeman after winning gold
25 September 2000

Ian Waldie

Cathy Freeman emerges from her futuristic body suit after winning the women's 400 metres title for Australia at the 2000 Sydney Olympics. Freeman emerged triumphant from the suffocating pressure imposed by her compatriots to give Australia the track medal the nation so desperately needed at the first Olympics of the 21st century.

Not only Australians were moved when Freeman emerged to light the Olympic flame at a stunning opening ceremony, an emotive symbol of progress towards reconciliation between the European settlers and the dispossessed Aboriginal inhabitants.

Anything less than victory would have been regarded as a failure whatever the circumstances, but fortuitously for Freeman, her only serious rival, Guadaloupe-born Frenchwoman Marie-Jose Perec, had fled the country in mysterious circumstances. Happily for the home crowd who packed the stadium on an electric evening, Freeman delivered with victory in 49.11 seconds. She became the first Aboriginal to win an Olympic track title.

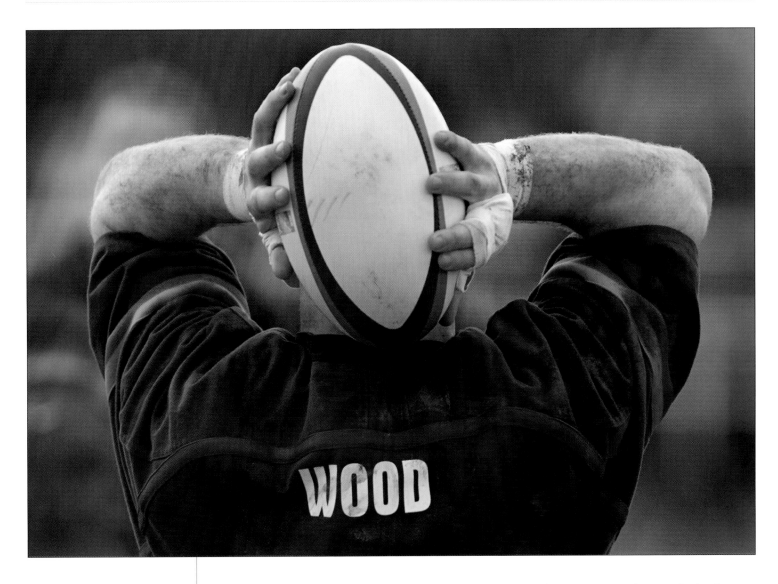

**Keith Wood takes
lineout practice**
1 February 2000

Ferran Paredes

Ireland captain Keith Wood throws into the lineout during practice for an international against England.

'Keith Wood is one of the most charismatic players in today's rugby,' said Ferran. 'I was drawn to two shapes: the oval rugby ball and Wood's head. During a training session I finally managed to match his head with the ball. He was about to throw the ball into a lineout which makes it look like he is holding his "new" head in his hands.'

Whether playing for Ireland or the British Lions, Wood engages the spectators' emotions. Heedless of personal safety, he hurls himself into the fray at severe cost to a battered body and has consequently sustained frequent injuries which have led to lengthy absences.

Wood is more than just a human battering ram. He is generally regarded as the world's best hooker, a specialist position demanding the presence to command the private battle of the front row and the ability to throw the ball with pinpoint accuracy into the lineout. In the loose, where a front row forward was once never expected to shine, Wood possesses a startling burst of speed, a nose for the tryline and ball skills worthy of an international centre. As yet his occasional drop kicks threaten the opponents' ankles rather than the cross bar but no one would bet against him dropping a goal before his international career ends.

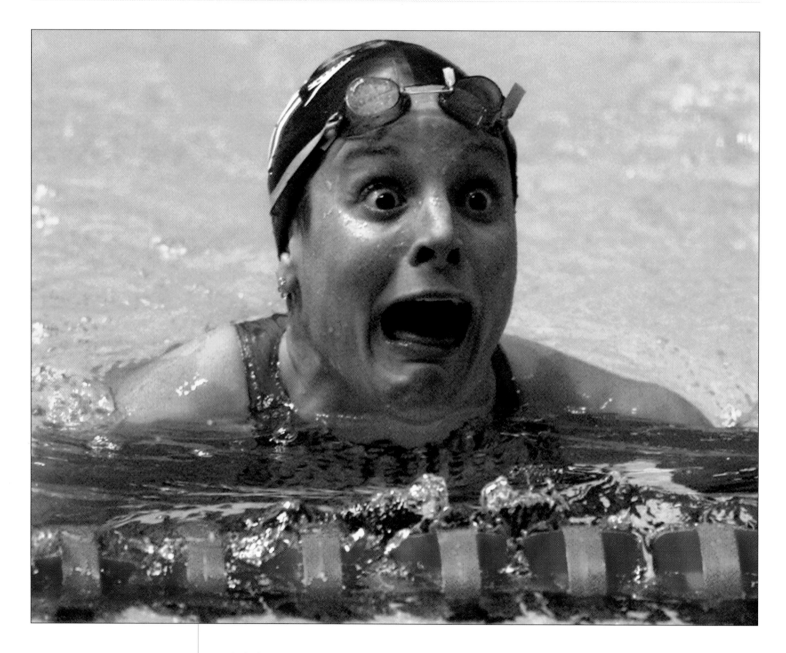

Benko sets a world record
7 April 2002

Alexander Demianchuk

Disbelief turns to elation as Lindsay Benko of the USA realizes she has won the women's 200 metres gold medal and also broken the world record at the world short-course championships in Moscow.

Swimming ranks second only to athletics at the Olympic Games, attracting most of the media attention before the track and field competition gets under way. Outside the games however, it still struggles for recognition.

Collina warms up
17 June 2000

Pawel Kopczynski

Instantly recognizable to soccer fans throughout the world, Italian referee Pierluigi Collina warms up before the 2000 European championship match between England and Germany in Charleroi. 'It was an unusual scene as Collina warmed up for more than an hour,' commented Pawel. 'His face was full of expression, showing the unique character that has made him a favourite of fans from many competing nations.'

Collina was given charge of the equally emotion-charged group match between England and Argentina at the 2002 World Cup and received the ultimate accolade when he was entrusted with the final between Brazil and Germany.

A multilingual financial consultant with a degree in economics, Collina is a distinctive figure with his bald head, intense grey-blue eyes and commanding presence. As a teenager he started refereeing his team mates' practice matches while recovering from injury, moved through the divisions, and acquired an early nickname of Kojak after the bald American television detective played by Telly Savalas.

A kayaker rides wild water
28 March 2002

Petr Josek

Curiosity and persistence enabled Petr Josek to capture this image of a kayaker riding wild spring water on the Vltava weir, swollen by the melting mountain snows, in central Prague.

'I saw this picture one day on my way home,' said Petr. 'But this guy in a strange-looking kayak was on the other side of the river and by the time I got there he was gone. The next day I came back again. He was not there.

'I was trying to find some spot from where I could see the famous Charles Bridge in the background, or somehow show the city in case he came back. Time was passing and it was already quite late when he showed up. I knelt and started to shoot, trying to get some nice background in the picture. Then I looked back and saw the waves behind him. It was not the Charles Bridge – but they didn't make a bad background either.'

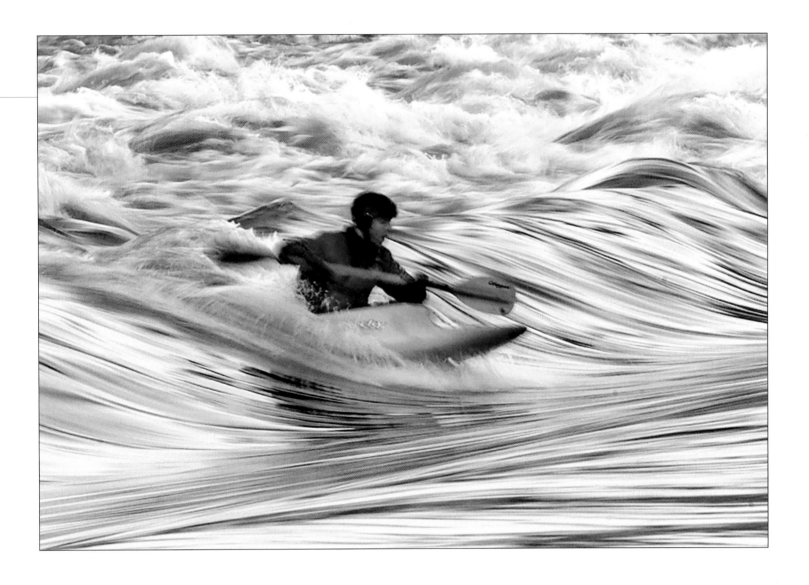

Olympic team épée final
19 September 2000

Jason Reed

Oxana Ermakova from Russia and Sophie Lamon of Switzerland form a mirror image in the final of the women's team épée event at the 2000 Sydney Olympics. Jason said that throughout the day all the pictures had started to look the same with the competitors lunging, retreating and diving their way to victory.

'As the competition hots up, more risks are taken and for the first and only time I had seen that day, both competitors in this gold medal final lunged towards each other and the result was this symmetrical image,' he said. 'The Russian took the gold medal.'

Olympic fencing bears little resemblance to the flashy pyrotechnics beloved of Hollywood but has a fascination all of its own. The Persians, Egyptians, Greeks and Romans practised fencing in peace as well as war and schools designed to teach the essential skill proliferated throughout Europe after the 14th century.

The Italians developed the art of using the point of the sword rather than the blade and rapier fencing placed the emphasis on quickness of thought and hand rather than brute force. The épée is one of three swords used in fencing and is distinguished by a triangular blade with a blunt point. Both the point and the cutting edges can be used to score touches, signalled as in the foil and sabre competitions by a wire on the implement which records a hit with a flashing light and a buzzer.

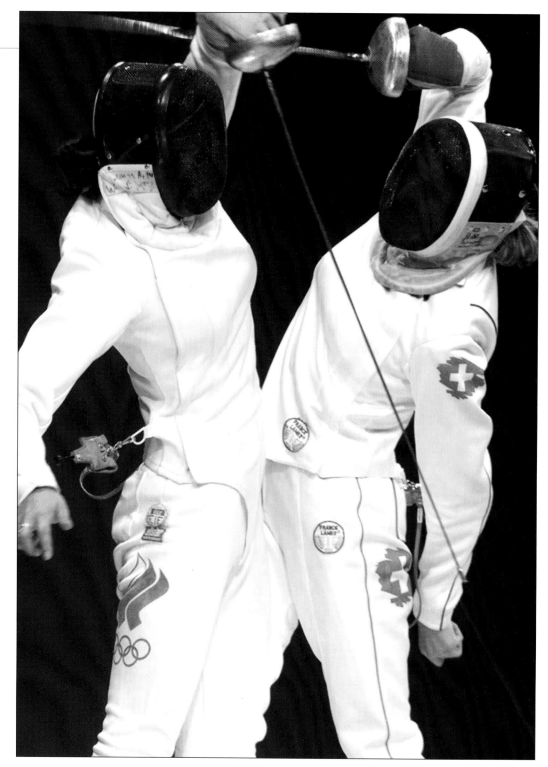

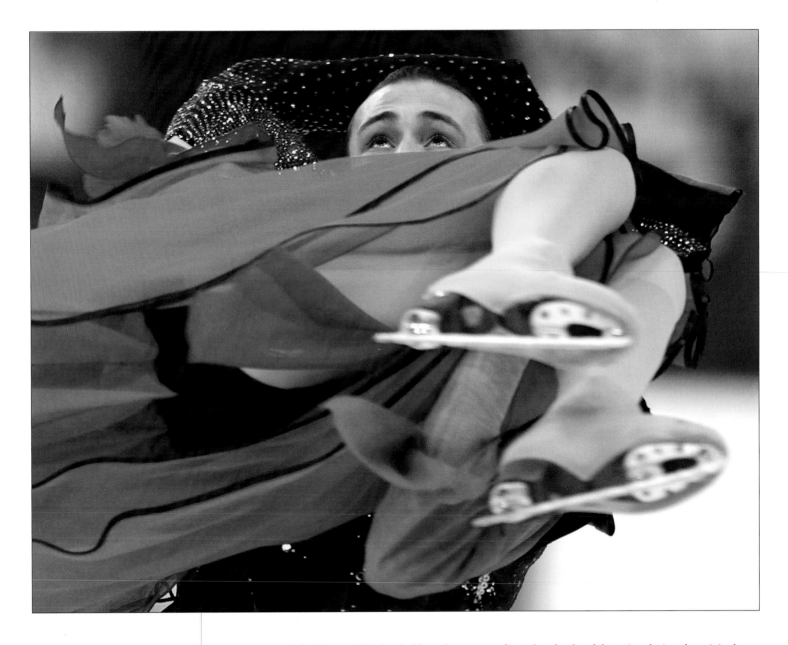

Original ice dance
17 January 2002

Dominique Favre

Russians Irina Lobachva and Ilia Averbukh perform a complicated and colourful routine during the original dance at the 2002 European figure-skating championships in Lausanne. This close shot captures the essence of the discipline and the symbiotic interaction between the pair.

A spectacular Vassell goal
13 February 2002

Paul Vreeker

England's Darius Vassell equalizes with a bicycle kick at the expense of startled Dutch goalkeeper Edwin van der Sar who looks as if he is facing a bullet rather than a ball in a friendly before the 2002 World Cup.

Rarely does a photograph capture the emotions of attack and defence as well as here, where the impact of Vassell's audacious slot is etched on the keeper's face. This Holland vs England match was Vassell's England debut and ended in a draw.

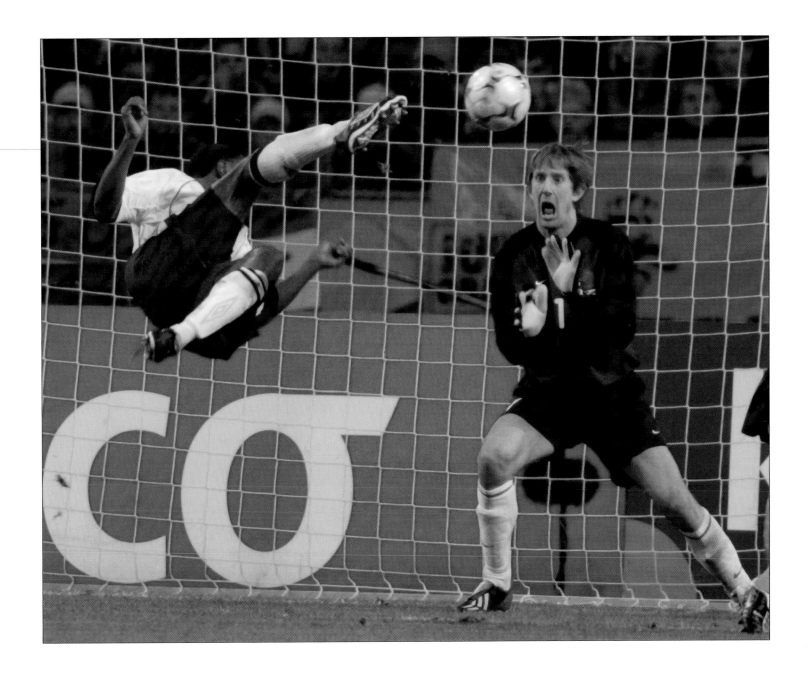

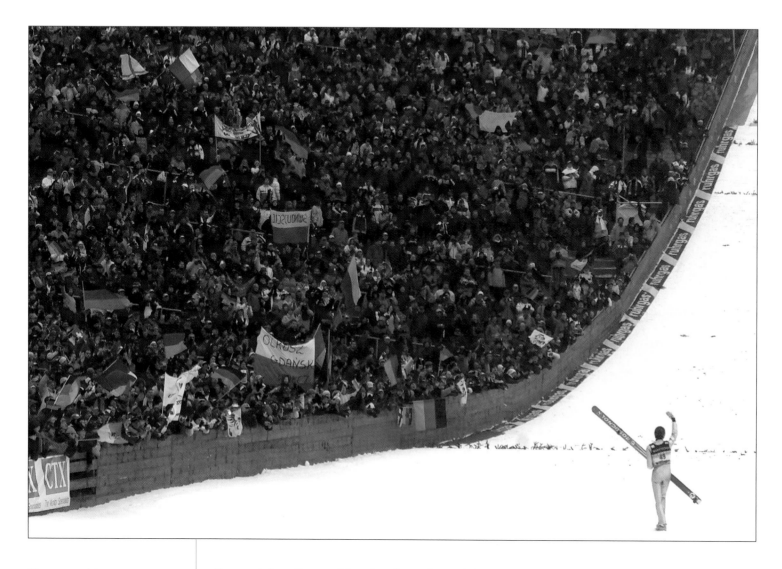

**Hannawald
acknowledges applause**
12 January 2002

Kai Pfaffenbach

Germany's Sven Hannawald receives the applause of thousands of spectators after his victory in the ski-jumping World Cup in Willingen.

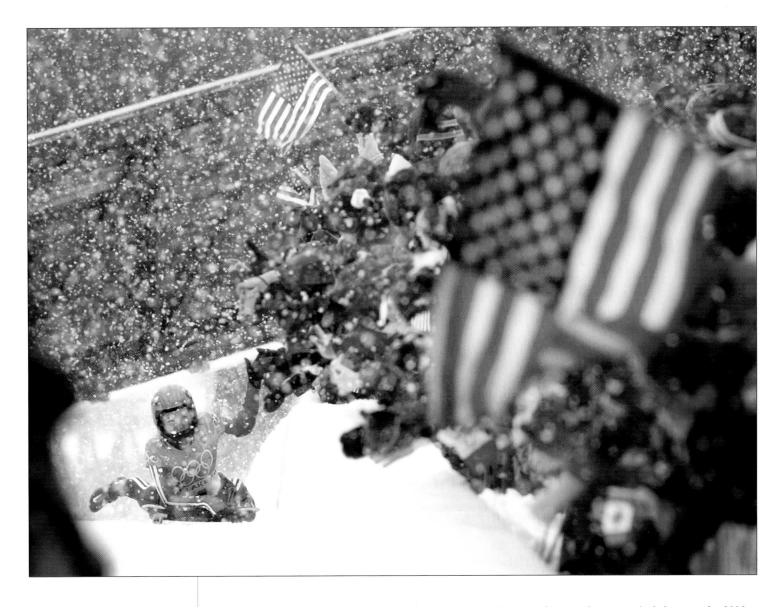

**Gale celebrates
with fans**
20 February 2002

Dan Chung

American Tristan Gale celebrates with fans after finishing the second run in the women's skeleton at the 2002 Salt Lake City Olympics. Gale won the gold medal in the first Olympic women's skeleton event, in which competitors hurtle down a steep slope on little more than a metal frame.

'The hardest thing about taking this picture was coping with the ice-cold conditions,' said Dan. 'I had layers and layers of thermal clothing as well as hand and toe-warming pads but still managed to feel the cold because of all the standing in a fixed spot. Keeping your camera working in the cold is also hard, requiring extra supplies of batteries and lens-cleaning cloths for all the snow.

'Because of our close proximity to the track we also had to be very careful so as not to drop anything into the path of the athletes that might injure them. When the finalists started, the crowd went wild, cheering on the American athletes. 'There were so many flags and banners it was sometimes difficult to see the competitors coming. The only way to know when they were coming was to watch the big-screen televisions showing live commentary. When you saw the competitor at a certain place, then you knew to get ready.'

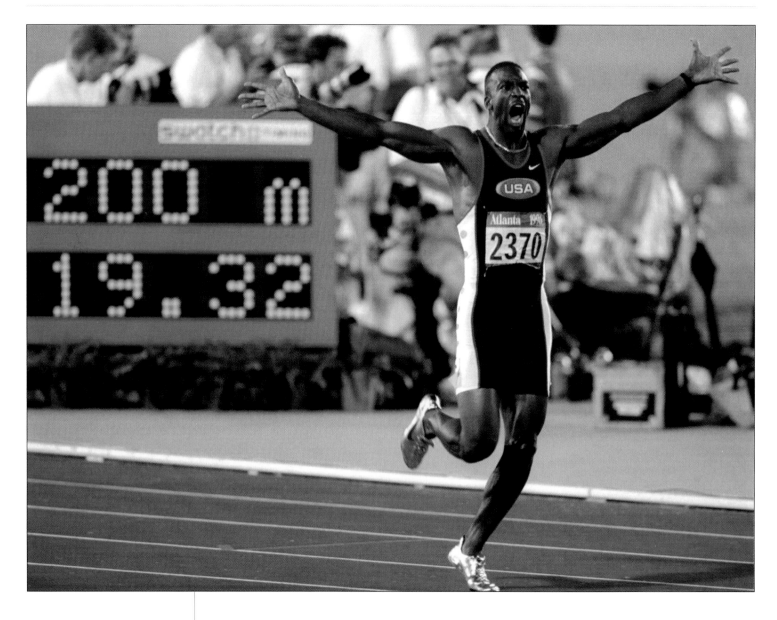

Johnson shatters the world record
1 August 1996

Mike Blake

Michael Johnson emits an enormous roar of unrestrained euphoria as he clocks 19.32 seconds to shatter his own world 200 metres record by nearly a third of a second at the 1996 Atlanta Olympics.

Statisticians had estimated that 200 metres would eventually be run in this time, but according to the graph of human improvement, such a time should only have been possible by 2020.

Johnson was indisputably the athlete of the 1996 Games, becoming the first male to complete the 200–400 double and taking the 200 record beyond reach for, if the statisticians are correct, a further 24 years. His distinctive upright style, with back ramrod straight and little leg lift, was reminiscent of the more fluid Jesse Owens, who won four gold medals at the 1936 Berlin Olympics, and he dominated his two distances for the best part of 10 years.

Before retiring after the 2000 Sydney Olympics, Johnson also broke the world 400 mark. Yet as one of his sport's great perfectionists, he did not believe he had run the perfect race in Atlanta. Later he recalled there had been a stumble early in the race, 'the briefest shudder, step three to be exact. Imperceptible to anyone but me.'

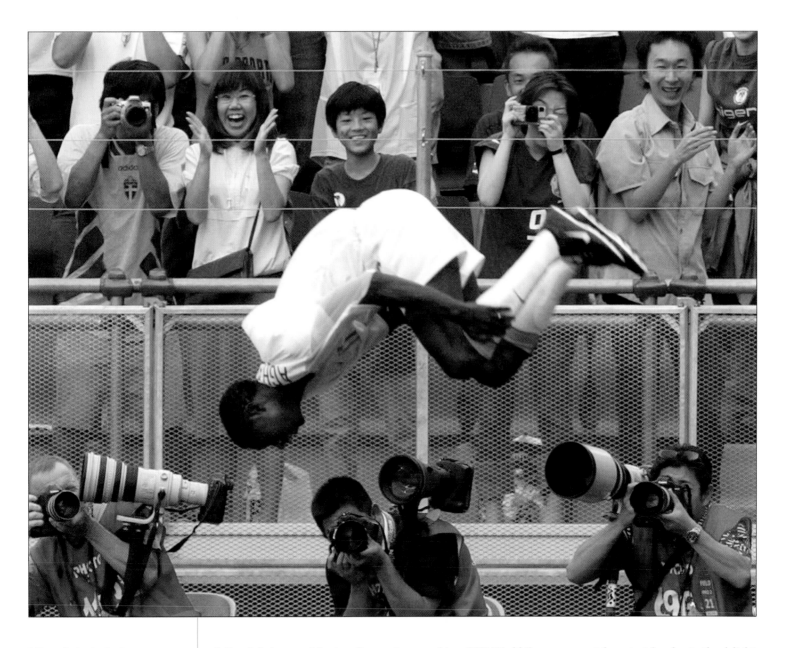

Nigeria's Aghahowa celebrates a goal
7 June 2002

Pawel Kopczynski

Julius Aghahowa celebrates after scoring a goal in a 2002 World Cup group match against Sweden to the delight of the crowd behind him.

The African nations, spearheaded this time by debutants Senegal, again supplied exuberance and originality to the Cup without upsetting the established order. Despite Aghahowa's efforts, Nigeria lost 2–1 to Sweden and left after the first round. Senegal made it as far as the quarter-finals before losing to Turkey.

A kite-surfer in Sydney
6 December 2000

David Gray

A kite-surfer loses his footing from the surface of his board as he is pulled through the air over Sydney's Botany Bay. The surfers hold on to a bar attached to a kite ranging from between 5 and 16 metres in width which, depending on the wind, can pull the surfers more than 20 metres into the air at speeds of more than 50 knots.

'This picture was taken when I was driving around the shores of Botany Bay trying to find an interesting picture for the day,' said David.

'I was driving along when, all of a sudden from above, a shadow flew across the bonnet of the car. I looked out towards the bay and saw about three kite-surfers screaming along and periodically lifting themselves high into the air.

'It was late in the afternoon, with the wind at its strongest when I captured this silhouette picture of one of the surfers being dragged at least 25 feet [seven metres] into the air. I had to run up and down the beach, frantically trying to get the right angle, and keeping the sand out of my equipment and camera bag was extremely difficult.'

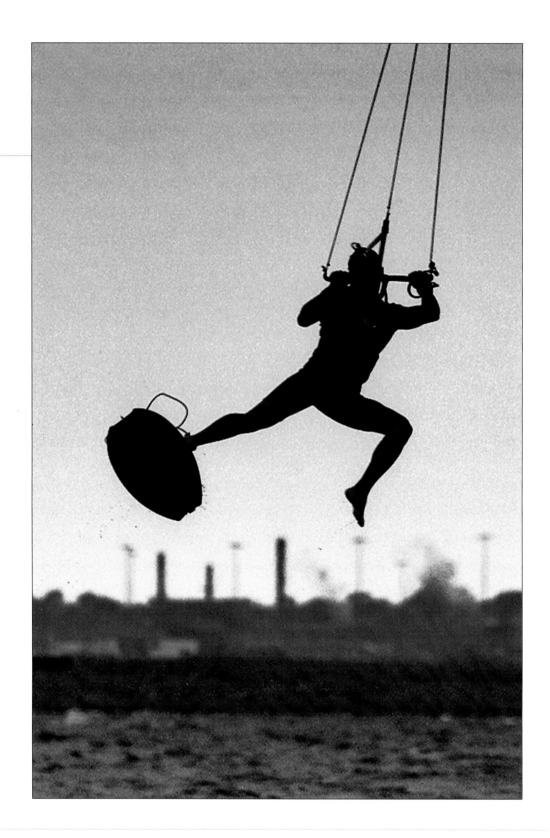

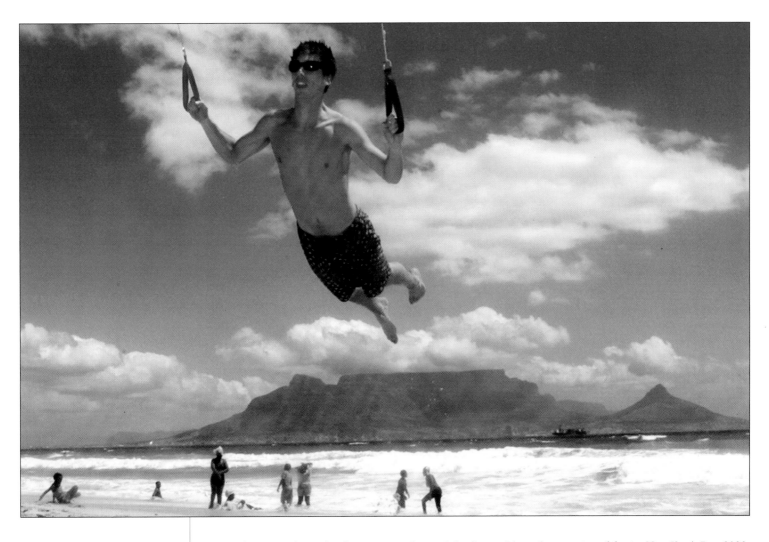

Power-kiting in South Africa

1 January 2002

Mike Hutchings

A British tourist, drawn by the warm weather and the favourable exchange rate, celebrates New Year's Day 2002 by power-kiting on Blouberg beach near Cape Town. Table Mountain is in the background of one of South Africa's most attractive areas.

'I did not really anticipate a sporting picture when I went out to look for a New Years' feature picture at Blouberg beach,' said Mike. 'But when I looked across the bay and saw these guys making their spectacular leaps across the beach it just looked so much fun.

'The city's strong south-easterly winds and warm sunny beaches have made the sport, which sometimes combines kiting and surfing, extremely popular at Blouberg. It also helped to illustrate an economic story too with the city receiving a record three million visitors following the sharp fall in the value of the Rand.'

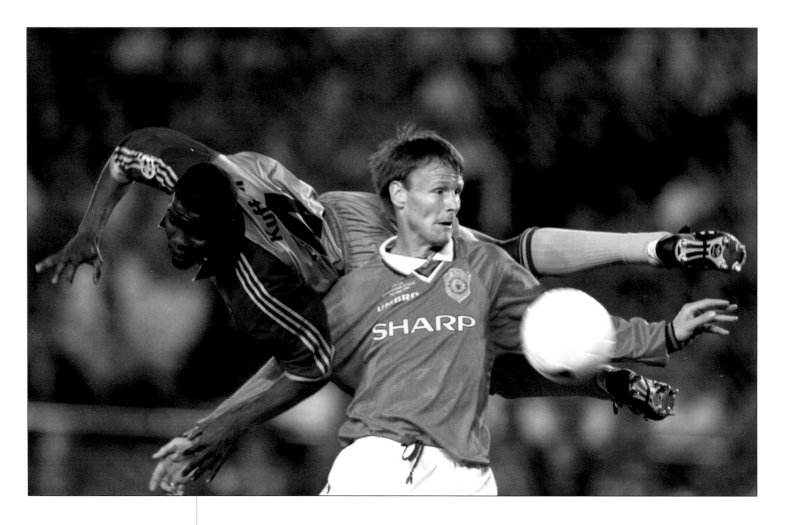

Sheringham and Kuffour challenge for the ball
26 May 1999

Jose Manuel Ribeiro

Manchester United's Teddy Sheringham tussles with Bayern Munich's Samuel Kuffour during the European Cup final at Barcelona's Nou Camp stadium.

With United trailing 1–0 deep in injury time, substitute Sheringham equalized. Another substitute Ole Gunnar Solskjaer scored the winning goal to complete an historic treble. United had already won the English premiership and FA Cup that season but the European Cup had eluded them since 1968.

'It was my first time working for Reuters with a large team of colleagues,' said Jose Manuel. 'As always in new situations many things are beyond your knowledge or control and I was only confident by the second half of the match. Fortunately at the end of the match I captured this picture. These guys were the key players in the match.'

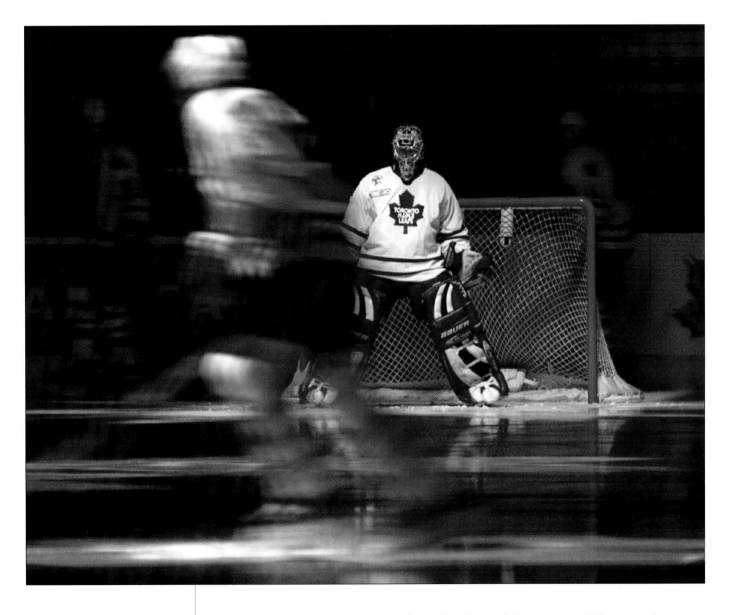

Goalie in the spotlight
5 April 2000

Andy Clark

Toronto Maple Leafs' goalie Curtis Joseph stands in the spotlight prior to an NHL game against Montreal.

'Prior to every home game of the Toronto Maple Leafs, the lights are turned off and spotlights used to highlight team goalie Curtis Joseph while the remaining players warm up,' said Andy.

'Shooting with a long lens and a slow shutter speed from the opposite end of the rink I tried to capture what looks to me like a moment from a fashion show.'

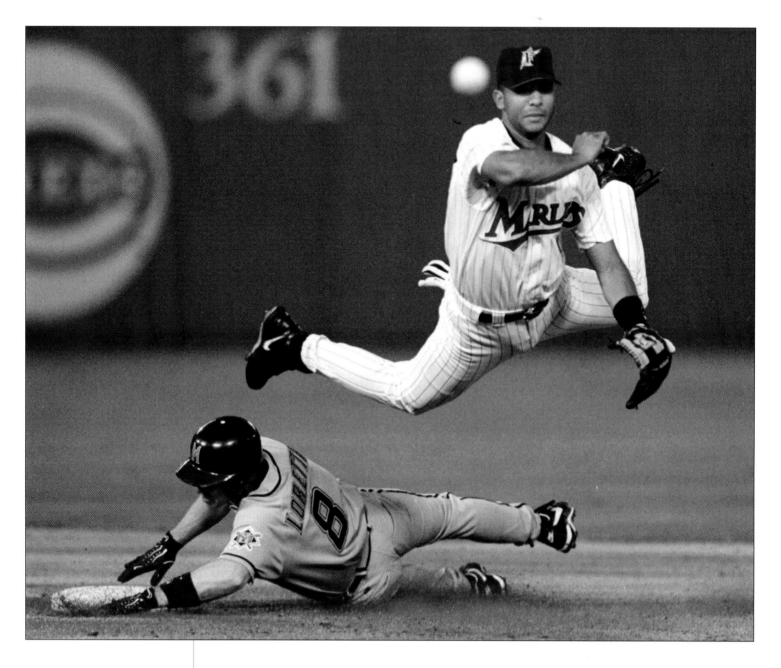

Shortstop leads during a double play
3 May 1999

Colin Braley

Florida Marlins' shortstop Alex Gonzalez soars over sliding Milwaukee Brewers' Mark Loretta. Loretta foils this third inning double play by delaying Gonzalez's throw to first.

Garcia follows his shot
20 August 2000

Scott Olson

Spaniard Sergio Garcia, leaps into the air to see his shot after hitting from behind a tree on the 13th hole during the final round of the 2000 PGA championship. Garcia finished a stroke behind Tiger Woods.

'Although Woods won the tournament, the young, brash Garcia's outstanding play and charismatic personality made him a huge story after the tournament,' said Scott. 'When this shot was taken there were few photographers on the same side of the fairway and fewer still captured this leap.

'The day had begun badly for Garcia but he began to close the gap on the back nine through two good shots of his own and two indifferent ones from Woods. On this hole Garcia had put his tee shot behind a tree on the edge of the fairway,' said Scott.

'He was shooting in an awkward position around the back of the tree. The ball needed to travel over a slight hill towards the green. When he connected with the ball, I think he knew he had hit a great shot but with the hill in the way he couldn't follow the ball's flight path so he began running towards the centre of the fairway straight towards me trying to keep the ball in sight.

'As the ball dropped he leapt into the air to see over the hill. The ball landed on the green, allowing him to save par.'

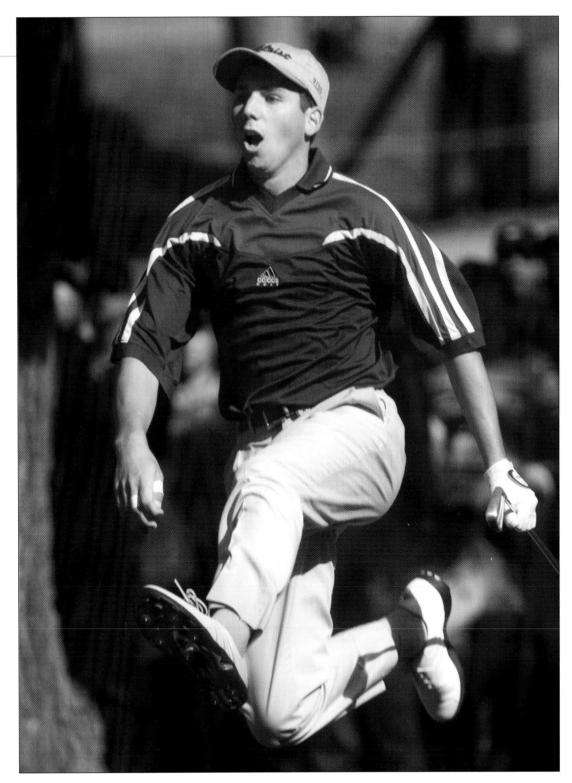

An Olympic weightlifter celebrates
18 September 2000

Oleg Popov

Australian Megan Warthold releases her pent-up emotions after hoisting 100 kg in the women's weightlifting at the 2000 Sydney Olympics.

On the surface, weightlifting should be one of the less interesting Olympic events. In reality, it can be one of the more dramatic as the athletes focus their physical and mental powers on lifting an apparently immovable object.

Weightlifting taps into folk memories of legendary sportspeople. Massive boulders inscribed with the names of the athletes who lifted them have been found in ancient Greece. A huge stone weighing 181 kg rests in the courtyard of the Munich Apothekerhof castle with a sign testifying that Duke Christopher of Bavaria lifted and threw it in 1490. Bar-bells and dumb-bells were a popular feature of circus and music-hall acts in the 19th century.

Modern weightlifting has been affected by illegal drug use to promote strength. In an effort to make a clean break, the International Weightlifting Federation wiped out all world records and started afresh with new categories after the 1992 Barcelona Olympics.

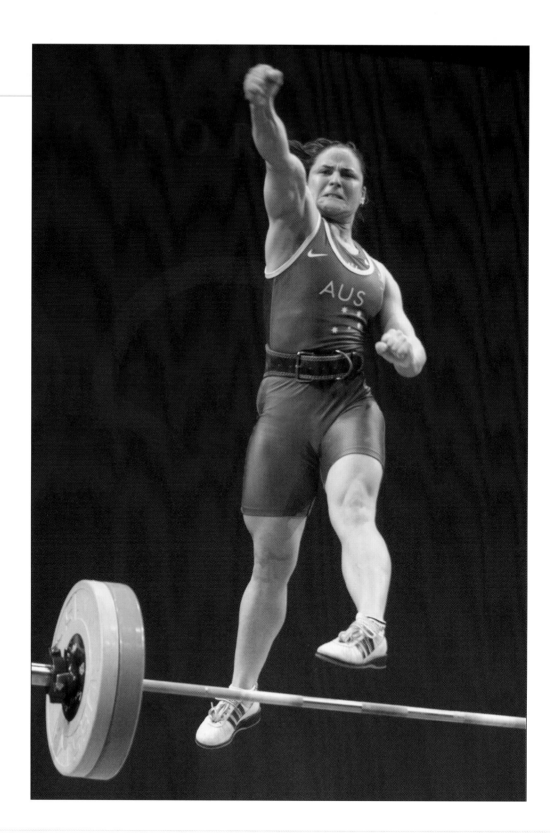

Australian cricketer celebrates a runout

24 March 2001

Anne Laing

Andy Bichel celebrates after running out South Africa captain Shaun Pollock in a one-day international at Super Sport Park in Pretoria. One-day cricket came of age during the 1977–78 and 1978–79 seasons in Australia when media tycoon Kerry Packer, frustrated at being unable to secure rights for his television channel to show test cricket, started his own rebel series.

Packer signed up most of the world's top players, including almost all the official Australia side, and decided to take the establishment on at its own game. Round one went to the Australian Cricket Board as spectators decided in the main to watch the official, and coincidentally gripping, series between Australia and India. But Packer was not only a buccaneer, he was also a visionary.

He decided to focus on one-day cricket with its instant thrills, put his players into coloured clothing to distinguish the team more easily, and stage cricket under lights. Australians responded by flocking to Packer's one-day matches in the summer of 1978–79 and, by the time a truce was signed in the following year under which Packer disbanded his World Series in return for the television rights, one-day cricket was firmly entrenched.

'Photographing the current Australia cricket side is really a pleasure,' said Anne. 'Besides being an incredibly talented team, they are hugely passionate as well. In this photograph, I sensed that the South Africa captain Shaun Pollock was taking a really risky run, so immediately after he played the shot I changed my focus to the far wicket where he was running to. A brilliant throw to Bichel saw Pollock run out.'

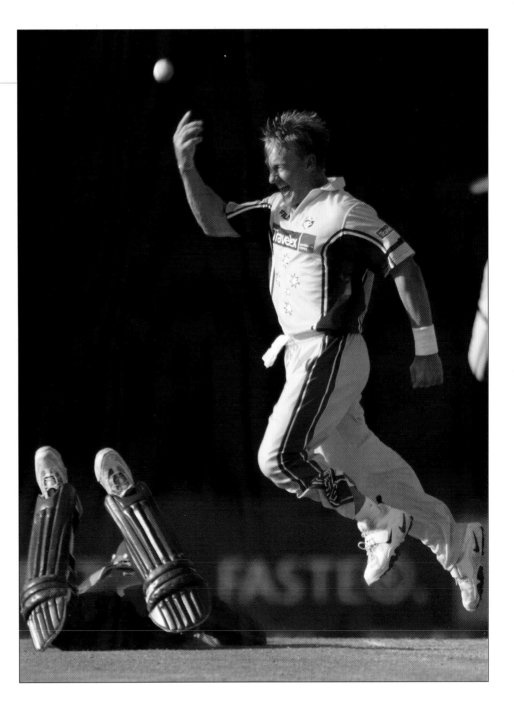

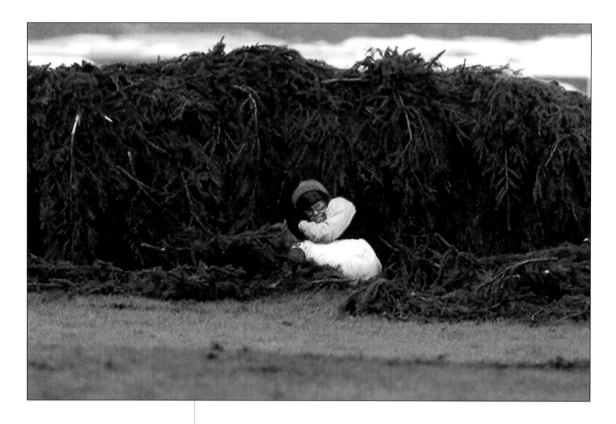

**Jockey takes
shelter after a fall**
7 April 2001

Dan Chung

Jockey Richard Johnson lies slumped on the ground after falling at 'The Chair' jump during the 2001 Grand National. Only four of the 40 horses that started the race, much criticized by animal welfare groups, finished.

'The Grand National is always physically a tough race to cover, almost as hard for the photographers as for the horses and jockeys,' said Dan. 'For several years I have followed the same routine along with about 20 other photographers.

'You first photograph the start of the race then dash 100 metres across the track after the horses have passed to "The Chair" jump to watch as the horses complete their first circuit. I then run from there back to the finish line in time for the winning horse to cross the line. This is while carrying a pair of cameras and a long telephoto lens.

'This particular jockey was unfortunate enough to fall off his ride directly in front of me at "The Chair" but luckily escaped serious injury.'

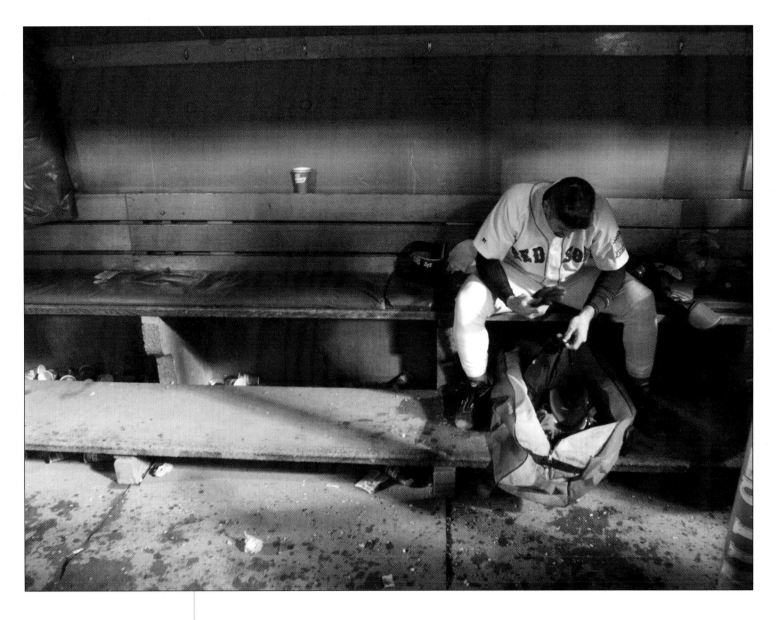

Boston Red Sox in defeat
18 October 1999

Andy Clark

Winners celebrate together; losers mourn alone. Jason Varitek of the Boston Red Sox slowly packs his gear after losing 6–1 to the New York Yankees in game five of the 1999 American League Championship Series. The Yankees won the series 4–1.

Two into one
6 August 1997

Petar Kujundzic

Two heads, two arms, two bodies, three legs, four shoes. This skilfully framed photograph shows two Kenyans; Bernard Barmasai, leaning back, and Moses Kiptanui, bending forward, finishing second and third respectively behind team mate Wilson Boit Kipketer (owner of the disembodied shoe) in the 3,000 metres steeplechase at the 1997 Athens world championships.

The steeplechase evolved from cross-country running, one of the many peculiarly 19th century English sports events which yielded strange fruits in distant lands. Both events are ideally suited to Kenyans, whose domination of the events shows no sign of disappearing in the early years of the 21st century. Kenya produces the most naturally gifted distance runners in the world, apart, possibly, from the Ethiopians. They possess fluid, economical running styles and seem to flow over the hurdles and float through the water in the steeplechase.

Although physiologists have found significant natural advantages in Kenyan runners as opposed to those from different countries, heredity is only one of several factors. Economic incentive is another. Hundreds of Kenyans run for money they would not earn otherwise whether on the grand prix athletics circuit or in US road races.

Rigorous training is another. Kenyans run faster, harder and longer in training than their rivals, usually at altitude, where the lack of oxygen forces their bodies to compensate by producing more oxygen-carrying red blood corpuscles.

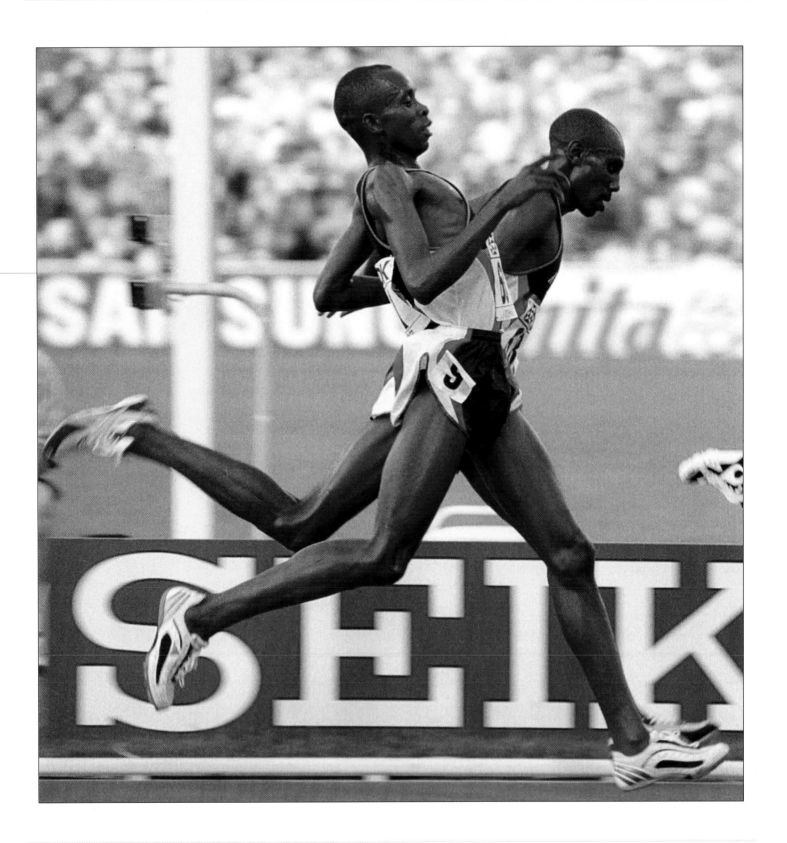

Ben Johnson flexes his biceps
May 1988

Gary Hershorn

In the mid-1980s Ben Johnson, a shy, taciturn and awesomely muscled Jamaican-born Canadian, brought excitement to the track. His 100 metres confrontations with Carl Lewis in 1987 and 1988 were the stuff of legend, reminiscent of the two world heavyweight title fights between Cassius Clay, later Muhammad Ali, and Sonny Liston a generation earlier.

Unfortunately for Americans, Johnson won on both occasions in world record time. Lewis was unimpressed and made unspecified allegations about something strange in the air after his defeat in Rome in 1987. He vowed revenge in Seoul and after an impeccable build-up and a series of fast times in the qualifying rounds the 1984 four times Olympic champion was a marginal favourite for the 1988 final.

Those who watched the race will never forget the sight of Johnson exploding from the blocks and shooting across the line in a world record 9.79 seconds, a time which has still not been bettered. Lewis, his race over after it had barely started, could only watch helplessly as Johnson, his right index finger raised in triumph, ran nearly another 100 metres before starting to slow down. However, the Canadian's hulking physique, captured here during a training session in Toronto in May 1988, hid a dark secret.

Johnson had been on a drugs regime since 1981 and his positive test for a body-building anabolic steroid in Seoul cast a shadow over the Olympics and his sport that has never quite lifted since.

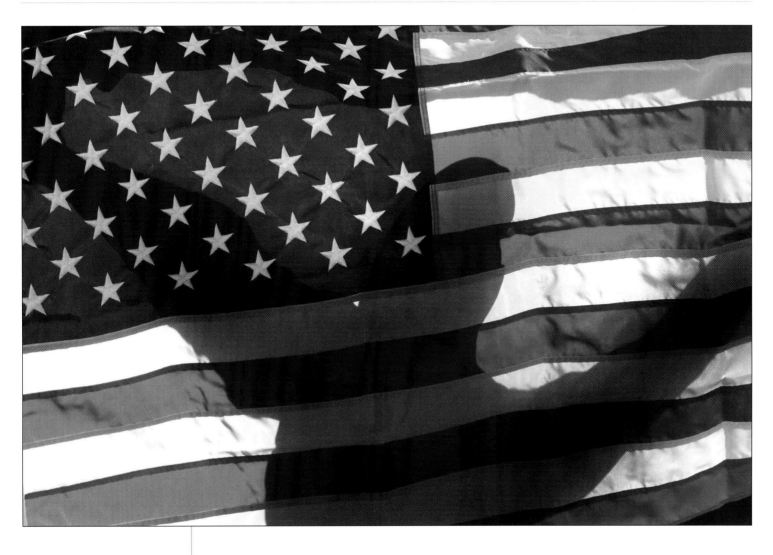

A triumphant Maurice Greene

5 August 2001

Jason Reed

Only one man has run as fast as Ben Johnson, the Kansas cannonball Maurice Greene, who set the present official mark of 9.79 seconds eight years after the disgraced Canadian's mark was expunged from the record books.

Greene watched disconsolately in 1996 as another Canadian, Donovan Bailey, beat the best of the Americans at the Atlanta Olympics. Vowing to realize his full potential, Greene moved to California to train under the world's premier sprint coach John Smith and in the following year set his present world record and won the first of three world 100 metres titles in Athens. He won the Olympic 100 title at the Sydney 2000 Games but attracted a torrent of adverse publicity after his and his team mates' antics before the 4×100 victory ceremony.

Greene is a more sensitive and intelligent individual than his exaggerated showboating in Sydney indicated. He is conscious of his heritage as the world's fastest man and also of the need to publicize a sport that is practically ignored in his home country outside Olympic years.

The picture shows him outlined behind the Stars and Stripes after he retained his world title with a time of 9.82 seconds at the Edmonton championships. But for a muscle injury in the final strides, which brought his year prematurely to a close, he could have threatened his world record.

'Being in field it was my responsibility to follow the winner on his victory lap and as the afternoon sun sank lower in the sky, I caught Greene's shadow through the American flag a spectator had given him,' said Jason.

The Italian coach watches his team train
23 June 2000

Paolo Cocco

Dino Zoff, famed goalkeeper turned coach, watches impassively as his players train at the Italian camp in Geel, northern Belgium before their 2000 European championship quarter-final against Romania.

'The exposure time was quite long, about half a second,' said Paolo. 'That's why the players look like ghosts. After following each team for a long time, I think you should try something different.'

Zoff, who led Italy to the World Cup in 1982 at the age of 40, was exceptionally consistent over two decades, playing 112 times for his country. In the 1970s he went for a record 1,143 minutes without conceding a goal in international soccer and estabilished a similar record of 903 minutes in the Italian league.

He was noted for his courage and concentration, with reflexes finely honed by the concentration on defence in the Italian leagues. Zoff marked his 100th international by keeping a clean sheet against Poland in the 1982 World Cup in Spain and was supreme in the final, won 3–1 by Italy against West Germany.

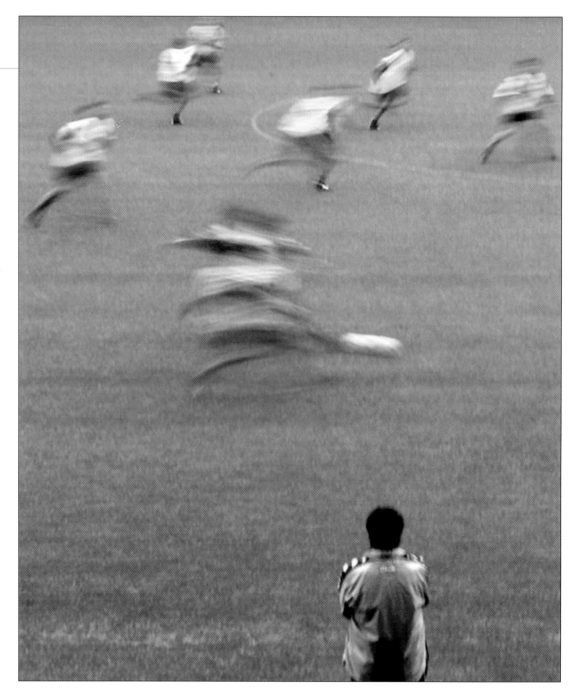

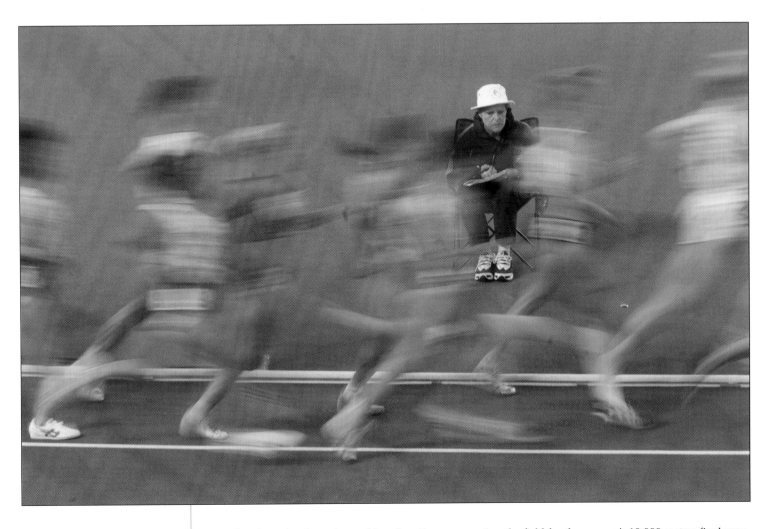

10,000 metres in Edmonton

7 August 2001

Kai Pfaffenbach

An official watches intently as a blur of motion representing the field for the women's 10,000 metres final races past in the 2001 Edmonton world championships.

A close look at the photograph reveals the tall, blonde Paula Radcliffe ahead of a posse of Ethiopians, all destined to relegate her to the minor places again in the final 400 metres.

Derartu Tulu won the sprint finish to add to her 1992 and 2000 Olympic gold medals and three world cross-country titles followed by team mates Berhane Adere and Gete Wami. Radford left the track in tears after a public row with her husband, which was quickly resolved.

Radcliffe, personable, modest and articulate, seemed destined for a bit part in the record books when fate relented and her life changed. She retained her world half-marathon titles and world cross-country titles before making her marathon debut in London April 2002 in a field including Tulu and most of the world's leading marathon runners. Radcliffe led from the start as usual, but set such a blistering pace that she quickly dropped the remainder of the field to clock the second fastest time in history. Back at the track, she won the 2002 commonwealth 5,000 metre title and the European Championships 10,000 metre race by an astounding 300 metres.

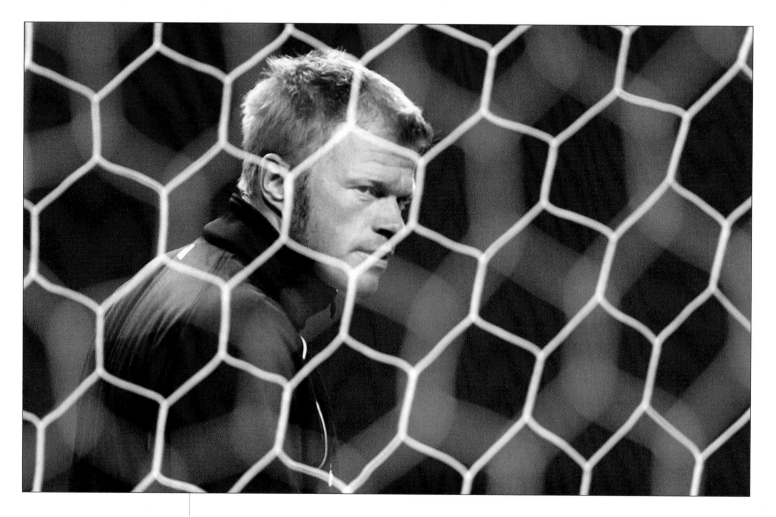

Kahn stares through the net
31 May 2002

Ian Waldie

At the heart of Germany's unexpected 2002 World Cup success in reaching the final was the consummately accomplished and fiercely determined goalkeeper and captain Oliver Kahn.

He conceded only one goal in the opening rounds and was named best goalkeeper of the tournament. He then became the first goalkeeper to win the world governing body FIFA's Golden Ball award as player of the tournament. 'He is at the peak of his career,' said Kahn's coach Sepp Maier, himself a member of the 1974 World Cup-winning West German side. 'He is making himself immortal.'

Sadly, a blunder in the final gave Ronaldo the first of Brazil's two goals in their 2–0 win. A bitterly disappointed Kahn was still welcomed home as a hero. 'What's important is that Germany is back at the top of world soccer,' he told a cheering crowd at Frankfurt Airport. 'We'll be back in four years and then maybe as world champions.'

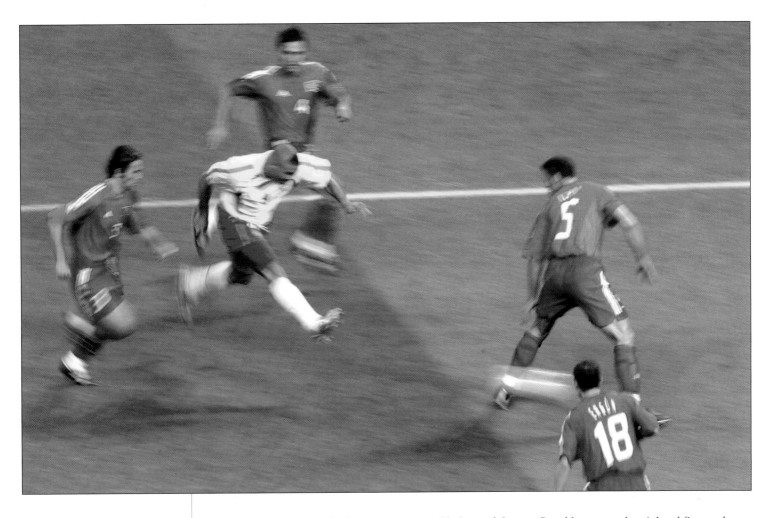

Ronaldo back on form
26 June 2002

Ruben Sprich

At the 1998 World Cup final in Paris, twice world player of the year Ronaldo was a sad peripheral figure who was originally left off the teamsheet after suffering a fit before the final match. He contributed little to the game, which his subdued Brazil side lost 3–0 to France.

Much of the subsequent years were spent in a cycle of injuries, operations and recuperation and nobody really knew what sort of shape he would be in for the 2002 tournament. In the event his form was a revelation and, most importantly, the smile was back on the Brazilian striker's face.

Ronaldo, pictured here slotting the ball into the net with the outside of his right toe in the semi-finals against Turkey, scored eight goals in the competition, including both goals in the 2–0 final win over Germany. He also equalled Pele's Brazilian record of 12 World Cup goals. 'A weight has been lifted from my conscience,' he said after Brazil's fifth world title. 'I'm free. This conquest has crowned my struggle, my recovery.'

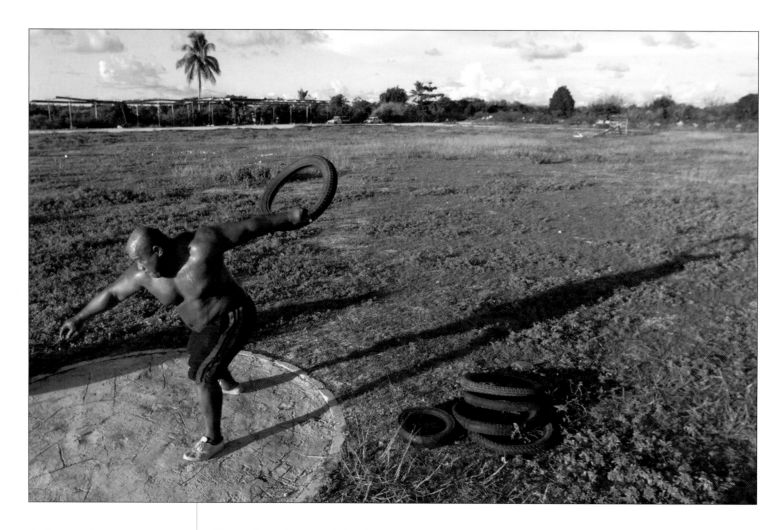

A discus thrower practises with a bike tyre
13 September 2001

Mark Baker

Nauru discus champion Gerrard Jones prepares to throw a bike tyre during a training session for a Pacific Islands athletics competition. At the time, Nauru, the world's smallest republic, was preparing a temporary camp for 500 asylum seekers who had been captured off Australian waters in September 2001.

'I stumbled across this guy on the tiny Pacific island of Nauru, two days after September 11,' said Mark. 'I was there for a boatload of unwanted refugees whose boat sank off the coast of Indonesia as they tried to get into Australia, who had refused to take them.'

'This grassed field was going to be a temporary refugee camp for them and late in this very quiet day I found the Nauru discus champion throwing bike tyres. It is one of my very favourite pictures.'

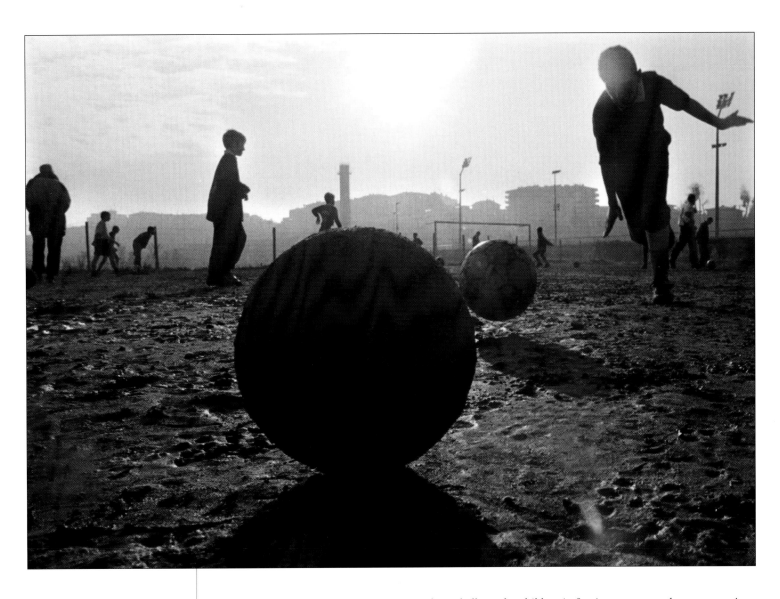

Children play soccer in post-war Sarajevo
9 November 1998

Damir Sagolj

Instead of hiding from snipers or sheltering from shell attacks, children in Sarajevo can now play soccer again near the stadium that staged the 1984 Winter OIympics.

'The muddy field is surrounded by thousands of graves of those who were killed during the siege of the city and is the only one that was not turned into a cemetery,' said Damir. 'One of the infamous graveyards from the war is next to that field.'

The best-known wartime soccer match was played between English and German soldiers on Christmas Day, 1914. The two sides laid down their arms for the day in no man's land near Ploegsteert wood in Belgium and played a game that the Germans won 3–2.

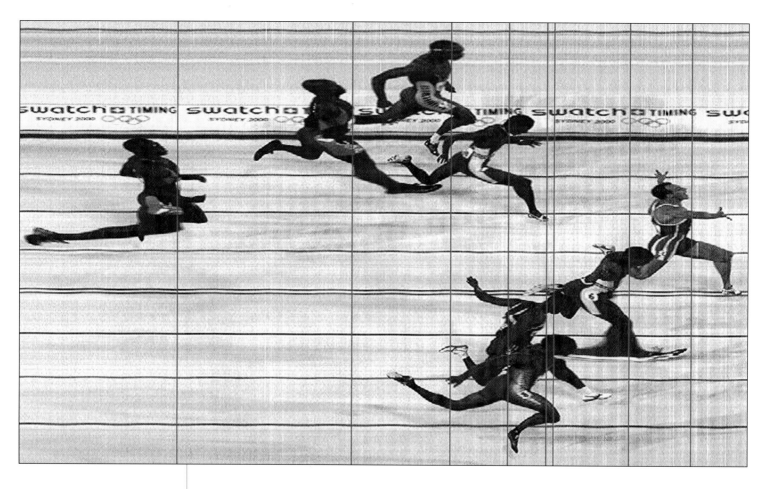

**Kenteris seizes an
unexpected gold medal**
28 September 2000

REUTERS/Swatch

In one of the biggest upsets in the world of sprinting, Greek Konstantinos Kenteris emerges from nowhere to win the men's 200 metre final at the 2000 Sydney Olympic Games. The event was wide open after world record holder Michael Johnson and world champion Maurice Greene both failed to complete the final at the US trials, making them ineligible for the Games.

In their absence Greene's training partner Ato Boldon, the 1997 world champion, was favourite but instead Kenteris created the biggest upset of the track programme in Sydney.

Kenteris confirmed his victory had been no fluke with a convincing win at the Edmonton world championships in the following year.

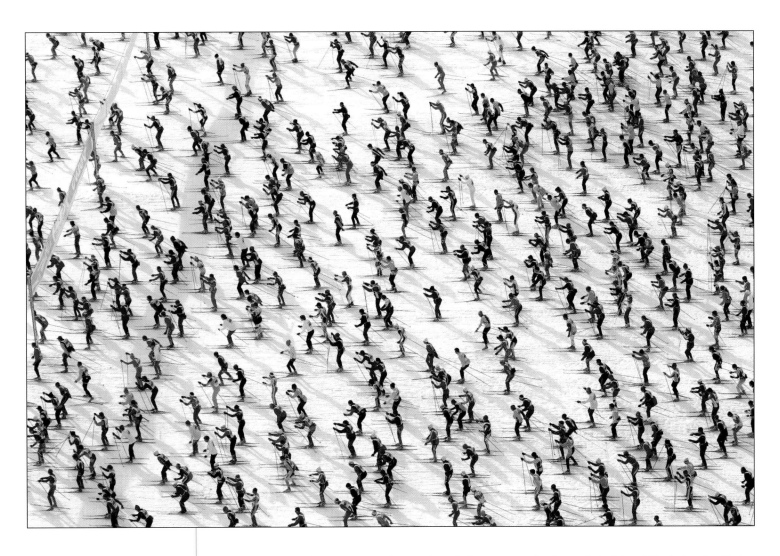

Skiers cross a frozen lake
11 March 2001

Remy Steinegger

This aerial view is of cross-country skiers making their way across the frozen Swiss lake of Sils during the 33rd Engadin ski marathon. More than 12,000 skiers took part in the marathon over 42 km from Maloya to St Moritz and Zuoz.

David Beckham receives a kiss from son Brooklyn
5 May 2001

Ian Hodgson

Few sportspeople have experienced the extremes of public adulation and vilification as the England soccer captain David Beckham, captured here accepting a kiss from his son Brooklyn after winning the premier league title with Manchester United at Old Trafford in the 2000–01 season.

A sublime ability to send the ball in an unerring arc from one part of the pitch to the other won him early admiration in the sporting press. A romance with Victoria Adams of the Spice Girls, then at the height of their fame, during the late 1990s transported an essentially unremarkable young man with sporting gifts and photogenic features into the world of celebrity.

His very public off-field lifestyle did not endear him to the conservative English football establishment outside the Manchester United cloisters, who suspected it displayed a lack of substance. This distrust was shared by the then England manager Glenn Hoddle, who did not include Beckham in his early plans at the 1998 World Cup in France, accusing him of being unfocused.

Beckham's critics believed they were justified when Beckham was sent off against Argentina in the second round for a petulant kick after he was fouled by Diego Simeone in a match England lost on penalties after one of their best displays in recent years.

The reaction in England was extraordinary, magnified by the fraught on-field relationship with Argentina after the 1982 Falklands/Malvinas war. Beckham stoically endured the taunts he received in the following season. He kept his thoughts to himself, fought back to help United win the treble in 1999, and was promoted to England captain for the 2002 World Cup. Finally, the public realized that despite his off-field image, Beckham is an admirably old-fashioned sportsman, devoted to his game and his family.

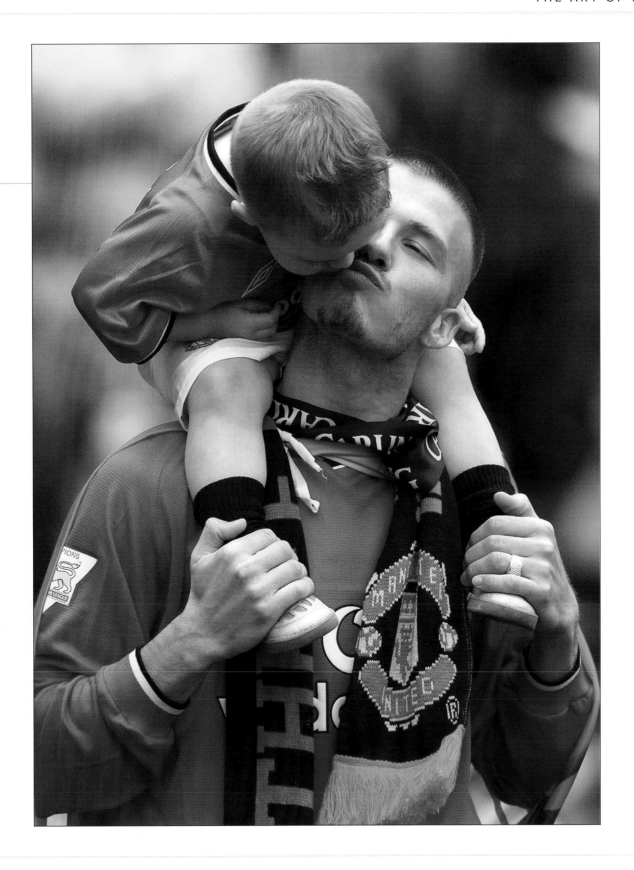

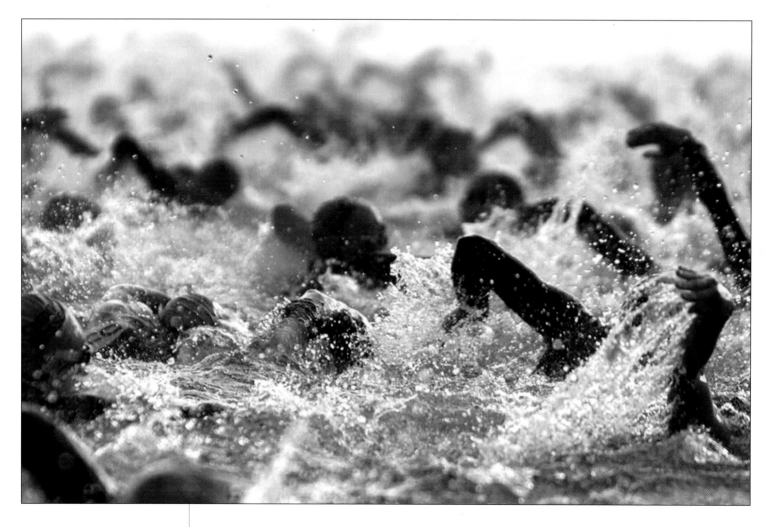

Triathletes in Lake Zurich

5 August 2001

Sebastian Derungs

More than 1,000 triathletes swim through Lake Zurich in the seventh Swiss Ironman triathlon.

The ironman edition of the triathlon, is almost impossibly demanding. The contestants swim for 3.8 km, cycle for 180 km, then run a full marathon of 42.195 km.

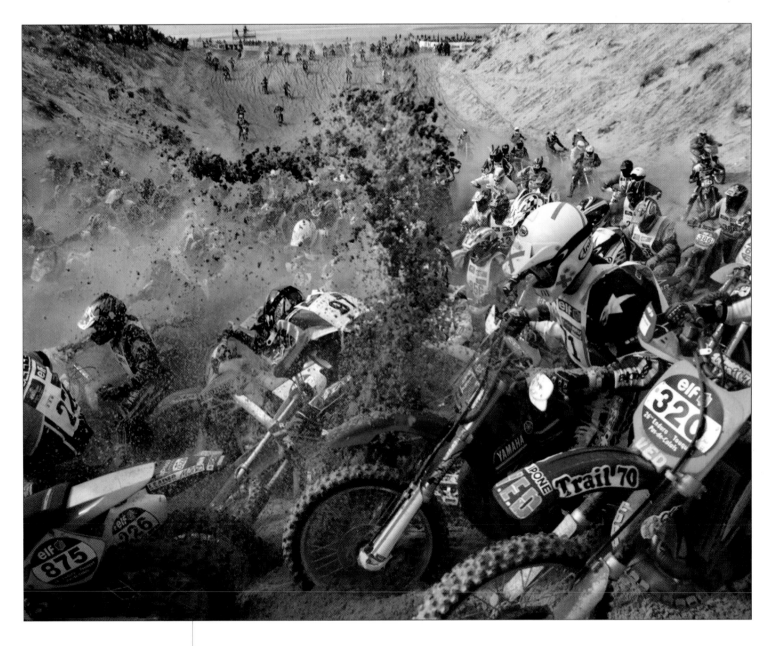

Bikers in the dunes
18 February 2001

Pascal Rossignol

About 1,000 bikers churn through the dunes section of the 26th Enduro du Touquet motorcycle endurance race on the beach of Le Touquet, northern France.

Disgraced Olympic champion Muehlegg rests
23 February 2002

Andrew Winning

Spaniard Johann Muehlegg rests on his poles after winning the men's 50 km cross-country classical ski event in Soldier Hollow at the 2002 Salt Lake City Winter Olympics. The real drama was to follow.

Persistent whispers that the incredible endurance of the cross-country skiers owed as much to drugs as training were confirmed when the triple gold medallist and two other athletes were thrown out of the Games for doping offences.

Tests confirmed that Muehlegg, Russian Larisa Lazutina and her team mate Olga Danilova had tested positive for a state-of-the-art drug darbepoetin, which had been on the market only since the previous October.

Darbepoetin is used for the treatment of anaemia in the same way as EPO (erythropoietin), the drug at the centre of the 1998 Tour de France drug scandal.

The International Olympic Committee (IOC) had introduced a combined blood-and-urine test for EPO at the 2000 Sydney Olympics in an effort to catch endurance athletes who were artificially enhancing the ability of their blood to utilize oxygen. New IOC president Jacques Rogge heralded the Salt Lake City drugs bust as a breakthrough.

'It is a sign that we have succeeded in tracking down the cheats,' he said. 'We find a new drug on the market that has only been used for three months and already the athletes are using it.'

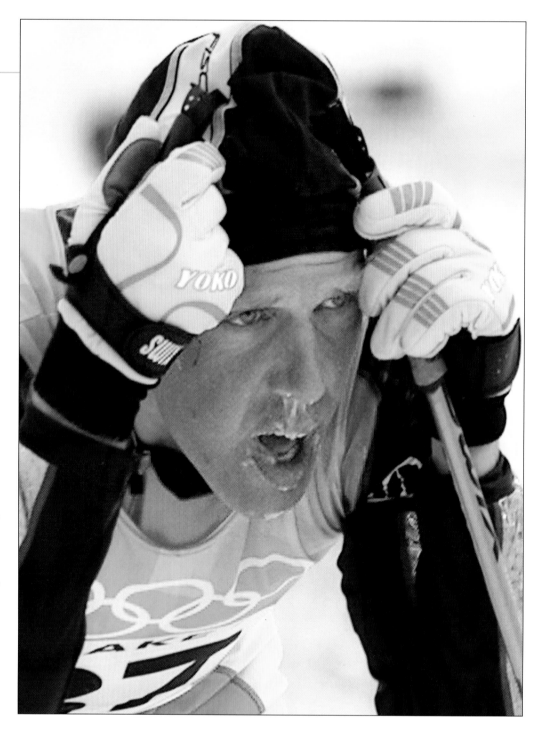

Goalkeeper weeps
5 May 2002

Fabrizo Bensch

Goalkeeper Dimo Wache of German second-division club FSV Mainz 05 weeps after his team fails to win promotion.

'I took this picture of the goalkeeper seconds after the referee ended the match, running on to the field while his team mates surrounded and comforted him,' said Fabrizo.

'His face was covered by his gloves but for a second he looked up and that was the moment I captured the image.'

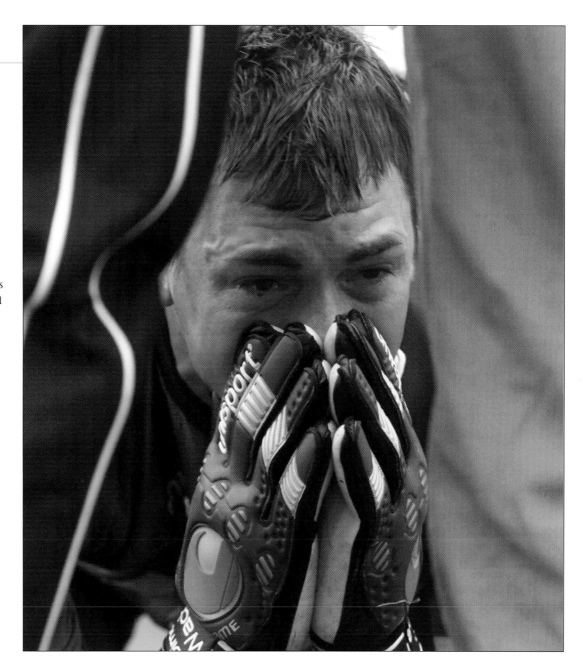

Stewart's stumps fly
25 March 1998

Kieran Doherty

A satisfying moment for any bowler, in this case Jamaican fast bowler Reon King who has sent Alec Stewart's stumps flying in a warm-up match during England's 1998 tour of the West Indies.

'I fired before the ball reached Stewart and the camera caught this moment,' said Kieran. 'Complete and utter luck.'

Stewart, an outstanding servant of English cricket, was named national captain after this tour when Michael Atherton decided he had had enough. He led England to a series win over South Africa in the following English summer but suffered the customary fate of modern England captains by losing a subsequent series in Australia. No England side has won a series in Australia since 1986–87 and England have not held the Ashes since they were overwhelmed at home in 1989.

Stewart's tenure was shorter than most when England failed to advance past the group stages of the 1999 World Cup even though they were playing at home. He will be remembered not for his captaincy but for his handsome stroke play and his athletic wicketkeeping.

As an opening batsman, he scored a century in both innings against West Indies in Barbados on the 1993–94 tour. Dropping down the order when asked to keep wicket, he was England's premier all-rounder of the 1990s. No matter what the selectors asked, Stewart always did his best to oblige. This year Stewart became the most capped England player of all time, with 119 test appearances.

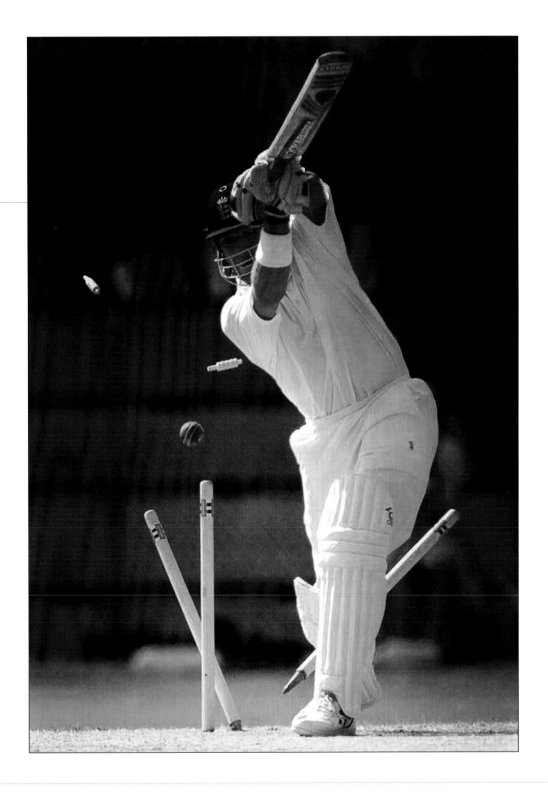

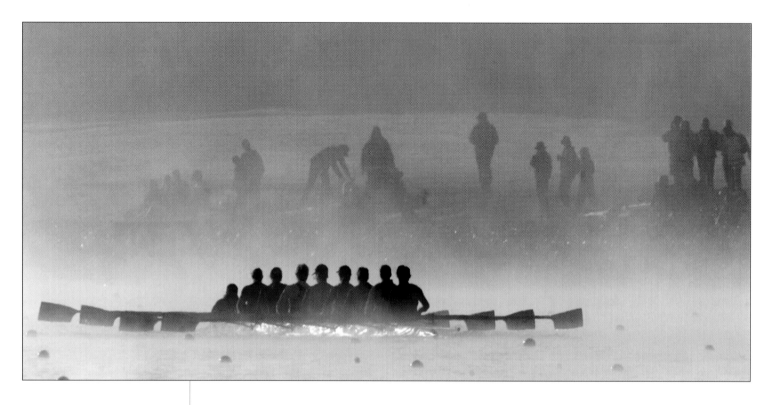

Rowers train in the dawn mist

17 September 2000

Andy Clark

'Eight minds with but a single thought,' the English critic, essayist and caricaturist Max Beerbohm once remarked of a rowing eight, adding: 'If that.'

Rowing and rugby have often provided interesting examples of the English upper classes at play, but at Henley as elsewhere, rowing is a serious and demanding sport.

Literary references to rowing have been traced to Virgil in the *Aeneid* in which he describes the funeral games arranged by Aeneas to honour his father. Rowing developed in England on the River Thames where professional watermen plied their trade across the river and, inevitably, contests for money evolved.

Organized competitive rowing was introduced into Oxford and Cambridge Universities in the 19th century and the first university boat race, an annual event which still receives an inordinate amount of interest in England, was staged at Henley in 1929.

In the US, rowing competitions also developed between professional watermen and in Australia crews of whaling boats compete with crews from shore stations. In the picture above a crew practises in morning mist at Sydney's International Regatta Centre before the 2000 Olympics.

Australians practise in the evening chill
29 October 1999

Kieran Doherty

Mist rises and the chill in the air is palpable as the Australian Wallabies warm up for a training session before their 1999 rugby union World Cup semi-final against South Africa at Twickenham.

Australia defeated the Springboks and went on to beat France in the final to become the only team to win the William Webb Ellis trophy twice.

Australian rugby union was for many years a poor relation of the professional rugby league, whose international impact was limited but whose domestic impact in New South Wales and Queensland was immense. To complicate matters Australian Rules was the predominant football sport in Victoria while European immigrants played soccer.

During the 1980s, Australian rugby union gained steadily in strength, helped by regular trans-Tasman contact with New Zealand, who along with South Africa are one of the game's two traditional giants.

After New Zealand had won the inaugural World Cup in 1987, Australia knocked the All Blacks out in the semi-finals of the 1991 Cup and went on to beat England in the final.

Rugby union in Australia is played mainly by the professional classes in New South Wales and Queensland, although its appeal is broadening. If the leading Aussie Rules and league players decided to join union en masse, the rest of the world might as well give up.

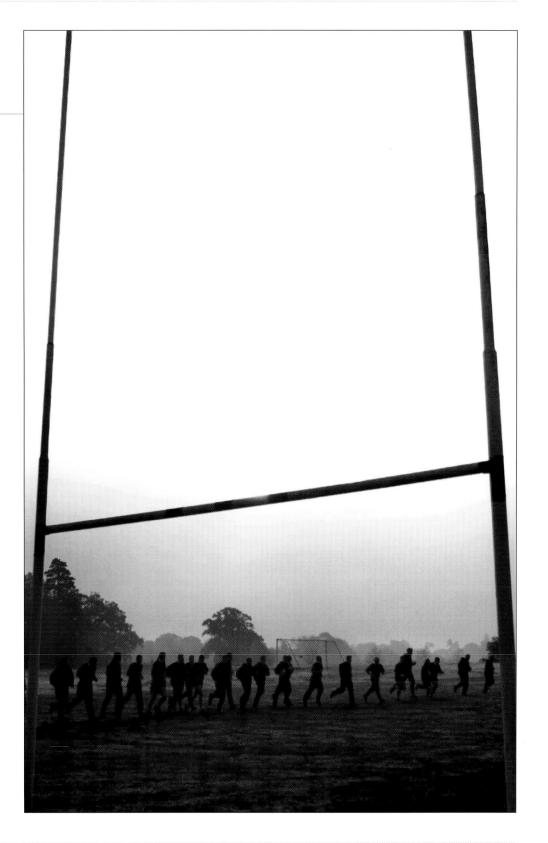

Russian speedskater Lobkov prepares to race
16 February 2002

David Gray

Russian Dmitry Lobkov at the start of the men's 1,000 metres at the 2002 Salt Lake City Olympics.

'A skater starting a race is a fairly static shot,' said David. 'However, adding a few elements can make the picture more dramatic. To get the best reflection on the ice I had to wait until after the surface had been re-iced, giving it the smooth reflective sheen that is required.

'After the first skater has completed his race, the surface has been broken by his skates and does not give the desired effect, so you only really get one chance to get the picture you want.'

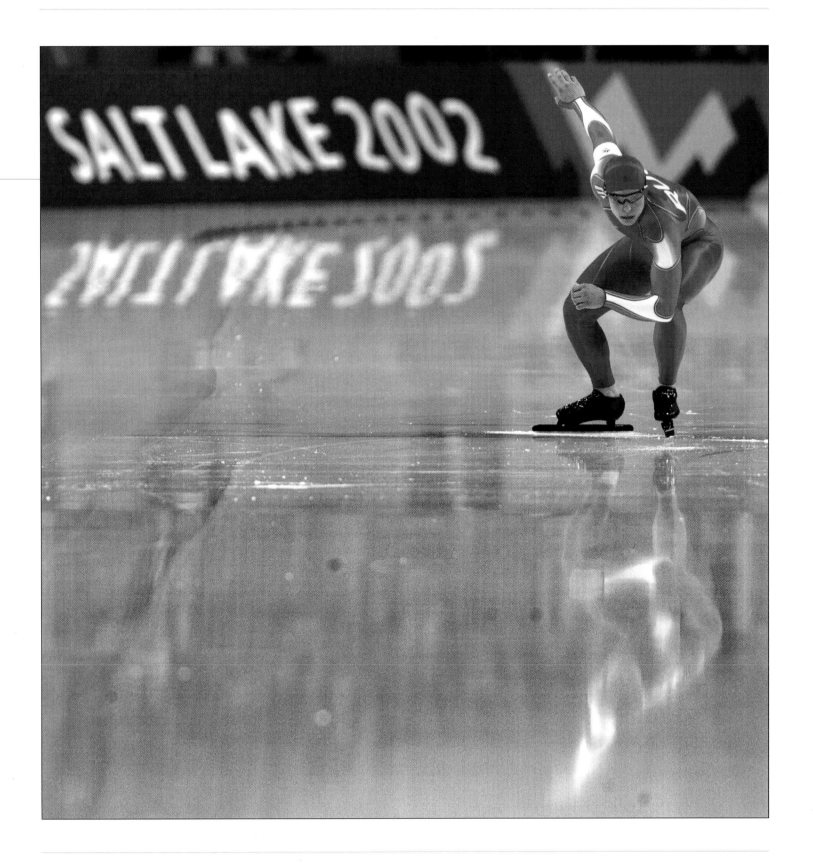

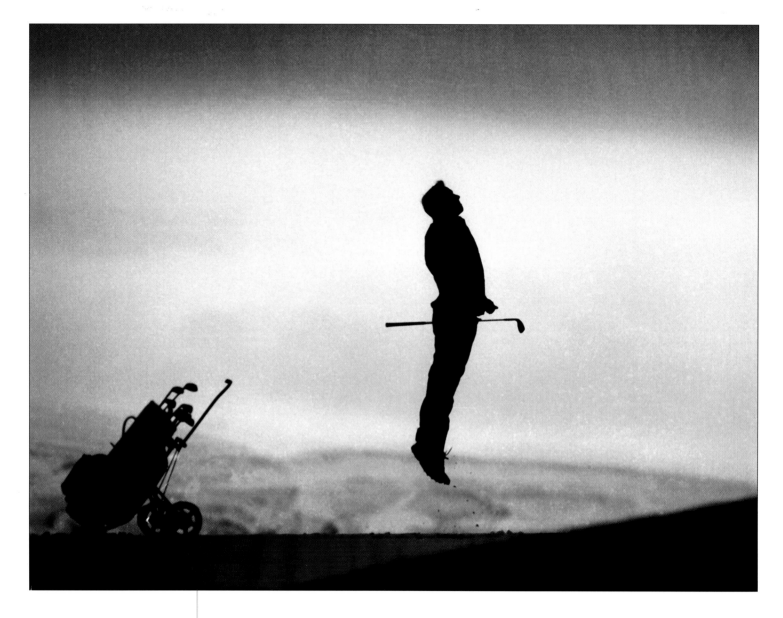

Spring golfing in Glasgow
May 1993

Ian Waldie

A golfer leaps high to follow the course of his ball during a round at the Crowood Golf Club in Glasgow. The mountains in the background are still covered in snow, although it is mid-May.

'I like the dynamics of the silhouetted vibrant golfer with the snow-capped mountains behind him,' said Ian.

Golf is historically associated with Scotland although there is no totally convincing evidence of its origins. It has been traced variously to Ireland, France and Belgium, where medieval illustrations show players wielding clubs in approximate golfing poses.

Advocates of the Scots' case argue that it was there that the practice of manoeuvring a ball with the purpose of placing it in a hole originated. In 1424 the parliament of James I passed an act forbidding the playing of soccer because it interfered with archery practice. Thirty-three years later golf was added to the act, indicating it had become a sufficiently popular leisure pursuit to clash with the sterner task of preparing a citizen army.

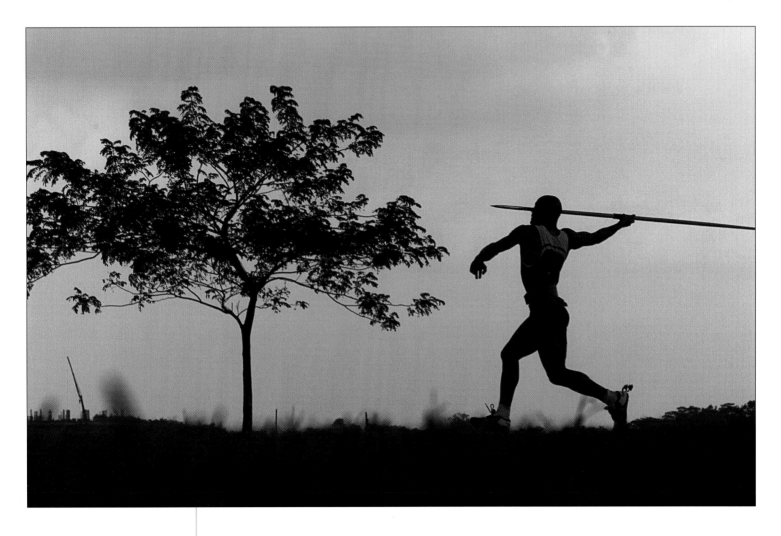

A javelin thrower practises
11 September 1998

David Gray

A javelin thrower, framed against a tropical sky resembles a hunter seeking to spear game as he practises before the 1998 Commonwealth Games in Kuala Lumpur.

Much of the potency of track and field, the central sport of both the ancient and modern Olympics, emanates from the essential simplicity of the individual disciplines. The javelin featured in both the ancient Greek Olympics, as evidenced by the writings of Homer and Tacitus, and the Tailteann Games in Ireland.

In the Middle Ages the javelin was thrown against fixed targets. Throwing for distance was introduced by the Hungarians and Germans in the late 19th century, the period when the laws for most modern sports were drafted. The event was taken up with most enthusiasm by the Nordic countries, in particular Finland, where it is still accorded a special status.

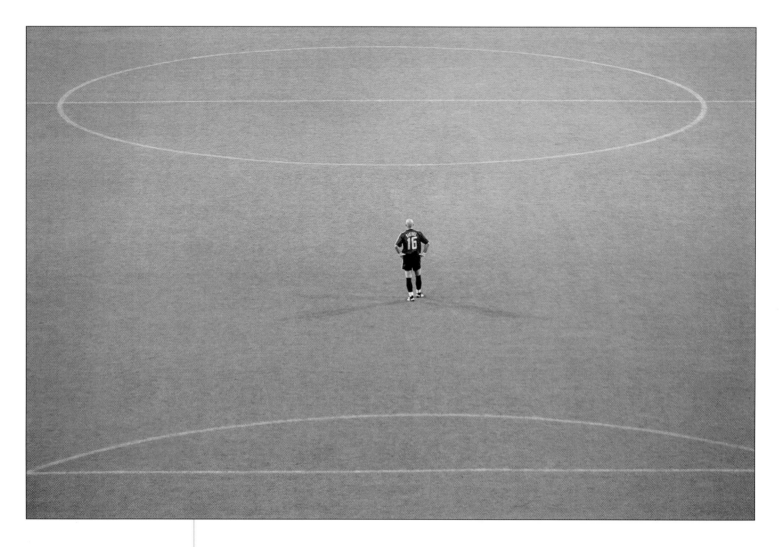

Fabien Barthez stands alone on the pitch
31 May 2002

Shaun Best

Possibly too old and certainly too tired, defending champions France limped out of the World Cup after the first round without either winning a match or scoring a goal, scarcely conceivable before the tournament.

Here, goalkeeper Fabien Barthez, one of the 1998 heroes, stands in ignominious isolation after the loss to Senegal. On his return to France, Barthez refused to watch any of the remaining matches on television.

'Under such circumstances, the only way out is to isolate yourself, to go back to normal life,' he said. Barthez also said he could not have dreamed France would leave so early. 'I hardly had time to look back and I was in Paris,' he said: 'Nothing could cheer me up.'

Cafu raises the World Cup Trophy
30 June 2002

Dylan Martinez

Head bowed, 2002 World Cup trophy aloft, Brazil captain Cafu acknowledges his country's fifth world title.

The Brazilian right-back's career was at rock bottom in June 2000. His commitment was questioned when he was sent off in a World Cup qualifier against Paraguay and decided to leave rather than stay with the team for a following game. The Brazilian media pounced again just before the World Cup, when the present coach Luiz Felipe Scolari said he needed to use three central defenders to compensate for Cafu's poor marking.

Cafu, 32, was given the captain's armband after Emerson was injured in training and responded magnificently, becoming the first player to take part in three World Cup finals.

'He transmits security to everyone,' said Scolari. 'He is a very special player. If there is one man who has made sacrifices and lent himself to the cause of the Brazil team, this man is Cafu.'

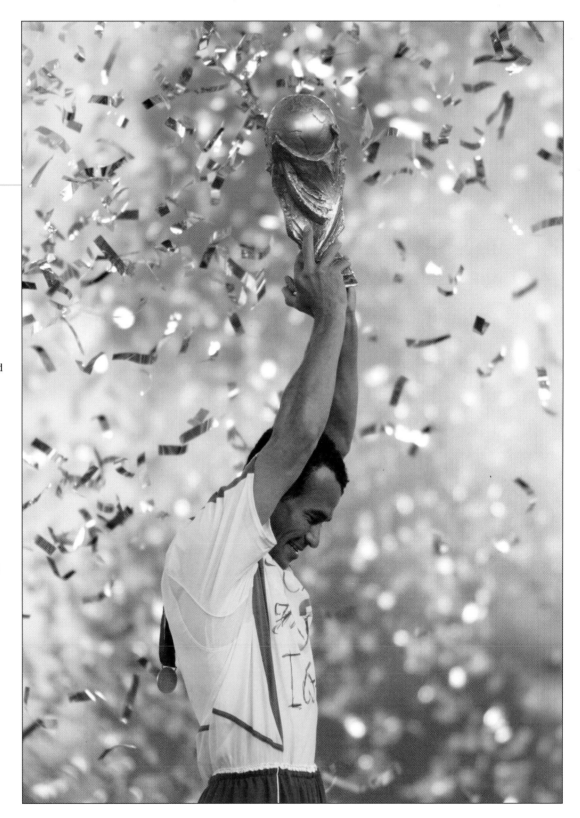

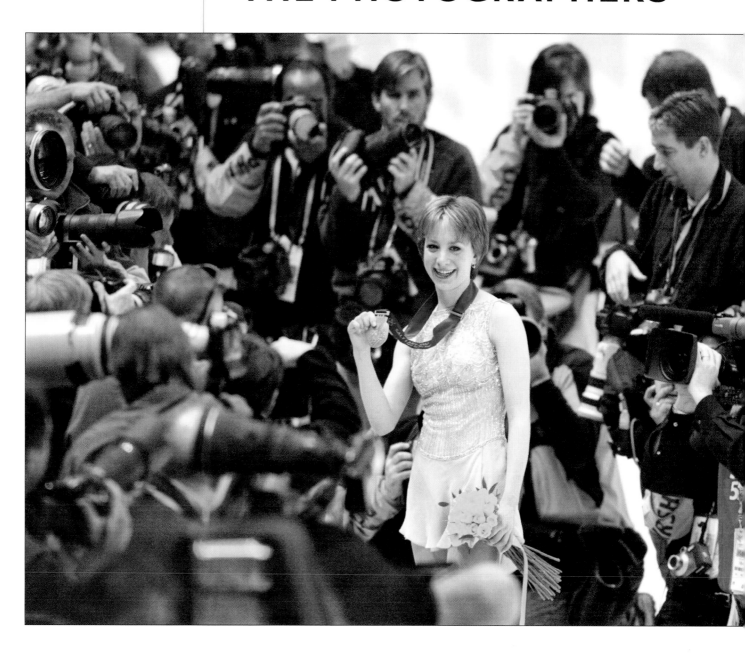

(Previous page)
American figure skater with Winter Olympic Gold
21 February 2002

Kimimasa Mayama

Sarah Hughes of the USA poses for dozens of photographers with the gold medal she won in the women's figure-skating competition at the Salt Lake 2002 Olympic Winter Games. Hughes won the gold, Russia's Irina Slutskaya won the silver, and Michelle Kwan of the USA won the bronze.

Andrew Winning

Born in Paris in 1970, Andrew Winning has lived in Brussels, Madrid, Nairobi and Buenos Aires. He went to school in London and to university in Bradford, Yorkshire. Andrew began his career in 1996 as a photographer with AFP in London, before taking his current job, Chief Photographer Mexico, Centam, Colombia and Venezuela.

Francois Lenoir

Francois Lenoir was born in Brussels in 1973. He studied photography at art school before working as a photojournalist for two national agencies, Way Press and Isopress. He joined Reuters as a freelancer in March 2000.

Russell Boyce

Russell joined Reuters as staff photographer in 1988 and has travelled the world extensively covering both news and sports stories since then. His assignments have ranged from covering sporting events such as the Olympics and soccer, cricket and rugby world cups, to working in war zones and covering international politics. As well as continuing to work as a photographer based in the UK, Russell now spends part of his time editing major international news and sporting events.

Sebastian Derungs

Sebastian was born in 1974 and raised in Zurich. He went to business school and after several years of working and travelling, he decided to study photojournalism at the MAZ in Lucern, Switzerland.

He started out as a freelance photographer for several newspapers and joined Reuters Picture Service Switzerland in September 2000 as a stringer.

Remy Steinegger

Remy was born in Ascona, Switzerland in 1957. He was a primary school teacher for three years, but in 1984, thanks to a lucky chance, he started working as a freelance photojournalist for a national news pictures agency in Switzerland. In 1992 he became a stringer for Reuters, covering the Italian-speaking part of the country.

Andrei Rudakov

Born in 1976 in the city of Kemerovo, Russia, Andrei studied physics in Kemerovo University from 1993 until 1999, but in 1997 he started collaborating with local newspapers as a photographer. In 1999 he started freelancing for Reuters. Now Andrei has moved to Moscow to work for the Capital's Eye photo agency, and in 2001 he won two second-place Interphoto prizes.

Tami Chappell

Born and raised in Atlanta, Georgia, Tami is a 1980 graduate of the Art Institute of Atlanta. She has been a freelance photographer since 1989 and a contract photographer for Reuters News Service since 1991. Tami has covered most major sporting events, including the Major League World Series, PGA golf, Super Bowl, Kentucky Derby and the 1996 Summer Olympics. Tami was a recipient of the 1990 YWCA Women of Achievement award and has also won sports awards from the Georgia Media Association in 1988 and 1989.

Erik De Castro

Erik has been with Reuters for the last 17 years. Born in Pola, Oriental Mindoro Island in central Philippines in 1960, he started his career in photojournalism in 1980 in the northern Philippines working at a small community newspaper called **The Gold Ore**. He joined United Press International three years later, before joining Reuters in 1985. He was named as Reuters Asia's Best Photographer for 2001 for his work in Pakistan and Afghanistan after the 11 September attacks and the Muslim rebellion in southern Philippines.

N.B. A 'stringer' is a freelance photographer, often on a retainer or contract.

Dylan Martinez

Born to Argentine parents in Barcelona, Dylan was brought up in Oxford and then moved to London. At 18 he started freelancing in London for music magazines, national newspapers and small news agencies. At 21 he started freelancing for Reuters London, and at 24 he was made a staff photographer based in the UK. In 1996 Dylan and his wife moved to Hanoi, from where he covered large swathes of Asia before returning to London in 1998, where they had a daughter. Dylan is currently Chief Photographer in Italy.

Jason Cohn

Jason was born in 1968 and grew up in Athens, Ohio, where he attended Ohio University's visual communications programme. During eight years of freelancing, Cohn's work has been published in newspapers and magazines all over the US and internationally. Cohn served as President of the Pennsylvania Press Photographers Association from 1996 to 2000. He has been a contract photographer for Reuters since 1997, when he and his wife moved to Pittsburgh. He has covered events from the crash of Flight 93 on 11 September to the come-back of Mario Lemieux.

Ian Waldie

Born in Nambour, Australia in 1970, Ian graduated from the Queensland College of Art in Brisbane in 1988. He worked on regional papers and then **The Brisbane Courier Mail** national daily newspaper as a graded staff photographer in 1989–1992.

In 1992, Ian quit his position to tour the UK and Europe. Having arrived in Glasgow in July 1992 he began freelancing for various Scottish newspapers. Ian became Reuters' Scottish stringer in 1993 and became staff photographer for Reuters based in London in August 1996.

Ian won the British Picture Editors Photographer of the Year Award in 2000 and 2002.

Jim Hollander

Jim was born in the USA and began his career as a photo-journalist in Europe in the mid-1970s. He joined UPI in 1980 and transferred to Tel Aviv as UPI Chief Photographer after covering the 1982 war in Lebanon. In 1985 he joined Reuters.

Jim has covered events in Israel and the Occupied Territories and then the Palestinian Authority areas from 1983 until mid-2001. In 2002 he published a book entitled **Run To The Sun**, documenting his 25-year photographic coverage of the running of the bulls and the fiesta in Pamplona, Spain. Following events of 11 September 2001, he has spent much of the time covering the conflict zone of the Arabian Sea and Afghanistan.

Mark Baker

Born in 1960 in New Zealand, Mark started his career on his parents' bi-weekly newspaper in 1977. He worked on various newspapers in New Zealand before moving to Australia in 1987 and working on the **Sydney Telegraph** and **Mirror** and doing a short stint as a staffer on the **Sydney Morning Herald**.

Mark joined Reuters in December 1988 and became Chief Photographer in 1994. He was New Zealand Sports Photographer of the Year in both 1985 and 1986.

Kin Cheung

Born in Hong Kong in 1973, Kin studied fine art photography at Bournemouth and Poole College of Art and graduated at London Guildhall University in 1998 with an MA in applied art. Kin started working as a photographer for **Cyber Daily** online newspaper before joining the Hong Kong bureau as a photo stringer.

Kin won the first-place award in the Hong Kong Press Photographers Association annual photo contest, sports category.

Colin Braley

Colin was born in 1962. He began his career freelancing for UPI while attending college. After working for several years at a mid-western newspaper, Braley joined Reuters as a contract photographer in 1989. Currently based in Miami, Florida, he continues to cover international news and major sporting events throughout the US and the Caribbean.

Pierre DuCharme

Pierre was born in St Paul, Minnesota in 1950 and has been working as a news photographer in Central Florida for the last 25 years. He started stringing for Reuters in the mid-90s on space shuttle launches and sporting events.

Jeff J. Mitchell

Born in Dumbarton on the outskirts of Glasgow in 1970, Jeff's first full-time job was as a photographer with the **Helensburgh Advertiser** in 1989. He moved to the **Edinburgh Evening News** in 1992 and **The Herald** in 1994. Jeff has worked for Reuters since 1996 and Jeff has attained various prizes in the Nikon awards, the British Picture Editors Guild, Scottish Press Photography Awards, and a first-prize story in the World Press Awards for coverage of Britain's foot-and-mouth outbreak.

Ferran Paredes

Ferran was born in Barcelona in 1975. He studied photography in Barcelona, where he graduated, and then started working as a photo-journalist for local newspapers. He spent some time working for national newspapers as a freelancer and started working for Reuters in 1998 as a stringer. He was based in Dublin during the first years of the Good Friday Agreement in Northern Ireland and has been based in London since 2001.

Kieran Doherty

Born in 1968, Kieran has worked at Reuters for the whole of his career. He is a staff photographer and is based in London.

Kieran has won many awards, including the English Sports Council's award for Action Image of the Year and Best Sports Photo in 1998.

Larry Downing

Born in California in 1952, Larry has worked as a professional photographer since 1976 in both Los Angeles and Washington. During the last 25 years, he has been a staff photographer for United Press International, **Newsweek** magazine and Reuters Photo, all based in Washington and assigned to coverage of the White House, including travelling on Air Force One and covering world events with Presidents Carter, Reagan, Bush, Clinton and Bush. Larry has been a staff photographer at Reuters since 2001.

Petr David Josek

Petr was born in Prague, Czech Republic in 1979. Since 2000 he has worked as a photo editor at the Czech photo agency, Spectrum Pictures. He is also a stringer for Reuters and a freelance photographer working in photojournalism.

Petr Josek

Petr was born in Brno, then Czechoslovakia, in 1952. He has worked in various professions including Czechoslovak TV and film studios, but has continued to take photographs throughout. In 1983 Petr entered a contest to become a news photographer in the Czech News Agency (CTK) and became a 'photo-reporter'. In 1990, after the 1989 Czechoslovak Velvet Revolution, Petr started to work as a stringer for Reuters, and in July 2000 became a staff member.

Alexander Demianchuk

Alexander was born in Kovel, Ukraine in 1959. He started out working on local newspapers in St Petersburg and has worked at Reuters since 1991. Alexander is currently staff photographer for Reuters in St Petersburg.

Bazuki Muhammad

Bazuki was born in the Malaysian capital of Kuala Lumpur in 1965 and was educated there until he studied architecture at Louisiana State University in the US.

Bazuki first started shooting American sports when he was 17 in Baton Rouge. Based in Kuala Lumpur since 1998, he now covers politics, features, sports and economics.

Jason Reed

Born in Sydney in 1970, Jason joined Reuters in his first year of college. In 1994 he transferred to Hong Kong, where he worked until the handover of the former British colony to China. He moved with Reuters to Singapore and since 1999 has been based in Bangkok, Thailand as a photographer with additional responsibility for coverage across Asia.

Jason has covered the past two Summer Olympics along with a list of other sports events. He considers sports coverage the most challenging and rewarding aspect of his work.

Dan Chung

Born near Leicester, England in 1971, Dan started doing freelance photojournalism work while still at college. He started working for a local newspaper in 1994 and joined Reuters as a London-based stringer in 1996.

In 1997 Dan became staff photographer and covered the Manchester United soccer team right through their European Championship campaigns in 1999. He has recently covered the Winter Games in Salt Lake City and the 2002 World Cup. Dan Chung won the Nikon UK Press Photographer in 2001.

Gary Hershorn

Gary was born in London, Ontario in April, 1955.

He started freelancing for a local paper in Toronto in 1978. He began working at United Press Canada in 1979. In 1985 Reuters News Pictures, which had just begun its worldwide picture service, hired him as Chief Photographer for Canada. He was transferred to Washington in 1990, where he is now News Picture Editor.

Andy Clark

Born in 1952, Andy began his career with Canadian Press as a copyboy in 1970. In 1974 he was promoted to photographer and transferred to Ottawa, where he joined the **Hamilton Spectator** and later the United Press Canada.

Andy joined the newly created Reuters News pictures operation in 1985 and later rejoined Reuters after a spell as Prime Minister Brian Mulroney's official photographer.

Andy is currently based in Vancouver but has travelled extensively throughout the world covering many assignments, including famines, disasters, world summits, sporting events and wars.

Christian Charisius

Born in 1966 in Freuburg, Christian has been working since 1989 as a freelance photographer. From 1989 to 1995, he was based in Munich, working in reportage and portrait for several magazines, in advertising and as a still-photographer. In 1996, he travelled through Spain, France and Belgium and later moved to Hamburg, where he started his work as stringer for Reuters in 1997.

David Gray

David started with News Limited Australia as a three-year cadet, moving to the Canberra Federal Parliamentary Press Gallery in 1991 for his final year. He was Sports Photographer for **The Australian** from 1993 to 1995 and moved to Reuters in 1996.

David has covered many sporting events in Australia, Papua New Guinea, New Zealand and India. In addition to sports coverage, David has covered news stories on political unrest in Indonesia and East Timor and has won the 1998 Australian Walkey Award for best Sports Photograph.

Ian Hodgson

Ian was born in Wakefield, England in 1964. He worked as a freelance photographer for local newspapers in West Yorkshire, joined Wilkinson Press Agency in Bradford in 1988, and then took a staff position on the **Gloucestershire Echo** in Cheltenham.

In 1990, he moved to Birmingham to work for the **Daily News** and later became Picture Editor on the **Birmingham Metro News**, from where he came to Reuters in May 1992.

Shamil Zhumatov

Shamil was born in Almaty, Kazakhstan in 1971. He studied journalism at Kazakh State University and, from 1987, worked as a photographer for the Kazakhstan newspaper, **Leninskaya Smena**. In 1990, he left to work as a photographer for the Kazakh State Information Agency (the TASS department in Kazakhstan) and since 1994 has been with Reuters, covering Kazakhstan, Krygyzstan, Tajikistan, Turkmenistan and Uzbekistan

Desmond Boylan

Desmond was born in 1964 in London. He worked for the Associated Press for three years before joining Reuters as a photographer and has been based in Madrid for six years.

Fabrizio Bensch

Fabrizio was born in 1969 in Berlin. He studied political science, during which he began working as a photojournalist in Germany. His first assignments were in 1989 before the Berlin Wall came down. After covering assignments all over Europe for many publications, he has worked for Reuters based in Berlin since 1992.

Mike Blake

Mike has been a Reuters staff photographer for the past 14 years. Based in Vancouver, Canada he spends a large portion of his year on the road covering everything from hockey, to football, basketball, skiing and golf. The Olympics in Atlanta were Mike's fifth games, having covered three winter games and the 1992 games in Barcelona.

José Manuel Ribeiro

Born in 1960 in Lisbon, Jose finished his studies in 1981 and started to work in advertisement photos. In 1987, he started working as a stringer on dailies and as telephoto operator at the Portuguese agency LUSA. At the end of 1989 he was invited to join the team of PUBLICO daily and in the early 1990s he also worked for the LUSA agency and Epoca magazine. Jose joined Reuters in 1996 and has now beaten his own record by staying there for more than three years.

Patrick De Noirmont

Patrick was born in Paris in 1949 and has worked as a photographer/editor with UPI, AFP and Reuters for 14 years from 1972 to 1999, in Europe, the USA, the Middle East, Africa and Asia.

Natalie Behring

Natalie was born in 1972 in San Francisco. She was a freelance photographer based in Beijing and worked non-exclusively for Reuters for three years, including a year in Israel as a staff photographer for Reuters in 2000.

Jerry Lampen

Jerry was born in Rotterdam, The Netherlands in 1961. He started working at a local agency in 1981, covering news and sports for local newspapers and the second biggest national newspaper Algemeen Dagblad. He moved to Haarlam and back to Rotterdam, still working with agencies who were occasionally stringers for Reuters.

Jerry has been working for Reuters since 1990, covering lots of sports such as soccer, speedskating and athletics, as well as general news stories.

Joachim Herrmann

Joachim was born in 1963 in Zell am Harmersbach, Germany. He attended photo school in Freiburg and became a freelance photographer. He worked as a staff photographer at the Offenburger Tageblatt in 1987–1988 and as a stringer at the DPA Hamburg office in 1988–1989. In 1990, Joachim started working for Reuters at the Frankfurt office, moved to Bonn for a while, and has been based in the Berlin bureau since 1999.

Michael Leckel

Michael was born in 1961 in Vienna, Austria and studied journalism and political science at the University of Vienna. He started writing articles for various Austrian magazines and then started to work in the editorial department of the Austrian Press Agency (APA), finally switching from writing to photography by 1988.

Michael started as Chief Photographer for Reuters in Austria and has also covered news and sports events for Reuters abroad, such as the crisis in Albania in 1997, political summits, the Olympics and the World Skiing Championships.

John Pryke

Born in Brisbane, Australia in 1965, John started out taking pictures as a cadet photographer in his home town at **The Daily Sun** and **Sunday Sun** newspapers.

He won Nikon Cadet Photographer of the Year in 1985, Australian Photographer of the Year and Sports Photographer of the Year in 1989.

In Brisbane, John was a stringer for Reuters, covering the World Cup rugby tournament and a number of Formula One and Motorcycling Grand Prix. He later joined Reuters as a staff photographer based in Sydney, Australia and is now based in London.

Paul Vreeker

Paul's professional career began on his sixteenth birthday when he started as a junior photographer with a local newspaper. In the following years, he worked for several papers and magazines and also did a lot of photography for advertising.

In 1982, Paul started working for ANP, the Dutch National Press Agency. In the 19 years he worked there, he covered events such as Summer and Winter Olympics, World and European championships, and state visits with the Dutch royal family.

In May 2001, he started to work as a freelancer for Reuters.

Andy Mettler

Born 1957, Andy was originally a school teacher before becoming a freelance photographer for Reuters and other clients in 1981. Living in Davos, Switzerland, he has specialized in winter sports, news and people.

Since 1991, Andy has been involved intensively in digital photography and mobile communication. In 1994, he developed the PhotoTraveler, a small picture transmission system with notebook and scanner.

Mike Hutchings

Mike was born in London in 1963, but studied social anthropology at the University of Cape Town, graduating in 1986. He began freelancing for both local and international publications in 1987 and followed the demise of Apartheid in South Africa during the turbulent 1980s.

He started working for Reuters in 1991 as a stringer and covered the historical first democratic elections that brought Nelson Mandela to power. Mike has worked across Africa and became a Reuters staff photographer in 1997. He received the Abdul Sharif award at both the 1997 and 2000 South African Fuji Press Photography Awards.

Damir Sagolj

Born in Sarajevo, Bosnia, Damir moved with his family to Moscow where he studied at the Moscow Energetic University and attended classes at Moscow's Academy for Film.

A few months before the war started in Bosnia, Damir returned to Sarajevo, where he worked in a small photo studio as photographer's assistant. A soldier in the Bosnian army for the next few years, he started taking pictures again as war came to an end.

In 1995, Damir joined the Paris-based Sipa Press agency as their Bosnia photographer and in 1997 he became Reuters Bosnia photographer. Based in Sarajevo, he covers major news stories and sporting events in Europe and the Middle East.

Eliana Aponte

Eliana was born in Bogota, Colombia in 1971. She graduated in journalism at Bogota's Externado of Colombia University, switching careers when she took a Reuters-taught photojournalism course at the university. She has worked for Colombian magazines and newspapers and for Agence France Press in Panama.

Eliana was a contract Reuters photographer based in Guatemala from 1997. Now she is working in Colombia and is based in Bogota.

Marcelo Del Pozo

Marcelo was born in Seville, Spain in 1970. He studied photography and television camera operation before starting work as a photo-journalist for a national newspaper in Spain. He has worked for Reuters in Spain and Portugal as a stringer since 1997.

Oleg Iordanov Popov

Born 1956 in Sofia, Bulgaria, Oleg graduated from photo school at Sofia University. He worked as a photographer and Chief Photographer on **Sport Weekly** magazine and **Nrodna Mladezh** daily before becoming a Reuters stringer between 1990 and 1994.

Since 1994 Oleg has been a Reuters Chief Photographer covering the wars in Slovenia, Croatia, Bosnia, Chechnya and the Kosovo crisis. He has also covered sporting events such as the World and European Soccer Championships, the Atlanta Olympic Games in 1995, and the World Athletics Championships in Sweden.

Petar Kujundzic

Petar was born in the Yugoslav capital of Belgrade in 1959. He has worked for Reuters for over 10 years, and has been a professional photographer for over 20 years. When war broke out in the former Yugoslavia, he was in charge of coverage and also covered the political turbulence that followed in Eastern Europe. He now runs the pictures operation in Serbia, Kosovo, Macedonia and Montenegro.

Daniel Joubert

Born in St Malo in 1960, Daniel studied psychology and information-communication for four years at the university in Rennes (Britanny). At the same time he started taking photos for a local newspaper (**Ouest-France**), who introduced him to Reuters.

In 1998, Daniel started working for Reuters as a stringer based in Nantes, in west France.

Dimitar Dilkoff

Dimitar was born in Vratza, Bulgaria in 1967. He started working as a photographer in 1990, working on several national newspapers until 1992, when he began working as a stringer for Reuters.

Jacky Naegelen

Jacky was born in Colmar, France in 1956. After studying photography in Paris, Jacky worked as a freelance photographer in the east of France and joined Reuters in 1985.

Anne Laing

Anne was born in Port Elizabeth, South Africa in 1958, where, despite obtaining a law degree, she decided that she would rather pursue a career in photography.

She joined the **Cape Times** newspaper in Cape Town as a staff photographer in 1983, becoming Chief Photographer in 1986 and Picture Editor in 1996. Anne regularly covered the unrest in the Western Cape in the late 1980s and early 1990s that led up to the first democratic election in the country in 1994.

Paul Hackett

Paul began his career in Birmingham, before moving to **Scotland on Sunday**. In 1991 he won the David Hodge Young Photographer award, and in 1993 joined the **Herald** in Glasgow. He moved to Reuters in 1996, and won the British Picture Editor's Guild Photographer of the Year award in 1999.

Kevin Lamarque

Kevin has been a staff photographer with Reuters for 15 years. Beginning in Hong Kong, Lamarque transferred to London, where he worked covering major sporting events, politics, royalty and more. Now based in Washington DC in his native US, Lamarque spends the bulk of his time covering the White House for Reuters

Joe Traver

Joe got his start in 1977 as a staff photographer for the **Buffalo Courier-Express**, where he worked until 1982. When the paper folded, he decided to start freelancing, working for Reuters, and various US magazines.

In 1993, after serving seven terms on the NPPA Board of Directors, he was elected National President of the organization for its 50th anniversary year. In 1996, he was the Deputy Photo Manager for the 1996 Atlanta Olympic Games, and returned to coordinate all photo coverage for the 2000 Olympic Games in Sydney, Australia.

Carlos Barria

Argentine photographer, Carlos Barria, who goes by the pseudonym Andres Moraga, was born in the Andean city of Bariloche in 1979. At the age of 18 he moved to Buenos Aires, where he began as an apprentice at the national newspaper **La Nacion**, going on to become one of Reuters' regular stringers. He was eventually hired as staff photographer at **La Nacion** and has worked on assignment for a wide variety of international publications and agencies.

Carlos was awarded first prize in the 2002 World Press Photo contest in the General News category, for his images of the social upheaval in December 2001 in Argentina.

Danilo Krstanovic

Born in 1951 in Sarajevo, Danilo was brought up in a world of photography. His late father and uncle were famous Sarajevo photographers who gave him his first lessons and gear. Danilo worked on the Sarajevo daily **Oslobodjenje** as sports and news photographer until the war started in his country. He lives in Sarajevo and has worked for Reuters since 1992.

Kimimasa Mayama

Born in Otaru, Japan in 1957, Kimimasa studied sociology before starting his career as a staff photographer at a Japanese news agency in 1981. He joined Reuters News Pictures in 1986 as a staff photographer and his major sport assignments have been the Olympics (Barcelona, Lillehammer, Atlanta, Nagano, Sydney and Salt Lake City), the World Championships (alpine skiing, athletics, speedskating and swimming) and the World Cup Finals (France and Korea/Japan).

Blake Sell

Blake joined Reuters in 1988 as one of the early members of the start-up operation in the US. He was based in San Francisco and Washington, covering assignments across the globe. Before coming to Reuters, he was a staff photographer for United Press International and the **Pasadena (California) Star-News**.

Pascal Rossignol

Pascal was born in Lille. After passing his CAP photographic diploma in 1981 Pascal started photo assignments with the newspaper **Le Matin du Nord** and then worked for **La Croix du Nord**.

Based in Lille, Pascal was engaged by Reuters in 1985 to cover northern France. Pascal is also a volunteer fireman, and regularly shoots pictures for French emergency services. He instructs journalism at the University of Lille and is also a keen underwater photographer.

Jim Bourg

Jim was born in Washington DC in 1964. He started his career at the age of 16 when he began photographing for the **Washington Post**. He began shooting for UPI in 1982 before joining Reuters in 1988 and has covered a myriad of political, sporting and general breaking-news events.

Shaun Best

Born in 1968 in Canada, Shaun has been a Reuters staff photographer based in Montreal, Quebec since February 2001. He previously worked for Reuters for six years as a contract photographer and before that he was a staff photographer at the **Winnipeg Sun**.

Joe Klamar

Joe was born in Lipt.Mikulas, former Czechoslovakia in 1965. He emigrated to Canada in 1987 and started working as a photo-journalist at the local daily paper **The Medicine Hat** and freelancing for Canadian Press in 1992.

In 1996, Joe returned to Slovakia, where he worked at TASR (Slovak national press agency) and as a stringer for Reuters for another couple of years, before returning to Canada for a year at the **Winnipeg Sun**. Since 2000 Joe has been back in Slovakia covering the country as Reuters' stringer.

Srdjan Zivulovic

Srdjan was born in Koper, Slovenia in 1959. He studied photography before starting work as photo-journalist on the national newspaper **Delo**. Srdjan has run his own photo agency as well as stringing for Reuters since 1991.

Scott Olson

Scott was born in 1960 about 100 miles north-west of Chicago, where he now resides. After a four-year stint in the United States Marine Corp, Scott attended Southern Illinois University, where he received a degree in English. He worked for a couple of newspapers around Illinois before moving to Chicago in 1990 to pursue a career as a freelance editorial photographer. He currently works regularly for Reuters, AFP, Getty as well as an international list of editorial and corporate clients.

Stefano Rellandini

Born in Milan in 1963, Stefano studied graphic design before working in a still-life studio for three years, also working in the dark room developing and printing the black and white images.

In 1987, he started to follow the alpine ski world cup and worked with the Pentaphoto agency since 1996. In 1997 his involvment with the Versace funeral began his collaboration with Reuters. He is now based in Milan.

Balazs Gardi

Balazs was born in Budapest, Hungary in 1975. He studied photography and photojournalism and graduated in 1996. Since then he has worked for **Nepszabadsag**, the leading Hungarian political daily.

In 2000, he was chosen for a World Press Photo "Joop Swart Masterclass" in Rotterdam, The Netherlands and in 2002, he spent a term at Cardiff University's School of Journalism, Media and Cultural Studies in Wales, with a grant from Reuters Foundation. Since 1998, he has been named Photographer of the Year in Hungary three times.

Pawel Kopczynski

Born in 1971 in Warsaw, Pawel graduated with a diploma in news photography. He began working in 1987, first for daily newspapers, then for the Polish Press Agency, and finally for Reuters, which he joined in 1995. Kopczynski has covered a wide variety of major world events, including the war in the former Yugoslavia, the Kosovo refugee crisis, the soccer World Cup, the Winter Olympics, and the rising of tensions between India and Pakistan. He is now Chief Photographer India and Pakistan.

Tom Szlukovenyi

Tom was born in Budapest, Hungary and worked for the **Globe** and **Mail** in Toronto, Canada for ten years before joining Reuters as a photographer based in Vienna in 1990.

He was Chief Photographer in the former Soviet Union from 1993 to 1996 and then moved to London as Editor in Charge/Senior Photographer, Europe in 1996. Tom started working from Singapore as Deputy News Pictures Editor in 1998 and is currently News Pictures Editor, Asia.

Paul Hanna

Paul was born in the US in 1965. He used to follow his father to photo assignments and started studying photojournalism in high school. After settling in Madrid in 1987, he started working for Reuters as a stringer in 1989, covering Spain, Portugal and a few foreign assignments. In 1992, he was hired as a photographer and desk sub-editor in London and in 1996 moved to Rome as Chief Photographer, Italy. He is currently back in Madrid as Chief Photographer Iberia (Spain and Portugal).

Kai Pfaffenbach

Kai was born in 1970. After studying history and journalism, he began his news photography career in Frankfurt as a freelancer for the German newspaper **Frankfurter Algemeine Zeitung**. Kai began working for Reuters as a freelance photographer in 1996 before becoming a staff photographer in 2001. He is currently based at Reuters, Frankfurt and was part of the team of photographers covering the disaster that struck New York on 11 September 2001.

Dominique Favre

Born in 1967 in Lausanne, Switzerland, after completing his business studies, Dominique took the decision to develop his personal interest in photography professionally. After two years as photo editor of the Swiss daily **24 Heures**, he joined the ARC Photo team in 2002.

Ruben Sprich

Ruben was born in 1967. His main area of study was publicity photography and he began his career as photographer in Switzerland for the AP. He became a freelancer for Reuters in 1991, as well as working for various other newspapers and magazines. In 1998, he became chief photographer for Reuters, Switzerland based in Zurich.

Ruben has covered a variety of events in Switzerland, including the Olympics, soccer, skiing, and track and field championships.

Robert Pratta

Born in 1948 in Lyon, Robert took a CAP in photography, then did compulsory military service, serving as a photographer. He was chief photographer for many years on a local magazine, but when the publication ended he changed direction to become stringer for the AFP in Lyon for six months. He has been stringer for Reuters Lyon ever since the photography department was created.

Paolo Cocco

Born in Rome in 1970, Paolo started taking pictures when he was 15 years old and studied at a cinema and photography school until he was 19. He started to work as assistant to a wedding photographer in 1987 and took his first assignment for an Italian magazine in South Africa in 1990.

Paolo ran his own photo agency for a couple of years and worked with an Italian magazine and a French agency. In 1994, he met Reuters photographer Luciano Mellace and started to work with Reuters as stringer. He became staff in December 1997.

Fatih Saribas

Fatih was born in Gazientep, Turkey in 1957. He has worked for Turkish newspapers and as a photo stringer for AP and UPI. Fatih joined Reuters in 1985 and has covered events in Turkey, the Middle East and Europe, such as the Romanian revolution, the death of Khomeini, the Gulf War, and the European football championships. He is now based in Istanbul and runs the pictures operation in Turkey.

Joe Mann

Born England in 1949, Joe's first job was as a cadet photographer with the Rhodesia Herald in Harare. In 1972 he moved to London where he got a job as a sports photographer with the Sporting Pictures Agency. In 1987 he landed the job of staff sports photographer for the **Daily Telegraph** in London and travelled the world covering major sporting events. He emigrated to Australia in 1991 and has since freelanced and worked for several international agencies, British and local papers.